―――――――

"Hauntingly beautiful . . . A work of art as luminous
as the old masters paintings that comforted him in his grief."
—THE ASSOCIATED PRESS

"Delightful . . . A heartfelt celebration of the power of art
and its ability to speak to us across the centuries and continents."
—*THE GUARDIAN*

"Bringley's story overflows with wonder, beauty, and the
persistence of hope, as he finds not just solace but meaning and
inspiration in the masterpieces that surround him."
—*THE CHRISTIAN SCIENCE MONITOR*

"Told with real literary gusto and an impressive command
of pace and shape. After finishing this book, plenty of sensitive
readers will be desperate to become museum guards."
—*THE SUNDAY TIMES* (London)

"A profound homage to the marvels of a world-class
museum and a radiant chronicle of grief, perception, and
a renewed embrace of life."
—*BOOKLIST*

"This absorbing memoir is also a beautifully written manual
on how to appreciate art, and life. It's
—TRACY CHEV
author of *Girl with a P*

PRAISE FOR

ALL THE BEAUTY IN THE WORLD

"An empathic chronicle of one museum, the works collected there and the people who keep it running—all recounted by an especially patient observer."

—*The New York Times Book Review*

"As rich in moving insights as the Met is in treasures, *All the Beauty in the World* reminds us of the importance of learning not '*about* art, but *from* it.' This is art appreciation at a profound level."

—NPR

"I loved Bringley's book. It taught me how to get more out of museums, how to pay attention, and how to think differently about time."

—*The Financial Times*

"The august galleries and their unseen basements throng with life and levity as well as with art appreciation. . . . There is a humility and generosity to this ekphrastic project—an ever-grateful acceptance of the fact that in art, its author found life."

—*The Times Literary Supplement*

"Bringley is a marvelous guide. . . . *All the Beauty in the World* succeeds joyously."

—*The Daily Telegraph*

"A lovely book . . . You will see the museum with new eyes."

—*BookPage*

"Intimate and fascinating."

—*Town & Country*

"With his engaging voice, Patrick Bringley takes the listener inside New York's Metropolitan Museum of Art in a uniquely personal way."

—*Audiofile* (Earphones Award Winner)

"The book works on so many wonderful levels . . . that at the end you make plans to visit the book again, perhaps this time with it under your arm on your next visit to the Met."

—*Air Mail*

"Patrick Bringley offers an intimate perspective on one of the world's greatest institutions. But *All the Beauty in the World* is about much more: the strange human impulse to make art, the mystery of experiencing art, and what role art can play in our lives. What a gift."

—Rumaan Alam, author of *Leave the World Behind*

"Wonderful. If you have ever been to a museum and stood motionless before an exhibit, if you've ever looked at a painting and found yourself crying, if you have ever wondered how a sculptor could find a human body inside a block of stone, this book is for you."

—Natalie Haynes, author of *A Thousand Ships* and *Divine Might*

"This book makes me yearn to have Patrick Bringley at my side in every museum I will visit for the rest of my life. Having a copy of *All the Beauty in the World* in my purse will be the next best thing."

—Hope Jahren, author of *Lab Girl* and *The Story of More*

ALL THE BEAUTY IN THE WORLD

THE METROPOLITAN MUSEUM OF ART AND ME

PATRICK BRINGLEY

SIMON & SCHUSTER PAPERBACKS

New York London Toronto Sydney New Delhi

An Imprint of Simon & Schuster, LLC
1230 Avenue of the Americas
New York, NY 10020

Illustrations by Maya McMahon

First Simon & Schuster trade paperback edition October 2024

SIMON & SCHUSTER PAPERBACKS and colophon are registered trademarks of Simon & Schuster, LLC

Simon & Schuster: Celebrating 100 Years of Publishing in 2024

For information about special discounts for bulk purchases, please contact Simon & Schuster Special Sales at 1-866-506-1949 or business@simonandschuster.com.

The Simon & Schuster Speakers Bureau can bring authors to your live event. For more information or to book an event, contact the Simon & Schuster Speakers Bureau at 1-866-248-3049 or visit our website at www.simonspeakers.com.

Interior design by Wendy Blum

Manufactured in the United States of America

1 3 5 7 9 10 8 6 4 2

Library of Congress Cataloging-in-Publication Data has been applied for.

ISBN 978-1-9821-6330-3
ISBN 978-1-9821-6331-0 (pbk)
ISBN 978-1-9821-6332-7 (ebook)

For Tom
ταλαίφρων

CONTENTS

AUTHOR'S NOTE

Information about every artwork referenced in the text can be found beginning on page 181, along with resources for locating objects in the galleries and viewing high-resolution images at home.

This book is composed of real events from my ten years as a museum guard. In an effort to write scenes that demonstrate the range of my experience, I've sometimes put incidents together that happened on different days. The names of museum personnel have been changed.

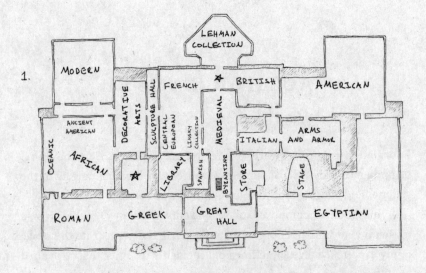

1.

LEHMAN
COLLECTION

MODERN

ANCIENT
AMERICAN

OCEANIC

AFRICAN

DECORATIVE ARTS

SCULPTURE HALL

FRENCH ★ BRITISH AMERICAN

CENTRAL EUROPEAN

LINSKY COLLECTION

MEDIEVAL

ITALIAN

ARMS AND ARMOR

LIBRARY

SPANISH

BYZANTINE

STORE

STAGE

★

ROMAN GREEK GREAT HALL EGYPTIAN

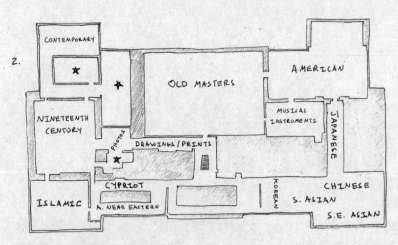

2.

CONTEMPORARY

★

★

OLD MASTERS

AMERICAN

NINETEENTH CENTURY

MUSICAL INSTRUMENTS

JAPANESE

PHOTOS

DRAWINGS / PRINTS

★

CYPRIOT

KOREAN

CHINESE

ISLAMIC

A. NEAR EASTERN

S. ASIAN

S.E. ASIAN

★ SPECIAL EXHIBITION

I.

THE GRAND STAIRCASE

In the basement of the Metropolitan Museum of Art, below the Arms and Armor wing and outside the guards' Dispatch Office, there are stacks of empty art crates. The crates come in all shapes and sizes; some are big and boxy, others wide and depthless like paintings, but they are uniformly imposing, heavily constructed of pale raw lumber, fit to ship rare treasures or exotic beasts. On the morning of my first day in uniform I stand beside these sturdy, romantic things, wondering what my own role in the museum will feel like. At the moment I am too absorbed by my surroundings to feel like much of anything.

A woman arrives to meet me, a guard I am assigned to shadow, called Aada. Tall and straw haired, abrupt in her movements, she looks and acts like an enchanted broom. She greets me with an unfamiliar accent (Finnish?), beats dandruff off the shoulders of my dark blue suit, frowns at its poor fit, and whisks me away down a bare concrete corridor where signs warn: Yield to Art in Transit. A chalice on a dolly glides by. We climb a scuffed staircase to the second floor, passing a motorized scissor lift (for hanging paintings and changing light bulbs, I'm told). Tucked beside one of its wheels is a folded *Daily News*, a paper coffee cup, and a dog-eared copy of Hermann Hesse's *Siddhartha*. "Filth,"

Aada spits. "Keep personal items in your locker." She pushes through the crash bar of a nondescript metal door and the colors switch on *Wizard of Oz*–style as we face El Greco's phantasmagoric landscape, the *View of Toledo*. No time to gape. At Aada's pace, the paintings fly by like the pages of a flip-book, centuries rolling backward and forward, subject matter toggling between the sacred and profane, Spain becoming France becoming Holland becoming Italy. In front of Raphael's *Madonna and Child Enthroned with Saints*, almost eight feet tall, we halt.

"This is our first post, the C post," Aada announces. "Until ten o'clock we will stand here. Then we will stand there. At eleven we will stand on our A post down there. We will wander a bit, we will pace, but this, my friend, is where we are. Then we will get coffee. I suppose that this is your home section, the old master paintings?" I tell her yes, I believe so. "Then you are lucky," she continues. "You will be posted in other sections too eventually—one day ancient Egypt, the next day Jackson Pollock—but Dispatch will post you here your first few months and after that, oh, sixty percent of your days. When you are here"—she stamps twice—"wood floors, easy on the feet. You might not believe it, my friend, but believe it. A twelve-hour day on wood is like an eight-hour day on marble. An eight-hour day on wood is like nothing. Pfft, your feet will barely hurt."

We appear to be in the High Renaissance galleries. On every wall, imposing paintings hang from skinny copper wires. The room, too, is imposing, perhaps forty feet by twenty, with egress through double-wide doorways leading in three directions. The floor is as mellow as Aada had promised, and the ceiling is high, with skylights aided by lamps pointing down at various strategic angles. There is a single bench near the center of the room, upon which lies a discarded Chinese-language map. Past the bench, a pair of wires dangle loosely toward a conspicuously empty spot on the wall.

Aada addresses it: "You see the signed paper slip," she says,

motioning toward the sole evidence this isn't a shocking crime scene. "Mr. Francesco Granacci was hanging here, but the conservator has taken him in for a cleaning. He might also have been out on loan, under examination in the curators' office, or having his picture taken in the photography studio. Who knows? But there will be a slip and that you will notice."

We pace along a shin-high bungee cable, which keeps us a yard or so from the paintings, and enter the next gallery under our watch. Here, Botticelli appears to be the famous name; and after that there is a third, smaller gallery, dominated by more Florentines. This is our domain until 10 a.m., when we will shift to the three galleries beyond. "Protect life and property—in that order," Aada continues, beginning to lecture with uniform staccato emphasis. "It's a straightforward job, young man, but we also must not be idiots. We keep our eyes peeled. We look around. Like scarecrows, we prevent nuisance. When there are minor incidents, we deal with them. When there are major incidents, we alert the Command Center and follow the protocols you learned in your classroom training. We are not cops except for when idiots ask us to be cops, and thankfully it isn't often. And as it's the first thing in the morning, there are a couple of things we must do. . . ."

Returning to the Raphael gallery, Aada gets on her tiptoes to stick a key in a lock and open a glass door on to a public stairwell. This done, she casually steps over a bungee cable—a startling transgression to witness—and drops to her haunches beneath a heavy golden frame. "The lights," she says, indicating switches in the baseboard. "Usually the late watch—that's the midnight shift—will have turned them on, but in case they haven't. . . ." She depresses a half dozen switches at once, and we are standing in a long dark tunnel, Renaissance paintings turned into silvery muddles on the walls. She flips the switches up and the lights kick on a gallery at a time with surprisingly loud *ka-chunks*.

The public starts trickling in about 9:35. Our first visitor is an art

student judging by the portfolio under her arm, and she actually gasps to find herself all alone. (Perhaps rightly, she doesn't count Aada and me.) A French family follows in matching New York Mets caps (which they likely believe to be Yankees caps, the more typical tourist choice), and Aada's eyes narrow. "For the most part, our visitors are lovely," she admits, "but these pictures are very old and fragile, and people can be very stupid. Yesterday I was working in the American Wing, and all day long people wanted to seat their children on the three bronze bears! Can you imagine? With the old masters, it's much better—not so quiet as Asian Art, of course, but a piece of cake compared to the nineteenth century. Of course, everywhere we work we must look out for unthinking individuals. You see? Right there." Across the way, the French father is reaching over the bungee line, pointing out some Raphaelesque detail to his daughter. "Monsieur!" Aada calls out, somewhat louder than she needs to. "*S'il vous plaît!* Not so close!"

After a little while, an older man saunters into the gallery wearing a familiar suit of clothes. "Oh good, it's Mr. Ali, an excellent teammate!" Aada says of the guard.

"Ah, Aada, the very best!" he replies, catching and adopting her cadence. Mr. Ali introduces himself as the "relief" on our team (team one, Section B) who is "pushing" us along to our B post.

Aada agrees emphatically. "Ali, you're first platoon?" she asks.

"Second platoon."

"Sunday-Monday off?"

"Friday-Saturday."

"Ah, so this is overtime for you. . . . Mr. Bringley, Mr. Ali started a bit earlier than we did this morning, but he gets to go home at five thirty. He is not tough like you and me, not a third platooner, no, no, he needs to go home to his beautiful wife. You work what days, Mr. Bringley? That's right, you told me: Friday, Saturday, Sunday, Tuesday, twelve hours, twelve hours, eight hours, eight hours. It is good. The long days will feel normal and the normal days will feel short, and you will always have that

third day off if you want to work OT. Stick with the third platoon, Mr. Bringley. Goodbye, Mr. Ali."

Our new post brings us both backward and forward in history, covering Italian paintings from the thirteenth and fourteenth centuries but also a large adjacent gallery of pictures from France at the time of the Revolution. As we explore, Aada occasionally points out cameras and alarms whose necessity she accepts but to which she condescends. Human workers have her respect, and she is more interested in running down a supporting cast of characters that are almost as important in her eyes as the guards: custodians, our union brothers and sisters; the nurse, who will distribute Excedrin; the elevator man, who's a contractor and gives himself just one day off a month; two off-duty or retired firefighters on the premises at all times; riggers, who move around heavy art objects; art handlers, or techs, who have the finer touch; carpenters, painters, and mill workers; engineers, electricians, and lampers; and then a lot of people one sees somewhat less, like curators, conservators, and executive types.

This is all very interesting, but I can't help but notice we are chatting just feet away from the *Madonna and Child* by Duccio, dating from about 1300. All morning, I haven't faced up to a painting, and I wonder if I might swing Aada's attention its way by making reference to its reported $45 million price tag. Aada is only saddened I would say such a vulgar thing. She pulls me in close to the diminutive panel and all but whispers, "You see the blackened singed bits at the bottom of the frame. Burn marks from votive candles. It's a beautiful picture, isn't it? These are beautiful pictures, aren't they? I try to remind these people . . . the schoolkids, the tourists . . . I remind them that these are masters. You and I, we work with masters. Duccio. Vermeer. Velázquez. Caravaggio. Compared to what?" She looks over at our American Wing neighbors. "Some picture of George Washington? I mean oh come on now. Be serious."

Mr. Ali approaches, and from across the gallery makes a jocular push

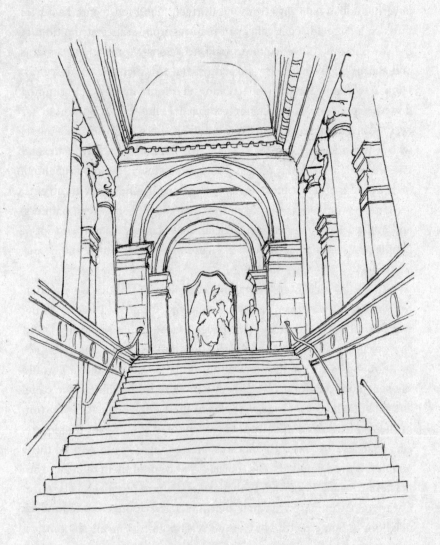

gesture with both arms. This carries us out of the old master wing almost, through a pair of glass doors, and into a mammoth gallery overlooking the museum's Great Hall. At this busy crossroads, Aada is constantly interrupted by a wide variety of requests: the mummies, the photographs, the African masks, "ancient medical instruments, or something like that?" (To this last, Aada replies confidently, "We have none.") More than once, she apologizes to me for the quality of these exchanges, insisting that more interesting questions will come our way when there's quiet. After finishing up a deft set of directions to Degas's ballerina statue, she taps me and points out a well-tailored man passing by: "A curator in this section, Morgan, or something like that." We watch as he hurriedly walks past with his eyes on the floor and disappears down the Duccio hallway— "To his office," Aada tells me, "behind the door with the buzzer in the Rubens gallery." The irony doesn't escape either of us. Those of us who spend all day out in the open with the masterpieces, we're the ones in the cheap suits.

It is almost 11 o'clock, and we will soon be on our break. A short line of people has formed to query Aada, and I have a moment to peer down into the cavernous Great Hall. A kind of salmon run of visitors ascends the Grand Staircase toward me and just as quickly races past as though I am a half-submerged stone. I think of the many times I have climbed these steps in the past, with no thought of turning around to watch the influx of art lovers, tourists, and New Yorkers, most of them feeling their time inside of this world in miniature will be too short. I am astonished that mine won't have to be.

You don't forget your first visit to the Met. I was eleven years old and had traveled to New York from our home outside Chicago with my mother. I remember a long subway ride to the remote-sounding Upper East Side, and I remember the storybook feel of that neighborhood: doormen in

livery, proud stone apartment towers, wide famous avenues— first Park, then Madison, then Fifth. We must have approached on East 82nd Street because my first glimpse of the museum was of its generous stone entry stairs, which served as an amphitheater for a saxophone player. The Met's facade was impressive in a familiar sort of way, very columny and Greek. The magical part was that as we drew nearer it kept growing wider and wider, so that even out front by the hot dog carts and the geysering fountains, we were never able to get the entire museum into view. I immediately understood it as a place of impossible breadth.

We climbed the marble stairs and passed a threshold into the Great Hall. As Maureen, my mom, queued up to make our "suggested donation" (even a nickel would have gotten us in), she encouraged me to wander a lobby that seemed no less grand than Grand Central Terminal's, and full of the same energy from people preparing to venture someplace. Through the entrance on one end of the hall I could make out a snowstorm of blinding white statuary, perhaps Greek. Through an entrance on the other side, a sandy-colored tomb was just visible, surely the way to ancient Egypt. Directly ahead, a wide, straight, majestic run of stairs concluded in a color-splashed canvas appearing as large and taut as a ship sail. We affixed our little tin entry pins to our collars, and it seemed only natural that we should keep climbing.

Everything I knew about art I learned from my parents. Maureen was an art history minor in college and evangelized to my brother, Tom; my sister, Mia; and me with amateur zeal. A few times a year at least, we ventured to the Art Institute of Chicago, where we tiptoed through almost like tomb raiders, picking out our favorite pictures as though planning a theft. My mother was a Chicago theater actor by trade, and if you know anything about Chicago theater, you know it isn't showy or glamorous but rather hardworking and true believing. I can remember driving with her downtown, hearing actor friends greet her not as Maureen but "Mo," watching the houselights go down and the stage lights go up and learning there was room enough in the world for this sacred

little playing space indifferent to the honking traffic outside. At home, we would gather in her big bed to read Maurice Sendak picture books, which we understood to be different from just ordinary books, asking us to clear a playing space in our minds for the Wild Rumpus to leap enormously into life. My earliest feeling about art was that it belonged to a kind of separate, moonlit world, and this was my mother's influence.

My dad was more hardheaded but had his own lessons to teach me. Working as a community banker on the South Side of Chicago, he was a latter-day George Bailey, with visceral scorn for the Mr. Potters of the world. To relax at day's end, he'd spend hours pounding on the family's upright piano. He adored the piano. For a time he had a bumper sticker that read in its entirety: Piano. And though he was never very good at it—he always said that his talent wasn't talent but rather diligence born of enjoyment—he played the music of his twin idols, Bach and Duke Ellington, with wobbliness but not shyness, all the while singing phrases out loud for the sheer pleasure of their beauty: "Da ta DA da doo." My sense of the artist as an unafraid person came largely from my dad.

I took the lead that day at the Met and barreled us through at fantastic speed, haunted by the suspicion a yet more unmissable sight lay just around the next corner. Since its opening in 1880, the New World's greatest art museum has expanded in a largely illogical sprawl, appending new wings to old ones in such a way that entire new atmospheres seem to spring up out of nowhere. To wander through, particularly if you get turned around as often as we did, is like exploring a mansion in a dream, rooms generating in front of you and vanishing behind, twice-visited galleries seeming only vaguely familiar from a new vantage point. Amid the whirlwind, I have only two clear memories of artworks I saw that day. I had never seen anything so leapingly imaginative as the wood carvings of the Asmat people of Papua New Guinea, in particular, a long row of totem poles each made of single sago trees. My favorite was composed of tattooed men stacked on each other's shoulders until the penis of the topmost man widened into a kind of intricately carved palm frond. It seemed to prove the world contained so much more possibility than I'd given it credit for.

Roaming the old master wing, I was stopped and held fast by Pieter Bruegel's *The Harvesters*, from 1565. I responded to that great painting in a way that I now believe is fundamental to the peculiar power of art. Namely, I experienced the great beauty of the picture even as I had no idea what to do with that beauty. I couldn't discharge the feeling by talking about it—there was nothing much to say. What was beautiful in the painting was not like words, it was like paint—silent, direct, and concrete, resisting translation even into thought. As such, my response to the picture was trapped inside me, a bird fluttering in my chest. And I didn't know what to make of that. It is always hard to know what to make of that. As a guard, I will be watching countless visitors respond in their own ways to the curious feeling.

Seven years later, I moved to New York for college. The Met's fall exhibition happened to be a display of Bruegel's drawings and prints, and again I climbed the Grand Staircase, this time gripping a notebook in my new role as starry-eyed, ambitious student. My whole life I'd been nip-

ping at the heels of my brilliant older brother—Tom, two years my senior, was a kind of math genius—and I saw myself as a plucky little brother with big artistic dreams.

Freshman year, first semester, I enrolled in the most serious-sounding course in the English department, a John Milton seminar in which we spent twelve weeks parsing the twelve books of *Paradise Lost*. Every couple of pages, there was a line like

> *Abashed the devil stood,*
> *And felt how awful goodness is*

that I felt should have held us up another twelve weeks. Great books and great art felt that tremendous to me.

I took only a few courses in the art history department, but they were maybe the headiest of all. I entered a lecture hall, the lights cut out, a slide projector whirred into life, and up on the screen jumped cathedrals, mosques, palaces, all the grandeur of all the world, click, click, click. Or else it was quieter than that: a little Renaissance chalk drawing blown up a hundredfold so that it quivered like an early film still on the luminous screen.

I wish I could say that my studies humbled me, but I was still perhaps too young for that. I had a professor who had helped to direct the cleaning of the Sistine Chapel ceiling, and I felt as though I was up on those scaffolds myself, a soon-to-be-eminent scholar of big, important things.

The day I visited the Bruegel exhibit I was intent on absorbing every word the curators had squeezed onto the little descriptive labels. I felt I was ready to push past the stupefied response *The Harvesters* had once provoked in me, which I now suspected was childish and perhaps even stupid. I yearned to become sophisticated, and I thought that with the proper academic tools and up-to-date terminology, I could learn to properly analyze art and thus never lack for something *to do* with it. Did I feel a little bird beating its wings in my chest? Not a problem! I could

quiet the strange sensation by applying my mind to the painting's motifs or identifying its school or its style. Such a maneuver was a means of moving past my perception of soundless beauty and finding a language that might allow me to move and to shake out in the real world.

But then my brother, Tom, got sick and my priorities changed. After college, for a period of two years and eight months, the "real world" became a room at Beth Israel Hospital and Tom's one-bedroom apartment in Queens. Never mind that I was starting out at a glamorous job in a midtown skyscraper, it was these quieter spaces that taught me about beauty, grace, and loss—and, I suspected, about the meaning of art.

When in June of 2008, Tom died, I applied for the most straightforward job I could think of in the most beautiful place I knew. This time, I arrive at the Met with no thought of moving forward. My heart is full, my heart is breaking, and I badly want to stand still awhile.

In the afternoon, Aada grabs hold of my shoulder and says, "Young man, I will leave you alone. You will be here. I will be there"—and disappears into, if I have this right, Spain. I am not entirely alone, of course, but passing strangers don't feel very much like company, and the museum is so rambling (the size of about three thousand average New York apartments) that a gallery like this one is seldom crowded. For several minutes, I stand on my C post, feeling time creep forward at a pace that might be confused with its standing still. I fold my hands in front of me. I fold them behind. I try them in my pockets. I lean back inside of a doorway, pace awhile, and then lean against a wall. In short, I am restless, apparently unready for the abrupt transition from following Aada around like a duckling to standing watchfully still. Indeed, for these past several weeks, I have been advancing through a process that has made my life feel directed for the first time since Tom's death. I put in my application. I interviewed. I trained. I passed a state licensing exam, was fingerprinted,

and had my measurements taken by the museum's tailor in the Uniforms Office. Now I have arrived! And the only thing *to do* is . . . keep my head up. Keep the watch. Let my hands remain empty and my eyes stay wide while my inner life grows all mixed up with beautiful works of art and the life that swirls around them.

It is an extraordinary feeling. After several long minutes more, I begin to believe this truly can be my role.

II.

WINDOWS

The mornings are church-mouse quiet. I arrive on post almost a half hour before we open and there is no one to talk me down to earth. It's just me and the Rembrandts. Just me and the Botticellis. Just me and these vibrant phantoms I can almost believe are flesh and blood. If you think of the Met's old master wing like a village, it has almost nine thousand painted inhabitants (8,496 when, years later, a gallery at a time I make my count).[1] They occupy 596 paintings, which by coincidence were brushed into being over almost the exact same number of years. The oldest is a Madonna and Child from the 1230s, the youngest a portrait by Francisco de Goya from 1820. After about that date, the paintings leap to the far south end of the museum, where the modern world steadily gains ground: machine power; capitalism; nation-states called things like "Germany" and "Italy"; and in the world of art, photography, and ready-made paint in tubes. What unites the "old" masters is just that they came before all these things. They were craftsmen working in medieval cities whose gates were shut against the dangers of pitch-black nights. Or they were courtiers dressed in silk stockings, eager for an audience with Lady

1. This figure, out-of-date after a significant expansion of the wing, includes every little background cherub, bullfight spectator, and ant-sized gondolier. If you're wondering how I could possibly count all that, you underestimate the kind of time I have.

So-and-So. Or they were pious monks, imperial propagandists, afford-able portraitists of an emerging middle class. Whoever they were, they are alike in straining the resources of our modern imaginations. Goya, the nearest old master to our own time, saw just one of his at least eight children survive into adulthood.

Wandering the wing, I feel something like a traveler in a strange and distant land. If you've ever spent time in a foreign city alone, without the language and without a companion poking your sides, you know how fantastically immersive the experience can be. You dissolve almost—dissolve into streetlights and puddles, bridges and churches, scenes you glimpse through first-story windows. You walk the streets alive to the exotic details, but even an ordinary pigeon flapping its wings is oddly vivid. There is a poetry about it, and as long as you glide through watch-fully, the spell won't break.

In these early weeks, I guess my brain is half broken, because I re-ally feel as engrossed as that—like every painting is a first-story window with curtains dramatically drawn aside. In a typical gallery, ten or twenty gold-framed windows are blowing holes through the four walls. Some appear to cut right through the masonry, providing vistas onto rolling hills and heaving seas. Others peer in on domestic interiors, inviting us to peek with our chins upon the sill. And finally, there are those that I hold my face up to only to find a stranger's face staring back at me, their nose all but pressed against the glass (if there *is* glass; in front of most of these paintings, there isn't even a pane of glass!).

On one of these quiet mornings, I rub the sleep from my eyes, lift my head, and there at eye level is María Teresa, the Infanta of Spain. I feel imme-diately that her painter, Diego Velázquez, had been in the room with her—that he bowed low, positioned his easel a few yards away, and performed the sort of magic trick that brings her intelligent presence a yard from me. It's such a particular face. She looks younger than her fourteen years, but her eyes look older. She isn't a pretty or spirited child; she looks neither kind nor unkind, neither revealing nor concealing, but rather frank and self-possessed—too

used to her strange life to feel that it is strange and not used to backing down. I can see the face as distinctly as I would see my own in a mirror.

Other times, I am more aware of my function as a scarecrow, as Aada put it, or, more generously, as a kind of palace guard. My second week, I am posted for the first time with paintings by Johannes Vermeer, precious things of which the world has perhaps only thirty-four. Absurdly, the Met owns five. I stand a bit taller knowing this, and, because even first thing in the morning, a handful of tourists—English, Japanese, Midwestern—are paying homage. A pretty young mother holds her ponytailed head before a portrait of a girl wearing a pearl earring dating from around 1665. She might mistake it for the more famous treatment of the theme in the Hague, and if she does, there's no reason to disabuse her.

Everyone is well-behaved, and my eyes wander to one of the quiet, domestic rooms Vermeer so liked to paint. I look at a dozing maidservant, her cheek resting on her palm, while behind her the empty, well-kept household receives that sanctifying Vermeer light. I startle at the picture because I can't believe he's captured it—that feeling we sometimes have that an intimate setting possesses a grandeur and holiness of its own. It was my constant feeling in Tom's hospital room, and it's one that I can recover on these church-mouse quiet mornings at the Met.

At the end of my first month on the job I arrive at the chief's desk uncharacteristically anxious about which team I'll be assigned to. I want badly to work on team three, covering the Venetian galleries, for reasons I'd find hard to explain. Aada is seated rather grandly at the supervisor's desk, awaiting the real chief's arrival, and when I mention my hope to her, she nods vaguely as though it isn't very interesting. We hear the crackle of a radio, the jangle of keys, and Chief Singh appears, a forty-year veteran of the department and one of its many Guyanese Americans. Mr. Singh asks for a volunteer to rope off an area where the art

handlers will be working. Aada says she'll do it, and she is rewarded with her choice of post. "Thank you, Mr. Singh," she says. "I will take second break on team three"—adding, after a pause, "And Mr. Bringley here will take third."

Aada insists that we hang back to discover which of the other fourteen Section B guards will join us on our team. As it happens, it is two rookies, members of a class of eighteen guards who started at the same time I did. Blake is about my age, a curly-headed, well-read native of a town in the Hudson Valley. Terrence, twice my age, is a jovial, backslapping sort of a fellow and another immigrant from Guyana. (When guessing a guard's country of origin, Guyana, Albania, and Russia are the good bets, with other Caribbean and former Soviet nations a tier below.) I clicked with Terrence the moment I met him—most people do—but at the end of training he was sent off to work at the Cloisters, an annex of the Met in Upper Manhattan devoted to medieval art. He is here with us on his overtime day. Blake I have kept a bit of distance from, only because I put a high value on my solitude and feel unready to make a friend my own age. The four of us chat good-naturedly; I am impressed with how easy-to-talk-to my colleagues tend to be. But when we split off in four directions, each to our separate posts, I feel a burden lift as I launch into a day of perfect lonesomeness.

Venice was an impossible city, a chain of 118 wave-lapped islands that once boasted the brightest, deepest colors in the world. Ultramarine from Afghanistan, azurite from Egypt, vermilion from Spain . . . Even the name *Venice* relates to the Latin *venetus* meaning sea blue. The greatest Venetian of the sixteenth century was Tiziano Vecellio, called Titian, and he enveloped his scenes in rose-tinted atmosphere, as though he mixed his pigments in puddle water and red wine. I approach his great *Venus and Adonis*, so beautiful and silent a poem that I can feel my mood become engulfed by it. I can't decide which is the more beautiful: Titian's flaxen-haired Venus, desperately clinging to her mortal lover, or his young, brash Adonis, rejecting the goddess's embrace to return to the perilous mortal world. I have read the same

ancient poem that Titian has, and I know what happens in the end. Adonis dies, Venus is inconsolable, and she transforms his spilled blood into the red flower anemone, whose name means "born of the wind."

I walk along listening to the creaking floorboards—at this hour there are still no visitors—and locate another Titian picture, much smaller and lesser known. It is a portrait of a young man he painted when he was himself a young man, and it is so fluently executed, showing so little study or strain, that it appears like a chance reflection on a sun-dappled pond. The young man wears long hair and a beard but neither obscures his face, which is an angel's face—as mild, vibrant, and youthful as that. He appears to be lost in thought, though about what he seems not to know. And though ostensibly I have caught him in the act of removing a glove from his hand, I can't feel that I'm looking at a single frozen moment in time. In the painting, time appears to have pooled instead of frozen, as if past and future are subsumed by the vital present, or as if there were a part of this young man exempt from time's pitiless arrow, and *that* is what Titian painted.

To a degree, there's a material explanation for the portrait's uncanny quality. Titian built the painting using layer after layer of semitransparent glazes through which light streams, reflects, and refracts with a constant freshness. But I also can't get away from the feeling it stirs in me. The picture is so beautiful, so tenderly flush with life that it seems to be itself living—living memory, living magic, living art, whatever you'll consent to call it, it looks as whole, bright, irreducible, and unfading as I would wish the human soul to be.

On the top shelf of my locker I keep a tattered envelope of Tom photographs my mom gave me. There is a difference between those snapshots and these pictures and I call different photographs to mind to try to make sense of it. There is the one of Tom in a tux on his wedding day: big, burly, boyishly happy. There is the one of him at his graduate school graduation, thinner because of the cancer, his bald head buried under a floppy doctoral cap, embarrassed and proud. There are the many candid moments from our childhood in a redbrick house on a street called Hickory Road: jump-

ing in leaves, eating birthday cake, wrestling on a bed. And it seems that all of these captured moments, these memories in the plural, are in danger of being lost to time like the dog-eared photographs themselves. But taken all together, they suggest something greater, a memory of Tom in the singular, which I can close my eyes and summon, and which looks a good deal like the Titian portrait: bright, irreducible, and unfading.

The day's first visitors arrive. I take up my position in a suitable corner. And I find that, in these galleries, I don't even need to close my eyes to feel what I wish to feel.

"Goddammit, I'm in the Jesus pictures again!"

The most memorable complaint I overhear in my early weeks comes when I'm patrolling the oldest of the old master corridors. Two parallel hallways through the center of the wing, one Italian, the other Flemish and Netherlandish, are given to art of the Late Gothic and Early Renaissance periods. These are pictures that not only are old but look and feel old, featuring tooled haloes on hammered gold backgrounds, cracking surfaces like crazed glass, and an obsessive interest in a certain first-century man from Galilee. (I will count 210 Jesuses in Section B.)

I sympathize with our unhappy customer. But, though I'm not a Christian, I adore the Jesus pictures. Pacing these galleries is like paging through a family photo album of a grim but exceptionally intimate kind. There are the baby pictures: Adorations, Holy Familys, Virgin and Childs. There are moments of transition in a young man's life: Baptisms, Christ in the Wildernesses. And finally, there are the episodes of the Passion, a word that originally meant "to suffer, bear, endure": Agony in the Gardens, Flagellations, Crucifixions, Lamentations, Pietàs. Apparently, the old masters channeled everything they had—all of their talent and energy, and all of their wonder and dread—into one story of a short, hard life.

Walking through again, I am struck by how the wordier aspects of

Jesus's life—his preaching, as opposed to his living—are almost entirely passed over. I can find no painting of the Sermon on the Mount, for instance, and few attempts to illustrate a parable. The old masters were quite sure that the most resonant parts of his life were its beginning and its end. Furthermore, for every painting of Christ as a supernatural being (Resurrections, Ascensions, Christ Enthroneds) there are a half dozen that are aggressively corporeal, where a halo is the only sign that this sufferer was more than human.

Perhaps the saddest picture in the Met was painted by Bernardo Daddi, a Florentine who succumbed along with perhaps a third of Europe to the bubonic plague. Squaring up to his *Crucifixion*, I look at a scene that is presented to me as devastating but not out of the ordinary. The body of Christ is dignified but limp; a gentle elegance in his bearing suggests that he suffered bravely. Mary and John sit reflectively on the ground. They look tired above all. The frenzy of the day has passed and only the death remains, the blunt fact, the impenetrable mystery, the immense and immovable finality.

As a watchman I can use this picture in something like the way it was intended to be used, and for that I am grateful. An artist in the fourteenth century wouldn't have dreamed that one day there would be art connoisseurs and textbooks dedicated to something called art history. In Bernardo Daddi's mind the painting must have been a kind of machine to aid in necessary and painful reflection. I am not interested in finding anything new or subtle about the Jesus pictures. Daddi has painted suffering, it seems to me. His picture is about suffering; it has nothing on its mind except suffering; and we look at it to feel the great silencing weight of suffering, or we don't see the picture at all.

Much of the greatest art, I find, seeks to remind us of the obvious. This is real, is all it says. Take the time to stop and imagine more fully the things you already know. Today my apprehension of the awesome reality of suffering might be as crisp and clear as Daddi's great painting. But we forget these things. They become less vivid. We have to return as we do to paintings, and face them again.

III.

A PIETÀ

When I was born, my brother, Tom, was not yet two. It follows that he was a child the whole time I was a child, a teen during my adolescence, and still a young man when, shortly after my twenty-fifth birthday, he died. But it's hard to feel that any of this is true. To the little brother, the big brother is always grown-up. My whole life I arrived on the first day of school to find the teacher flicking her eyes up from the roster. "Bringley?" she'd say. "You're Tom Bringley's brother?" with a look that was half delight and half alarm. If I live to be a hundred I think I will still be Tom Bringley's brother. He was a singular kid. He could invigorate teachers or wear them out. In middle school, he was bussed to the local high school to take math. In high school, to the community college. He understood math as fast as you could teach it and other subjects more adeptly than a math kid had any right. You could throw extra work Tom's way, but you could never quite rid a glint of conspiracy from his eyes: "How about it, teach? Am I being a good sport?" And everyone had to admit that he was. He was a good kid—cheerful, patient, helpful, modest, normal. He didn't show off. He seemingly didn't strain. In fact, there was something about the contented manner in which he bubbled away that made you laugh.

Much later, Tom was typically himself when he explained why he set aside pure mathematics to pursue a doctorate in the field of bio math. (He studied, as far as I could make out, the ways liquids swirl within living cells.) "Pure math is obviously extremely beautiful," he explained. "It's elegant. Physics, too, is elegant. Biology is anything but elegant. It's an absolute mess. Patrick, you wouldn't believe it. I didn't believe it until I started reading Krista's organic chemistry textbooks." (Krista, his girlfriend at Duke University, was later his wife.) "Put it this way. If you or I were to build a machine, we'd go about it logically, with the fewest necessary parts moving in clean, efficient ways. But living nature doesn't work that way at all. It builds via the most fantastic redundancies and curlicues, millions of little variations around a theme, so that if three-quarters go haywire, life survives. The results are Rube Goldberg devices, but sturdy Rube Goldberg devices, unimaginably weird and densely layered Rube Goldberg devices, literally unimaginable in that our brains aren't adequate to comprehend the sort of microscopic megacities hidden within the tiniest cell. I thought that was neat."

Tom called things "neat."

Another time, he looked up from a glass of Yuengling and said, "Do you know what's amazing? That everything alive—a ladybug, a sequoia tree, Michael Jordan, algae—evolved from a single living cell. But do you know what's more amazing?" His little brother didn't. "That single cell." Quietly, we drank as we pondered that. We didn't know at the time that a single cell in Tom's left leg would mutate, raise an army, and besiege him.

Tom was a big strong fellow. When we'd fight, I was happy if I could whip an object at his head and run. He had some linebacker in him, some Chris Farley, and a bit of the Buddha. I remember a JV football game where, playing center, he failed to snap the ball, causing mayhem as he remained in a squat and all his teammates jumped offside. After the game, he shrugged sheepishly but also raised an impish finger. "The ref had it wrong, by the way," Tom insisted. "The ref said, 'Offside: the entire offensive line.' He needed to add, 'except the center.'"

Tom moved to New York for graduate school in the fall of 2003. He was married in the summer of 2005. In the two years we shared the city in health, we probably saw each other about once a month. This was less than I saw my college friends, but then Tom wasn't a college friend; there was no hurry; our kids would be cousins. After the wedding, Tom felt a strangeness in his left thigh. In November, a tumor was cut out, and, despite courses of radiation and chemotherapy, by January 2007, the cancer had spread to his lungs. In the two years and eight months we shared the city in Tom's poor health, New York itself seemed to change. In college, it had been record stores, diners, the fountain in Washington Square. It was rambling, colorful, romantic—a place to walk with a young love hand in hand. After college, shifting uptown, it was skyscrapers, yellow cabs, famous addresses on celebrated avenues—a place to find a foothold if you wanted to be in the conversation. Then Tom was sick. And it was suddenly a hospital room on the oncology floor and Tom's apartment in Queens.

The apartment.

If today I close my eyes and think about Tom, he is in Queens. He is sitting on a worn red couch, a stack of chicken-scratched paper balanced on a knee. The ball game is on. He is thinner, because of the cancer, and bald. I am over. Our sister, Mia, is over. My mom and dad were over but have left for the evening to their by now very familiar hotel. And Tom is trying to get math work done against a literal deadline—he'll finish his dissertation while gravely ill—except that everyone keeps interrupting him. But Tom doesn't mind it, he likes it.

"Hey, Tom," I say. "Hey, Tom," beginning a long and probably needless story, and taking my time with the details of the story, since I like telling Tom stories better than anyone else, since he enjoys it so much, since I enjoy it so much. He leans back on the couch and listens, listens almost like he's slow, giving me space for miles to frolic in his glad attention. And at last it is his turn to speak and he rises to his feet, moved physically by the point he is making about *Moby-Dick* or baseball or our aunt Joanie. Either that, or he's coming the long way around to the punch

line of a joke he is telling. Then he sits down and continues to wiggle a chewed-up pen with a diarist's fluency; only it isn't English sentences he's writing, it's Greek, page after page of mathematical Greek, a sort of *Iliad* with equal signs.

That was Tom in the apartment.

So it came as a surprise when one afternoon, I got a call from Krista, in distress. Tom was weakening rapidly, mysteriously, and when I arrived to help out, I found my big brother actually scared.

"Get him to the neurologist," his doctor told us over the phone. "Go now. Never mind an appointment. Get him in a car and go now."

We swung his dominant left arm over my shoulder, and I supported his weight as we stood on the sidewalk waiting for an outer-borough black cab.

"So, Patrick," he said in a whisper, "watcha been up to?" And we both laughed.

In one of the drab waiting rooms where a modern Passion plays out, I handed Tom a bottle of Gatorade. He found he lacked the strength to twist the cap. He raised his ink-stained left fist and rained down blow after blow on the bottle cap; and it seems impossible that this should be true, but it was the only time I ever saw Tom break apart. A few days later—he would survive this episode, an autoimmune attack—he was almost too weak to blink.

"Hey, Tom," I asked him once, "what caused all this?"—meaning *all* of this, the cancer. He cocked his head. "Well, it's hard to say. The funny thing about what I do, with my bio math, is sometimes I can really knock it out of the park. And that's amazing when you think about it. All of this beautiful abstract math, this language human beings came up with based on our observations but also our instincts, it turns out to *actually* describe actual nature. It's hard to believe. But most of the time, to put it mildly, I'm humbled by what I do. And, no, I don't think anyone has a good idea about what causes a soft tissue sarcoma." He looked at his leg with curiosity. "Something does."

At the peak of the autoimmune crisis, Tom summoned us one by one into the room to say goodbye. When I left the room, my heart full past breaking, I wrote the following on the back of a medical pamphlet:

Gonna lose speech soon. I'm happy though. Lucky in so many. Family. Take care of Krista. Regret not finishing the math. Ain't giving up. Don't worry about you. A great guy. Love. Think I've been a good person. Fall asleep and someone's returned to video store. Everybody suffers, my time. Everybody dies, my time. Do and don't want to have drugs to not suffer. Don't mind dying, don't want to suffer. See everyone grown old. Make sure Krista is happy. Many happy memories. Happy memories of talking to me. Like you fall asleep in a movie and someone returns it before you get to finish.

As it happened, we had him for another year.

The hospital.

It was on the whole cheerful in Tom's little hospital room (really, many hospital rooms, but in my memory they become one). It was simple. It was crosswords, the newspaper, ball games on television, books read out loud, ordering lunch. Tom wasn't restless in his illness, he didn't seek new religion, he liked and loved the things he always had. For me, this threw a kind of halo around the lot, so that the ball games were good ball games, and the books were good books, and the friends who visited were good pilgrims, and all of it simple, all of it an embrace.

Tom liked Raphael, so we thumbtacked the *Madonna of the Goldfinch* above his hospital bed. My dad admires Dickens, so he opened a paperback and read out a sad and funny passage. It was curious, the way great art collapsed so simply into so ordinary a setting. I had long supposed otherwise. In college especially, I thought of great art as a thing

to gape up at or stare back at, where nobler persons than ourselves had splashed it around cathedrals or fit it between the covers of great books. And yet, even a story as exalted as the Passion now felt near and unmysterious, being plainly an attempt to express the very plain thing that was happening in that room.

Then night would fall, and when Tom was very sick, someone would stay with him, usually Krista. We'd watch television on mute while he slept, and the stillness in the room couldn't be believed, as nothing about any of it could be believed. There's Tom. There's funny old Tom. There's his body that was once big, bounding like old Tom, and is now gentle, graceful like this Tom. How beautiful. Later I'll roll him on his side, dig my fists into his muscles, rub circles on his aching back. And he'll moan and say thank you quietly. And the stillness will return. And I'll watch him breathe.

It was a moment like this one—actually, the early dawn—when I sat with my mother at the bedside and watched her take everything in as though for the first time. She looked at her sleeping son. Looked at me. Saw the light, and the body, and the horror, and the grace. "Look at us," she told me. "Look. We're a fucking old master painting."

A few months later, we visited my mother's four siblings in Philadelphia. You can imagine the comfort and also the difficulty of talking with siblings and their grown children after burying your twenty-six-year-old son. It was my mom's idea to find some simpler, quieter place, and the two of us stole away. Out of our car windows, we watched the ordinary locomotion of city life, the joggers, dog walkers, all the evidence the world won't stop turning just because something arresting has happened. Then we turned off the Ben Franklin Parkway and stopped our car at the museum of art.

In my memory, it was so still in the museum that the statues ap-

peared to have fallen under a recent and sudden enchantment. It was so silent, we could hear our footfalls on the pale stone floors. We climbed a stairway toward a golden Diana statue, her weight forever on the ball of one foot, her hand perpetually adding tension to a bowstring. My mom was leading this pilgrimage, and she brought us past fading tapestries and illuminated manuscripts into the old master paintings collection. These galleries resembled a church or monastery, with stained glass windows, a stone baptismal font, holy scenes of suffering and grace of a type familiar to a Philly girl called Maureen Gallagher (she had lost her Catholic faith long ago but retained her feeling for the scenes). And, indeed, the atmosphere in the galleries was intensely familiar, though for reasons that had nothing to do with plaid skirts or severe nuns. It was the atmosphere of all those months at Tom's bedside, one of speechless mystery, beauty, and pain.

Wordlessly we parted ways, each to find our own sad, bright picture to be near. Mine was a jewel-like panel painted seven centuries ago by an unknown Italian with a plain, earnest style. It was composed of tempera paint (that is, with an egg-yolk base) on a smallish piece of poplar, and it depicted the Virgin Mary with her newborn at the mouth of a grotto, or cave. A star of wonder hung over their heads. Kings and angels crowded in to bear witness and adore. Mary, appearing immune to the clamor, fixed her eyes on her soundless infant lying peaceably in a manger. A scene of this type is called an Adoration, and I held the rather beautiful word in my mind. How useful a name for a kind of tender worship that arises in such a moment. We are silenced by such a vision, softened, made penetrable by what is vibrant and unhidden but felt only weakly amid the clamor of everyday life. We need no explanation of our adored object. Adding context could only obscure its plain and somehow unmysterious mystery. No doubt you have felt this way about a sleeping child or lover, or maybe about the rising sun or the pounding surf, or maybe about a holy relic or a sweetly painted picture by a long-dead Italian. Watching my big brother squeeze hands and

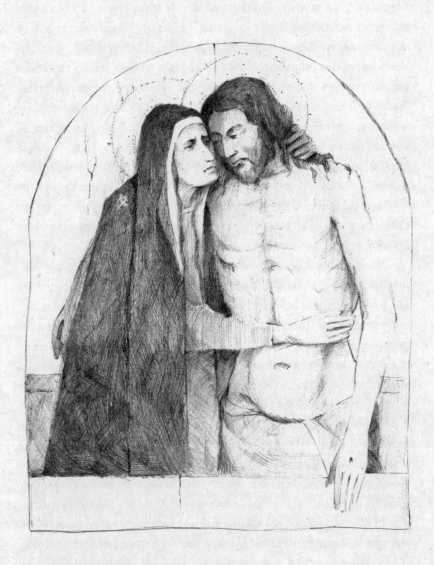

bravely endure, I had felt hardly anything else. There is a special clarity of light that seems to fall from a star of wonder, the same clarity seen in old master paintings.

I left the picture and went looking for Maureen in the Early Renaissance galleries. When I spotted her, she was framed by a work more brutal and beautiful and even more truthful than the one I had found. It was painted by a master called Niccolò di Pietro Gerini, a Florentine working in the fourteenth century. Against a featureless gold background, it depicted a young man who was very beautiful but bluntly dead, supported bodily by his mother, who hugged her son as she would if he were living—a scene that is called a Lamentation or Pietà. My mother has always been a good one to cry—at weddings, at the movies, but this was different. She cupped her face, and her shoulders shook, and when I met her eyes, I saw she wept because her heart was full as well as breaking, because the picture inspired love in her, bringing both solace and pain. When we adore, we apprehend beauty. When we lament, we see the wisdom of the ancient adage "Life is suffering." A great painting can look like a slab of sheer bedrock, a piece of reality too stark and direct and poignant for words.

An hour or two later and it was time to leave the museum, back to the so-called real world towering over the bedrock. My parents and sister, Mia, flew home to Chicago. I took an Amtrak train to my adopted home of New York. I was twenty-five years old. I joined the rapid, heedless foot traffic of midtown, uncertain, in the broadest sense, of where I would go. Not to the nearby skyscraper with the high-flying desk job I'd been lucky to get but could no longer stomach. Not along any path, I thought, that would find me scrapping and scraping and muscling my way forward through the world. I had lost someone. I did not wish to move on from that. In a sense I didn't wish to move at all. In the Philadelphia Museum of Art, I had been allowed to dwell in silence, circling, pacing, returning, communing, lifting my eyes up to beautiful things and feeling sadness and sweetness only.

I rocked with a car full of weary passengers on the Brooklyn-bound subway home. An idea was beginning to take shape in my mind. For years, I had noticed the men and women who worked inside New York's great art museum. Not the curators hidden away in offices—the guards standing watchfully in every corner. Might I join them? Could it be as simple as that? Could there really be this loophole by which I could drop out of the forward-marching world and spend all day tarrying in an entirely beautiful one? I walked along Brooklyn's Fifth Avenue, passing a half dozen taquerias on the way to my third-floor walkup. By the time I turned my key in the door, it all felt remarkably simple. In the fall of 2008, I took up my post in the Metropolitan Museum of Art.

IV.

OF MILLIONS OF YEARS

At the end of my fourth month on the job, I am sent to the union office, essentially a closet below the ancient Egyptian wing. A no-nonsense chief called Mr. Carter beckons me in and, unusually, addresses me by my first name. "Congratulations, er uh, Patrick," he says. "Your probation period is over and you are now a member of DC Thirty-seven, Local Fifteen oh three. Fill out this form for me. Good, good. You should see an immediate bump in your sick-hour and annual-leave-hour accrual rate, but a raise won't hit until the end of one-year service time. Sometime after that, probably next spring, they'll call you in to schedule your first vacation, and you should plan on it being in the following winter, likely February. Weeks are chosen strictly by seniority and that's all that's usually left. But the Dispatch Office will be posting you in all different sections now, so you'll get some traveling in that way at least. . . . Okay. Great. Let us know if your address changes and expect your union card in the mail. From here, they want you at the Uniforms Office to pick up your shoes. And, oh, look out in your next paycheck for your first hose allowance—that's eighty dollars paid annually for socks."

"Thanks, chief," I say, and leave the office wondering where on a paycheck one looks to find a hose allowance.

On a typical morning, I approach the museum from East 82nd Street, getting a head-on look at the stately Beaux-Arts facade, its columns and its elegant skirt of marble stairs. But a guard doesn't climb any marble stairs. Instead, I turn toward a sentry booth at 84th Street, passing early-bird colleagues who sit in nooks on the facade of the museum, drinking deli coffee, chatting, smoking, meditating, reading the *Times* and *Daily News*. When an M1 bus drops off some guards coming in from Upper Manhattan, someone yells, "Hold the door!" and late watch guards (the midnight shift) run full tilt across my path to the same bus to get home. Approaching the sentry booth, I watch a nondescript white truck being cleared for entry into the loading dock (carrying art on loan from the Louvre or hot dog buns for kids' meals, one can't be sure). Then I proceed to a second booth, where I swipe credentials and my face blips up on a monitor. "Morning," I hear from a veteran colleague who by this point knows my face if not my name.

I push through a heavy metal door and see that my path is blocked by a group of contractors waiting outside the Escorts Office, until a guard in coveralls leads them away. There are always renovations happening somewhere in the building, but as you can't have men just wandering anywhere with power tools, an escort will babysit them throughout the day. The hard-hatted workers fit in easily with the aesthetic of the museum at ground level. It is concrete underfoot, piping and ductwork overhead, piled-up art crates, maps in many languages sitting around on pallets. The one decorative element is a procession of old photographs taken in and around the museum over the last hundred-plus years—the stones of the Temple of Dendur arrayed under tarps on Fifth Avenue; Mrs. Astor touring construction of the Chinese scholar's garden, called the Astor Court; turn-of-the-century schoolgirls dressed like Edith Wharton in front of *Washington Crossing the Delaware*; an old black-and-white picture of a guard looking straight into the camera as he leans against a doorpost in the classic style: hands folded behind him, tailbone resting on his hands, legs slanted out about thirty degrees, ankles crossed. In his day, there was a shooting gallery down here below the art

galleries, wherein the day guards took on the night guards in an annual contest. Perhaps my favorite photo shows the winning team posing with pistols beside a custom trophy made by Tiffany & Co.

I am headed for the Dispatch Office, but I can't help stealing a look into the Command Center, where a big boss in a black suit, a security manager, is punching in an access code. Before the door shuts and locks behind him, I am just able to see a bank of closed-circuit television monitors, but I never will get a clean look into the place, not once in ten years. The Dispatch Office is homey by contrast. Up at a counter, there is a guard signing his name in the overtime availability book, another filling out a holiday request, and a third flipping through *Met Matters*, the biweekly employee newsletter. Behind the counter, a handful of dispatchers stare at computers, while a white-bearded man named Bob, on his feet, works the big board. Bob is one of very few persons who knows all five hundred–plus guards' names. As we walk in, he finds a tile with our name and home section and places it in a column representing one of the various sections of the museum. Each section has a target number of personnel he's trying to hit, but depending on how many callouts there are that day, he may find himself creating extra posts or he may have to short a section and leave some galleries closed. "Bringley, Section A!" he then hollers (Medieval), or "R!" (Modern), or "K one!" (Greek and Roman), or "F!" (Asian), or "I!" (Nineteenth Century), or "G!" (American), or some other epoch, culture, or clime. This morning it is "Bringley, Section H!" and it takes me only a second to remember that this is the Egyptian wing.

"Section H," I echo. And as quickly as I walked in the door, I am pinballed away.

On the way to the locker room, colleagues are comparing notes.

"Where they got you today?"

"C [the Great Hall]. What the hell, man? That's three times this week. You?"

"J [Contemporary Art], not so bad, not so good, far from the lockers, but I'll take it. How do you think Bob decides anyway?"

"Who knows? I used to think I'd always get my home section if I came in real early. But every time I've got a theory, he changes up on me."

We arrive at a flight of stairs divided between those of us still in our street clothes, descending, and our cleaned-up brethren in uniform, ascending, and I'm reminded that I've dropped off a pair of pants with Johnny, the museum's tailor.

At the base of the stairs, I duck into the Uniforms Office and see "Johnny Buttons," as he's generally called, seated at a sewing machine beside a rack of dark blue suits. On the wall, there is a Brooks Brothers poster with a hand-drawn arrow pointing out the way, the proper way, that the model has buttoned his blazer. Johnny, a veteran of the Korean War, is universally well-liked despite his grumbling manner. Seeing me, he removes pins from his mouth.

"Pants, right? A ripped pocket . . . Kid, what were you doing in that pocket? Don't tell me, don't tell me."

He gets up and shuffles toward the rack but then he stops and looks me over.

"Jesus, kid, you know those aren't real naked ladies in the pictures. . . ."

Another guard walks in—Steve.

"I was saying to this guy," Johnny says to Steve, meaning me, "that he's gotta keep his hands out of his pockets—you know, like a gentleman."

Steve ignores this and says, "Johnny, what do I have to do to get better shirts? Look at this, Johnny. I'm being choked to death. I do what I'm supposed to do, Johnny. I drop my shirts in your box there: Soiled Garments. I wait. I open up my shirt locker, expecting those nice dry-cleaned shirts. Those nice ironed shirts, Johnny. And this is what I get back! This isn't mine! We have ten-year-olds working here, Johnny? Look at this neck!"

Johnny's been nodding along, waiting for Steve to finish so that he can tell him that, as everybody knows, shirts are not his (Johnny's) responsibility, and that he (Steve) has got to call Mr. Dankworth.

"Call Mr. Dankworth . . ." Steve huffs. "Get the hell out of here, call Mr. Dankworth. You've really got it made, Johnny. Sitting on your ass all day sewing buttons, telling people to call Mr. Dankworth . . ."

"Yeah, and what do you do?" says Johnny, "besides standing around talking to the fucking statues?"

They both laugh, and Johnny hands me my mended pants.

The locker room is loud with the clatter of metal doors swinging shut and a hundred conversations proceeding in a dozen languages. I pass men brushing their teeth, shaving their faces, eating breakfast in various stages of undress. Some are bleary-eyed and shuffling, others polished and professional and shining up their shoes. I get to my locker row and excuse myself while wedging into a line of grown men dressing at lockers that, like all lockers, are sized for high school students. On some mornings there is a common conversation going, but today people are mainly visiting in pairs. Mr. Rahman, from Bangladesh, jokes around with a Polish guard with a handlebar mustache, Eugene. Salvatore, a young Jersey guy in a heavy metal muscle shirt, talks men's fashion with Mr. Jackson, native of Harlem. Nathan, a soft-spoken second generation Filipino, shares a common hygienic practice with his conversation partner Tommy, a Liberian immigrant and visual artist: they lay paper towel on the concrete floor before removing their shoes. After a few minutes, the back-and-forth of Luis and J.T., New York natives who have been dressing elbow to elbow for two decades, grows loud enough and funny enough that most everyone is drawn in. Listening to the banter, I climb into my suit, affix two golden *M* pins to my lapels, drop a paperback into my vest pocket for reading on break, and notice that my payroll number, written in Wite-Out on an inner vest pocket, is fading. I pat my pockets for my whistle and keys, put on my company shoes, and clip on a wine-red tie having not said very much to my fellows, but it's live and let live here, and nobody minds.

They say that the roots of a tree are every bit as extensive as the

branches. The Met is like this, too, with two floors below the galleries exactly as endless as the areas the public knows. Talented guards have internalized the whole of it in three-dimensions, such that they can tell you outside of a basement restroom that Aztec deities are over-head, and over their heads, Cézanne's apples. As I lack the talent, I will sometimes wander in novel directions, passing woodshops and plexi-glass shops, conservation studios and storage facilities, and a working armory, until I find a staircase up and discover where in the world of art it lands me. Today, I take a final turn around a plaster cast of the Emperor Augustus—it was once fashionable to display such casts, but now it is backstage decoration—and ascend into the classical art proper. Greece is on my right. Rome is on my left. The bare bottom of a Hellenistic ath-lete is in front of me, and behind and above it, a monumental column from the Temple of Artemis in Ionia. Charting the most efficient route to the Section H chief's desk, I cut through the Great Hall and find myself in ancient Egypt.

"You're Brinkley?"

"Bringley, chief."

"Sorry about that, Bringley. You're third platoon?"

"Yes, chief."

"You want the overtime tonight?—midnight, some party in the Pet-rie Court, time and a half."

"No, chief, no overtime."

"All right, Bringley, go ahead and take third break on team three."

"Team three . . . That's the temple and all that?"

"No, it's out in the front here, Tomb of Perneb and all that. Hang on, Bringley, I'll write you a slip. . . ."

Making the guards behind me wait, the chief takes her time filling out the little cheat sheet reserved for rookies like me.

"Enjoy the day, Brinkley," she says. "Next."

It's a singular place to work, Egypt. It is a huge section, with room enough to display almost all twenty-six thousand objects in the Egyptian collection, a luxury most of the Met's other curatorial departments would kill for. But despite its size, it has an unusual degree of unity, as all of its objects are so essentially and forcefully Egyptian. Nobody has ever been so much themselves over a span of three thousand years as the ancient Egyptians, whose aesthetic you recognize the moment you enter these galleries. Among many other things, Egypt is a pure gift to our imaginations—the Valley of the Kings, the pyramids, the cyclically flooding Nile. . . . It feels make-believe, but it's true. This is the wing of the Met with the widest appeal, attracting schoolchildren and tweedy professors, New Age healers and Afrofuturist comic book artists. And if you happen to be a guard in the wing, it is the place where you will most often hear the most iconic question posed by museumgoers: "Hey, is this real?"

I am posted at Perneb's tomb, from around 2350 BC, a modest limestone structure that is called a mastaba. A young couple approaches. From their style of dress and the way they carry themselves they appear to be New Yorkers, and I reflect on the ease with which I can make this call. But they have clearly never been to the Met before, and perhaps never to any art museum before, as they have the telltale look: eyes wide, heads on a swivel, much more hesitant than excited at this juncture, as they don't yet know what they are dealing with.

"Excuse me," says the guy. "My girlfriend is saying that these artifacts and whatnot, they're real. Are they, you know, real?"

I tell them they are.

"But what does that mean, though?" he presses. "They're, like, original? They're the original ones? They're from Egypt?"

I tell them they're from Egypt.

"So, this right here . . ." This time it is the girl speaking, and she reaches to pet the mane of a granite lion before, gently, I stop her. "Oh, right, sorry. So, this here, it's how old?"

I tell them it's five thousand years old.

"Five thousand years old?" she says.

"Five thousand years old!" he says. They repeat that jokily back and forth to each other like it's no big deal. "But listen"—now the boyfriend is really trying to level with me—"not all this stuff can really be real. . . ."

I like these people, and I watch as they peer into a case containing the museum's very oldest objects, taking their time with each Paleolithic hand ax and Neolithic arrowhead. I can guess the reason for their slowness: as yet they have no idea just how big the museum is. Elbowing her companion, the woman points to information on a label, and I can guess what has grabbed her attention: a hand ax dated 300,000–90,000 BC—sometime in that little window in which you could fit about a thousand United States histories. Moving their eyes ten inches or so, they've traveled tens of thousands of years into a world in which humanity, and Egypt in particular, was hitting its stride. Seven thousand years ago, these elegant flint arrowheads shot small birds out of the sky. My couple is patiently focused. Maybe they feel an incredible remove from these prehistoric objects, or maybe they've noticed how neatly that hand ax would fit into their own palms. Maybe they are trying to imagine what a hundred thousand years could possibly mean. I'm struck by the thought that these objects have become real to them, in the midst of their imaginative effort, in a way that the objects are not quite for the rest of us. I doubt that even the curator who arranged this case has successfully assimilated its contents into her day-to-day thinking about reality. As with geological time or astronomical space, we can glimpse the staggering breadth of our ancestry when we devote energy to doing so, but the moment we fall back on our heels, we forget these realities. I experience a rush of gratitude for museums as places to return to and remember.

After a long minute, the girl turns around, laughs, and shakes her boyfriend, as she has just gotten a clear look down the Old Kingdom hallway stretching back apparently without limit. In an instant, I can see the two of them transform into more conventionally paced museumgoers. He looks at his watch. Her eyes narrow with a sure sense of the outing's

purpose. And they stride away into Egyptian history proper, not wanting to miss anything. Bye, guys, I think, and remain. The tomb at my back represents a fork in the road for the visitors, and I notice that roughly half of the growing crowd flows in the opposite direction of what the curators intend, beginning after the fall of the last pharaoh, Cleopatra, and working thousands of years back to the time of the Great Pyramids and the predynastic age. Such is the strange timelessness of so much Egyptian art, probably a majority of them won't notice they're going backward.

I receive my push and proceed to an often-overlooked gallery that is isolated from the main loop. Inside the gallery is exactly half of everything that the museum unearthed in a remarkably productive excavation from 1918 to 1920 (the other half was handed to the Egyptian authorities, as was then the standard arrangement). The museum had been digging around the (robbed) tomb of a wealthy man named Meketre, when a workman noticed dirt escaping down a crack in a rock. Pickaxes swung, revealing a chamber the raiders had missed, with treasures untouched for four thousand years. Not gold. Not jewels. Rather, two hundred-odd painted wooden figurines, most about nine inches tall, grouped inside intricate model ships and other faithfully rendered settings: a brewery, a garden, and a granary to name a few. These were the avatars of real men and women who labored on the several estates of this official, Meketre, and they're here so that they might magically labor for him in the afterlife.

I step in very close to a combined brewery and bakery. It is behind glass, like everything in the room, so I can relax a bit about looking out for visitors' hands. On and off, I have been reading a book about Egyptian history, and I am reminded again how different are the experiences of reading books and looking at art. The book's information has pushed my knowledge of Egypt forward. By contrast, coming into contact with an actual fragment of Egypt seems mostly to hang me up. This is an essential aspect of a work of art: you can't empty it of its contents and patly move on. It seems to scorn a world

where knowing a few bullet points about a subject is counted the least bit impressive. Indeed, bullet points are what it won't spew. A work of art tends to speak of things that are at once too large and too intimate to be summed up, and they speak of them by not speaking at all.

It is a horrible, claustrophobic vision, this scene. Eighteen figures labor in cramped quarters, the men with their heads shaven and naked above the waist, the women in single-strap linen frocks with shoulder-length hair. The task of grinding falls to the women, so each has a stone cylinder to roll endlessly back and forth over the grain while the men crush it with pestles nearly as tall as themselves. Others among the men shape loaves with their hands, and tread in a mash of dough and water with their feet, and pour what will be beer into large vats to ferment—all in a space about twice the size of a bankers box.

The Egyptians did not think about time as we do—*neheh*, they called it, "of millions of years," and its essence was the circle, not the arrow. The sun rises, sets, and rises. The Nile floods, recedes, and floods. The stars wheel with absolute regularity around the fixed observer, and so, too, does the great wheel of time dispose of the dead and usher in the newly born who will mature and ripen and spoil, everything constantly in flux but nothing ever really changing. This was thought to be so obviously and observably the nature of things, the pattern was extended into the next world as well, hence the necessary never-ending labor of the Met's figurines. Looking at the women in particular, I feel deep in my gut how their past, present, and future must have felt indistinct—each day rolling that cylinder, never an end to it, never an end to anything. How absurd it would have seemed to imagine a history that marches forward when there were pyramids that were already in this era ancient and would anchor the culture for thousands of years to come.

My reverie ends when a cell phone rings. I catch the eye of the offender and politely shake my head, no, no. He has other ideas. Raising an impertinent finger, he engages in a bit of pressing business with an associate on the other end of the line. Waiting for him to wrap up (I'll give

him one minute), I ponder what a rare set of duties I have for the modern world. Unlike this businessman, unlike most people, I have no ball to push forward, no project to advance, no future I am building toward. I could work at this job for thirty years and I will make no progress, per se. The public will gain no surer sense of where the mummies or the toilets are. They'll continue to ask me for King Tut's tomb, and they won't stop slapping their hands on granite sarcophagi. Not so long ago, I had a very different sort of a job, one where they told me I was "going places." The businessman at last wraps up his call, all is still again, and I find myself happy to be going nowhere.

After college, before Tom got sick, I applied for a job at the *New Yorker* magazine, and to my inexpressible delight they hired me. More than just an entry-level position, it felt like an imprimatur, like I had rocketed up to the big leagues. The building was on 42nd Street just off Broadway, and when I got off the elevator on the twentieth floor, I met a man named C. Stanley Ledbetter III at a reception desk all but collapsed under books. To Stanley's right and left, glass doors and golden logos were a vision of corporate rectitude. But to reach the doors, I'd first have to trip through a weird contemporary art installation curated by this regal receptionist. Every bit of it said "Yes, you've arrived at the *New Yorker*."

Stanley wished me luck, and I was guided along hallways where editors walked to and fro carrying exotic things called "galleys" and "proofs." Soon, I would learn to open software at my desk and watch the magazine assemble each week in real time: paragraphs slashed, articles spiked, a thousand changes proposed, resisted, imposed. I would learn, too, the rhythms of the week: this was a Monday, so calm. The pace would quicken until Thursday's rush of brick-wall deadlines, followed by Friday's postcoital collapse.

My desk had a view of the Empire State Building. This is a very dif-

ferent thing from college, I thought. That had been a kind of play world, putty in a student's hands. This was an institution as iconic and inflexible as the tower out my window. I wouldn't mold it; it would mold me. I was ready to be recast in the *New Yorker's* famous style.

I worked in a small, somewhat glamorous department that produced the magazine's public events, principally the annual New Yorker Festival. My boss spent her mornings at a big board dreaming in colored Post-it notes:

> *Jay-Z in conversation with editor David Remnick*
> *A visit to Mikhail Baryshnikov's studio*
> *The World Explorers panel, with mountaineer Reinhold Messner, high-*
> *altitude archaeologist Constanza Cerruti, and a deep-sea diver (?).*

Sometimes these ideas worked out, sometimes they didn't. It was my job to help book the talent, knock out logistics of production and travel, and then for seventy-two hours a year, put on a suit and play the big shot at venues across Manhattan.

"Hi, I'm Patrick Bringley from the *New Yorker*," I told Stephen King, pulling the six-foot-four author out of his town car. Fans crushed in on us shouting "Stephen! Stephen!" Those people were nuts. I on the other hand was Patrick Bringley from the *New Yorker*.

"Michael Chabon, do you know Stephen King?" I heard myself say, addressing the young Pulitzer Prize–winning novelist, who didn't, and who depended on me for the introduction. When the event began, Chabon was first at the mic, and King and I watched from the wings. As Chabon read his short story, the master of horror bopped his head and rocked in his chair, going "Yeah, man, yeah. Yeah, man, yeah, yeah. Ooooo . . ." like he was a hepcat listening to Coltrane. It was such a strange, such a wonderful, such a flattering thing to be part of, it didn't even occur to me that I'd read neither man's books.

Which should have warned me: I was more than a bit blinded by the bright lights. But it's very hard, when you're in a good light—"Where did

you say you work? The *New Yorker*?!"—to accept that it isn't you; it's just light. Naturally, among the first things I did when I started at the magazine was crack open a Word doc and attempt to write an article in the witty, urbane *New Yorker* style. I was obviously faking it, and I failed. But rather than take a lesson from that, I retreated to the safety of magical thinking.

It speaks well of me that I'm around so many accomplished people, I told myself, many of whom know my name! I have the business card of a serious, substantive person, so keep playing the game and I am sure to become one!

It took me almost three years to grasp an unwelcome paradox. If I were working a less "impressive" job, I would be scribbling my thoughts down in obscurity, free to take big swings at whatever topic inspired me. Here in the big leagues, however, my thoughts were cramped and my ambitions were curiously small. I spent my time trying to write one-paragraph book reviews in the "Briefly Noted" section, using a voice that was not my own, claiming authority I hadn't earned, and expressing opinions I often wasn't sure I really held.

Meanwhile, the office part of the job seemed also to have narrow horizons—ironically, nothing like what a museum guard enjoys. My colleagues and I cobbled together systems such that I didn't always have forty hours of work to do in a week, but by the customs of the modern office, there I sat. Also by custom, I couldn't open a book at my desk, or take a head-clearing walk, but it was just expected that I'd waste hours clicking around on the Internet, learning how to not read books. So into that muck I sank. And before long I became something I had never really been before: lazy.

This was a really hollowing disappointment. I don't know exactly what I expected upon entering the "real world" after college, but I expected that it would feel real. But now here I was with a seat in a gleaming skyscraper, midtown Manhattan roaring below, and my prestigious job amounted mostly to playing a kind of computer game: in-box, out-box, sent.

I smoked the occasional cigarette just to have the break, an excuse to

stand down on the pavement and forget about penny-ante work concerns. Pigeons clucked, the world turned, it had nothing to do with me. For the few minutes I smoked, I was Huck Finn, a dropout, just regarding a bend of a river wider, deeper, and even less concerned with my opinion than I could say. So I said nothing. And felt sane.

Then I would stamp dead the ember, return to my desk, and rejoin the so-called real world that felt blind to the Huck world and its grace. I did that for almost four years, until Tom's illness worsened, I was plunged into that real world, and I could no longer bear to turn away.

It is that time again, and I get my push. The third post (of three) in my rotation puts me inside an ancient Egypt that looks like the one you've probably carried with you since childhood: rigid pharaohs carved in stone, clean columns of sharply rendered hieroglyphs, gods and priests and royals showing off elegant profiles in shallow relief. In front of me is a famous seated statue of the New Kingdom pharaoh Queen Hatshepsut, dating from around 1470 BC. On either side of me, colossal kneeling statues of the queen present offerings to the god Amun-Re, who happens to be Hatshepsut's divine father. Almost everything in the room was found in her mortuary temple, a complex at the base of desert cliffs that doubled as a sanctuary for dear old dad. This was a sacred space, and it came with its own sacred version of time. *Djet* it was called, the time of the gods and the time of the dead, the time that governs what is complete, unchanging, perfect, and everlasting. Unlike either the circle or the arrow, *djet* stands apart from nature and her ever-fluctuating processes. It is the time of austerely unnatural settings—of temples, of tombs, and of the art around me, which seems to join in the eternal standstill.

It is a bit comical, then, that I stand amid a scene that borders on pandemonium. School groups regularly flood the Egyptian wing, and I am looking at dozens of charter school kids in matching collared shirts,

khaki pants, and, like me, clip-on ties. They are K through five, tiny and big, innocent and devilish, engaged and checked out, and they make a tremendous noise that overmatched chaperones try to tamp down. I remain on my toes, for sure, but I don't want to give anyone a hard time. These kids seem to know not to touch, and they smartly fill out their worksheets on one another's backs. I look over at the seated Hatshepsut statue, and I find her regal indifference impressive in light of the racket. They say the same thing about the *Mona Lisa*: the more that people swarm her, the more poignant is her serene detachment. The effect is even more pronounced here, because the statue was designed to have a life independent of the viewer. It wasn't made to be an art object. It was a machine for establishing Hatshepsut's presence in the *djet* world.

I take a closer look at the queen on her throne. She is a woman, which cannot be said of the more formulaic images of Hatshepsut the Egyptian public would have seen. In political statues, she was masculine, but there was no fudging it with an object of such important magical purpose. Each morning, her priest would have opened her temple's doors so that the limestone statue would catch the morning light. At that moment, she (the eternal Hatshepsut) would transform into an *akh*, a radiant being, in communion with her father, the sun. (More precisely, Amun-Re was the power that powered the sun, the invisible creative force behind the observed solar phenomenon.) Ever under halogen lights, she's radiant, and it's extraordinary to think there's actually a theological explanation for why the Egyptians made such resplendent stuff from their earliest days. Nothing imperfect could partake of *djet* time. For an object to reach into the sacred realm, it had to be faultlessly excellent, like the gods, such that artisans never allowed themselves a corner-cutting, good-enough phase in their art's development. Egyptians invested lavishly to secure objects that would strike the eye as uncannily, unthinkably beautiful, and as such unearthly and immortal. And to look at the crowds five thousand years on, it's easy to think they pulled it off.

Predictably, what the kids really want to see are the mummies, and

they express disappointment when none of the four I show them are un-wrapped. Nevertheless, the questions come in like spitballs.

"There's a dead dude in there?"

"Who killed him?"

"Who said anyone killed him?"

"Miss Robbins said they took the brain out."

"Yeah, after he was dead."

"Does he smell?"

"Why do they wrap him like that? So he don't smell?"

"What's he look like under it?"

I tell them he looks horrible under it, a bone-dry shriveled old corpse, about as ghoulish as they can imagine. Turning, I point out jars like the ones where embalmers had packed up his liver, lungs, and kidney—Ukhhotep was the fellow's name—and I tell them the idea was to make his real body as much like a statue as possible. Because believe it or not, I say, to the Egyptians statues seemed more real than dead bodies—they were more, you know, eternal. Of course this means very little to the students and with justification they focus on what a creep show it all is. A minute later they bolt from the room, and I'm left behind to reflect on how ugly the mummifying impulse was, what a failure, what a brazen, feeble denial of a fundamental truth. The body doesn't make it. Believe all you want that some piece of a person is immortal, but a significant part is mortal, inescapably, and mad science will not stop it from breaking down.

In a twelve-hour day, the first eight hours consist of three turns around a three-post rotation (plus breaks). In the late afternoon I am handed a green slip by my section supervisor detailing my evening assignment, which will consist of two turns around a different three-post rotation (plus shorter breaks). The slip reads: (A) Temple, (B) Temple, (C) Temple. It seems that after dinner I will be on the Temple of Dendur team.

I check my watch. By this hour, the office staff will be packing up to go home—or what am I saying? It's Saturday; they were never here. So what I find in the staff caf, when I'm pushed down to dinner, is closed buffet stations, a cold grill, and a line of guards and custodians waiting to heat curries, pastas, and stews in microwaves. Clutching my sack dinner, I pick out an empty table, pull a chair around to kick up my feet, and eat quickly so I can sneak in a nap. The other end of the cafeteria is full of dinner companions conversing. This side is unofficially reserved for the dazed out or dozing.

I slide into my evening rotation. That's the best way to put it. Wearing out in body and mind, I'll let these remaining hours gently drift. I'm standing dreamily in front of the temple, resting my eyes on this, resting my eyes on that. When a cheery visitor asks me if I'm bored—probably not because I look bored; it's just a common question—I tell her no, not really, and she says, "Great!" and walks away. I don't get to tell her that I hardly remember how to be bored. Perhaps I have Stockholm syndrome, but I feel that I've surrendered to the turtleish movement of a watchman's time. I can't spend the time. I can't fill it, or kill it, or fritter it into smaller bits. What might be excruciating if suffered for an hour or two is oddly easy to bear in large doses. Mostly, I don't have my eye on the finish line. I've adjusted to a life that feels deeply old-fashioned, aristocratic even, where hours are idled away with princely detachment (for a modest hourly wage).

The Temple of Dendur will do nicely as my backdrop. It is one of the marvels of the museum, a handsome structure whose eight hundred tons of sandstone were brought to New York in the 1970s when dam construction flooded its perch along the Nile. The museum accommodated it by building a majestic hall offering a view of Central Park, inside which the ancient building more than holds its own. The temple, harmonious and restrained, is paired with a stand-alone entry gate, and each is emblazoned with the sun disk and the sky god Horus's outstretched falcon wings. Exterior carvings of lotus flowers and papyrus were meant to give

an appearance of floating on the Nile and in ancient times were brightly painted. Stepping over a threshold, today's visitors enter where very few Egyptians would and peer at a sanctuary of Isis, an inner sanctum, a holy of holies of a type restricted to priests who shaved their bodies and heads to imitate the dead and in that way partake of eternity. In the present day, a shaggy-haired college kid enters, and a girl with braids and beads, and her church-hat-wearing grandmother.

I stroll over to the side of the temple to examine the relief carvings. I find the pharaoh—he's not hard to spot—wearing the dual crowns of Upper and Lower Egypt. I wonder who among my fellow onlookers knows that there's something strange about this particular pharaoh. It isn't his profile or regalia; those are conventional enough. It's his name, Caesar Augustus, a conqueror who's playing the *role* of pharaoh but will soon bring an end to an institution older than memory. The Temple of Dendur, built soon after the turn of the first millennium, is its swan song.

I check my watch. We are almost done, too. The sky outside has grown black. The temple now glitters under spotlights. At 8:30, I begin calling out warnings and at 8:45 we pull the plug. We walk swiftly all around, bringing the news to reluctant patrons, allowing just one, okay, two last photos if they insist. "Clear?" we guards call out to each other. "Clear." We join our colleagues in the next gallery, and the next, and the next, gaining numbers as we nip at the heels of the slow-moving public retreating to the Great Hall. Throughout the building similar dark blue clusters amass behind similar foot-dragging hordes. We're done. It's clear. The manager shoots up his hand: "Good night!"

The next morning I walk into Dispatch and Bob gives me Egypt again.

V.

FURTHER SHORES

Days begin to run together, and then weeks. One evening, about six months into my tenure, I have the pleasure of being posted in the Astor Court, a re-created scholar's garden from Ming Dynasty China, during a performance on traditional Chinese instruments. Before the performance, while the musicians tune, I gaze at the garden's moon gate with its accompanying legend, In Search of Quietude, and at the sun gate with its legend, Elegant Repose. I look at the limestone monoliths and little fish-filled pool, which together spell out a Mandarin term for "landscape": "mountains and streams." And I feel at ease, even a touch self-satisfied, as though I already have the "elegant repose" thing all figured out.

But then the performance begins. I stand behind a musician who plays the *guzheng*, a sort of harp that's been turned on its side. She has eight picks affixed to her ten fingers, which she sways breezily and bounces merrily and skitters spiderlike, producing melodies like I've never heard before, obeying rhythms that I cannot catch, consisting of notes that seem always to slot a little above or a little below where my ear expects them. I surrender to the idea that I am having one of those experiences that arise when you put away your expectations and simply absorb what is happening. When the musician finally stills her hands,

I would guess that only ten minutes have elapsed, but they've been so filled with detail, it's as though thousands of strokes of a painting have hung at different moments in the air. I am humbled. I feel like a newborn baby qualified only to explore.

I watch the musician put away her instrument and click shut the case, and I look at the surrounding galleries of Chinese paintings, burning to put expectations away and newly discover them. It feels impossibly generous of visual art to affix its strokes to a surface, making it a performance without end.

The next day I am returned to Section F, and I come upon a thousand-year-old hand scroll painting by the Northern Song Dynasty master Guo Xi—vibrant, unblemished, and unfurled. *Old Trees, Level Distance* is of a modest size for a hand scroll; originally it was not longer than my wingspan. But over the centuries, scholarly owners of the scroll have appended written tributes to the work called colophons, such that the fourteen-inch-tall scroll is now more than thirty feet long. The colophons first draw me in, with their plumb-straight columns of characters brushed with the blackest ink. I haven't spent any time with Chinese writing because, well, I can't read what it says. But my illiteracy confers an advantage: I can look at the gorgeous and varied characters without a stroke of their visual splendor disappearing into linguistic sense. If one is a languid, snaking discharge of the brush, the next is a series of swift violent stabs, and every gradient between these two poles is represented somewhere. I rest my eyes on one and then another, noting the slightly different impression each makes on me—too subtle and too purely visual for words. In moments like these I realize how much sensory experience falls through the cracks between our words. The skill and panache of the calligraphers is a bravura display of that most basic art-making impulse: the urge to transform a blank surface with a dark mark.

After several minutes, I pace the considerable distance to the far-right end of the scroll where Guo Xi's performance begins. Ink on silk is an unforgiving medium; there are no do-overs; he couldn't rub out and

paint over his mistakes as the old masters could do with oils. My eyes can trace every stroke Guo made in AD 1080. No part of his artistry is hidden from me, nothing submerged under overlapping layers. According to Guo's son, the master's regular practice was to meditate several hours, then wash his hands and execute a painting as if with a single sweep of his arm. Were I viewing the scroll in an earlier era, I would have held it in my hands and slowly turned and directed my eye to take a leisurely walk through Guo's unfurling landscape. I don't need it in my hands, though. What this picture has afforded for a thousand years it affords today. My eyes travel the same old routes, past the fishermen in their small, still boats, the bare autumnal trees, the peddlers and their pack mule, the rock croppings, the stooped old men ascending a hill, and into the mountains shrouded in mist. It is achingly beautiful. In a treatise Guo wrote, he argued that landscape paintings allow escape from the "bridles and fetters of the everyday world" to a place where "the flight of cranes and the howling of apes [are our] frequent intimacy." I don't need to feel transported into literal nature, though. I am happy to be inside this picture, so clearly a melding of nature and the artist's mind. Guo himself feels like my intimate, more than any apes or cranes.

My eyes could never exhaust this scroll, and neither could my mind, so I drift into an even deeper silence, trying to absorb the fullness of the world it presents me.

In time, I develop a method for approaching a work of art. I resist the temptation to hunt right away for something singular about a work, the "big deal" that draws the focus of textbook writers. To look for distinctive characteristics is to ignore the greater part of what a work of art is. A portrait by Francisco de Goya is beautiful because of traits peculiar to his genius, but also because colors are beautiful and shapes are beautiful and faces are pretty and curls tumble—in short, because attributes

of our diverse and beguiling world have been recruited into a worthy medium. The first step in any encounter with art is to do nothing, to just watch, giving your eye a chance to absorb all that's there. We shouldn't think "This is good," or "This is bad," or "This is a Baroque picture which means X, Y, and Z." Ideally, for the first minute we shouldn't think at all. Art needs time to perform its work on us.

As a Section B guard (the old masters), I'm surprised whenever Bob sends me to Section I (nineteenth-century paintings). In my own head at least, there's a friendly rivalry between the wing of Raphael, Titian, and Rembrandt and the wing of Monet, Degas, and Van Gogh. At least once a day I'm approached by a visitor who takes a hard disapproving look at the Jesus pictures and says something to the effect of: "Water lilies? Sunflowers? Anything Impressionistic?" I am then obliged to give a long-winded set of directions to the far end of the building, a few city blocks away. I don't begrudge these visitors their taste. But as a result I haven't always been quite fair to their beloved Impressionists, in particular to Claude Monet. His pictures are so pretty, I've suspected this is all they are. But then I remember the first step of looking at art, and I give them a chance.

It is Friday evening. I share a gallery with some water lilies, some haystacks, and a couple of die-hard art fans who are closing the museum out. The haystacks belong to a series of pictures Monet painted in different seasons and at different times of day. Yawning, I can understand the worth of the exercise. Even indoors, everything looks more relaxed at this hour; the paintings themselves appear ready to turn in. It's been a busy day of barking "Not so close!" and "No flash, please!" as it always is in this popular section. But the few visitors who remain are milling around peacefully. And I have my chance to square up to a Monet painting and discover what if anything it does to me.

If you want to know if something is funny, see if it makes you laugh. If you want to know if a painting is beautiful, see if it evokes an equivalent response, one as definite as laughter though usually quieter and shyer to emerge. I step up to a landscape painting called *Vétheuil in Summer*,

close enough that it swallows my field of vision. I find that my eyes can accept its fictive world as real. I see a village and a river and the village's reflection suspended in river water, only in Monet's world there is no such thing as sunlight really, just color. Monet has spread around the sunlight color like the goodly maker of his little universe. He has spread it, splashed it, and affixed it to the canvas with such mastery that I can't put an end to its ceaseless shimmering. I look at the picture a long time, and it only grows more abundant; it won't conclude.

Monet, I realize, has painted that aspect of the world that can't be domesticated by vision—what Emerson called the "flash and sparkle" of it, in this case a million dappled reflections rocking and melting in the waves. It is a kind of beauty that the old masters seldom could fit into their symbolic schemes, a beauty more chaotic and aflame than our tidying minds typically let us see. Usually, we are looking around for useful information and dampening or ignoring a riot of irrelevant stimuli that threatens to drown it out. Monet's picture brings to mind one of those rarer moments where every particle of what we apprehend matters—the breeze matters, the chirping of birds matters, the nonsense a child babbles matters—and you can adore the wholeness, or even the holiness, of that moment.

When I experience such a thing, I feel faint but definite tremors in my chest. I imagine that a similar sensation inspired Monet to pick up a paintbrush. And with this picture, he has trembled his feelings over to me.

Eventually I work up the courage to put in for an overtime day (a "double day," as guards call it, in honor of the doubled pay). Until now, I've been afraid of overtaxing my feet, which don't deserve to bear my weight an additional eight hours. Standing for a living is easy as far as manual labor goes, but your body does tell you straightforwardly when it's had enough.

This doesn't go away, but I have grown better at ignoring the feedback. So I write my name in the overtime book and am called into work on a Monday.

The museum is closed on Mondays, and without the public stomping around, the Met's staff comes out of their hovels. The Met employs more than two thousand people, and many look to be in their element today. Curators stand in the center of galleries, conferring about what objects should go where. Technicians push art-laden carts around without fear of being bumped into. Riggers spend hours plotting how to hoist a statue with ropes and pulleys, overseen by conservators who trust in their skills and appear at ease. Everywhere one hears the beep-beep-beep of scissor lifts in motion, driven by electricians, HVAC guys, painters (the type who use rollers, not fine-point brushes). Some employees come in on their off day, making use of a privilege to bring along a guest or two. While curators lead big-money donors and VIPs through the museum, guards and custodians give the grand tour to mom and dad.

It's a treat seeing how dynamic this seemingly hulking institution is. The Met's collection consists of more than two million objects, or roughly one per square foot of available gallery space, so only a fraction are shown at one time. Seventeen curatorial departments operate more or less independently, making the best of their unique constraints.[2] The departments for American Art, Egyptian Art, and Greek and Roman Art are blessed with visible storage areas, where objects jammed into glass cases remain on public view. Other departments aren't so lucky. The Costume Institute devotes its limited space to semiannual exhibitions, ever popular displays of clothing and fashion items organized around a designer or theme. The Drawings and Prints department has a single corridor to work with, albeit a very long one, and constantly shuffles its offerings, particularly as some are sensitive to light. The Modern and

2. Like several details in this narrative about the Met's operations, the number of curatorial departments has changed since this day on post and may change again by the time you're reading this.

Contemporary Art department has a number of large-scale artworks it must try to accommodate: there are only so many Jackson Pollock–sized canvases and installation art pieces it can fit. Also, Contemporary Art curators are more responsible for staying current than their colleagues in, say, Ancient Near Eastern Art. All together the Met's departments organize as many as thirty special exhibitions every year, some expansive, with loans from museums around the world, others modest, filling only a gallery or two. In short, there is always something new to see.

On my morning post, I see a class of about fifteen new guards being led on a tour by a security manager. They're in street clothes, as it's their first day of classroom training. Every four to six months, the security corps needs an infusion of fresh recruits, not because turnover is especially high—among veteran guards, it's notable when someone leaves before retirement age—but because our department is the museum's largest, with about six hundred personnel. The manager, Mr. Cruz, was once a guard himself before he was promoted to chief, then made a lateral move to the Dispatch Office, then was given an office upstairs where he makes, presumably, high-level decisions. This week, he will lead the new guards through presentations on security protocols, emergency preparedness, fire safety, their legal rights and powers, and—he went to art school way back when—the history of the museum and its collections.

Judging by the way they study their maps, some of my soon to be colleagues are exploring the Met's galleries for the first time. You don't need an art background or a security background to become a museum guard. You just need to see the job posting, attend the open house, have a solid résumé in whatever field, and display good sense in the interview. It doesn't win you special favors if you have a friend or relative who's a guard, but that's often how applicants learn about an opening. Decades ago, a few members of New York's Albanian, Guyanese, and Russian communities found gainful employment here and ever since word has spread through their networks: It's a steady job; it's union; base pay is poor; overtime can help cover the bills; benefits are good; and . . . When

it comes to describing the work itself, I wouldn't put words in anyone's mouth. Some guards find it tolerable, others inspiring.

The group departs after a few minutes and I am left alone inside African Art—completely alone, as on Mondays, our posts are spaced farther apart. It's an opportunity to explore the wing, and I start by approaching famous treasures from Benin. Around the time that Michelangelo painted the Sistine Chapel and Mimar Sinan built the great mosques of Istanbul, Benin's artists produced works of ivory and brass that similarly were judged unsurpassable in their region for centuries. Benin City, already seven hundred years old in this era, boasted sixty-eight royal guilds, among them potters, weavers, architects, brass casters, ivory carvers, and elephant hunters.

From a distance, I make out the powerful features of Idia, queen mother of the kingdom of Benin, on a mask made from a thin slice of elephant tusk. Idia raised an army to help her son, Esigie, win the throne and another army to expand his kingdom northward. The mask of her indomitable face is a particular type of artwork: one that makes a forceful first impression and on subsequent encounters grows in stature into an icon. There are many kings and queens in the Met, but this mask may be the most indelible image of royal might and majesty.

I pay a long visit to Idia, suspecting that someday she won't be kept in this case anymore. One day, a happy day, I believe that technicians wearing latex gloves will loose her from her stand and bring her to the basement where the signs read Restricted Area, Authorized Personnel Only. I don't mean the storage facilities but rather that area by the registrar's office where packers place objects in custom-made crates before they're transferred to the loading dock. In short, I expect Idia will be sent to a new museum being planned for Benin City, which today is part of Nigeria. In 1897, British forces plundered that city, which is how, a few tainted transactions later, she ended up in the Met's collection. As a guard, I have no particular expertise in questions of repatriation, but I can say that none of us wish to feel like prison guards, holding on to objects that have a strong case for release. In the meantime, at least the mask is in a public collection

in a global city. Speaking of West Africa, off the top of my head I can think of guards from Nigeria, Ghana, Togo, Burkina Faso, and Cameroon.

Just by turning around I travel more than a thousand miles to Central Africa, where there are a number of wooden power figures on display. I've come to believe one of these is perhaps the most wonderful sculpture in the whole museum, though I didn't realize it right away. With experience I'm coming to know that some works of art reward long looking while others give back less, and you often can't guess at the outset which will be which. For a long time, I second-guessed myself when I began to suspect this particular statue stood out among its peers. If the curators hadn't placed it on a higher pedestal, who was I to do so? Only the long and lonesome act of looking showed me that, yes, this is the one.

It is a *nkisi*, or power figure, made by the Songye people of what is today the Democratic Republic of the Congo. Carved sometime before 1970, its approximate date cannot be guessed. It stands about three feet tall and looks something like a small man but it isn't one: a *nkisi* is not of our world. It has a distended belly as though pregnant, arms and a chest slick with anointing oils, a fur and feather headdress, a shield-like convex face, and a massive head balanced on a neck like a coiled spring. Many pairs of hands played a role in its creation. Village elders commissioned the figure. Community members harvested a carefully chosen tree. A master carver realized the *nkisi*'s form, and a *nganga*, or holy man, invested it with medicinal and magical substances called *bishimba*. Upon completion, the figure was much too powerful to be held by human hands, so it was moved via long sticks attached to its wrists by raffia cords. It was paraded to a sacred dwelling place and constantly attended to by one of the village men, who received vital messages and warnings for the community in his dreams or through spirit possession.

Looking at the *nkisi* now, I am thrilled by the extent to which I can *see* this backstory. There are raffia cords still attached to its wrists. That gunk in its mouth is *bishimba* (also stored in channels inside the body), and the statue looks wet from anointments of palm oil and animal blood.

Above all, I can see the extraordinary geometry the wood-carver achieved in his effort to make the *nkisi* supernatural. This artist faced a tremendous formal challenge, I realize. Unlike Guo's scroll or Monet's painting, his sculpture wasn't an imitation or a depiction of anything else. It wasn't meant to *look* like a divine being; it *was* the divine being and, as such, had to appear as though it existed across a chasm from ordinary human efforts. It had to look a bit like a newborn baby looks: not an imitation or depiction of anything, but rather a new, miraculous, self-insistent whole.

Circling the vigorous figure, I can only marvel that he pulled it off. The miracle of great art was performed and a novel piece of beauty was added to the world's store. More than just dazzled, I am moved. With its eyes softly shut, the *nkisi* has a powerful air of inwardness, as though summoning the will to take on perilous forces closing in on it. The statue was meant to protect the Songye against the usual indefatigable hardships: violence, misfortune, disease. It couldn't have triumphed in this fight, but the attempt itself is affecting. Created in the vise of great pressures, it had to be this magnificent to push back.

VI.

FLESH AND BLOOD

Picasso in the Metropolitan Museum of Art is the first blockbuster exhibition I work, and it is one for the record books, attracting more than ten thousand visitors some days. Beginning with a teenaged self-portrait dated 1910, the exhibition concludes a dozen galleries later with selections from a series of 347 etchings that the eighty-seven-year-old artist completed in just 270 days. Who knew that the Met owns several hundred Picassos—paintings, ceramics, sculptures, drawings, and prints—only a tiny fraction of which it displays at any one time? Until now.

Most of my colleagues dislike working "the show," as we call special exhibitions. "Too much of a circus," one of them grumbles. To work the show is to manage an endless herd of jostlers and murmurers, a nightmare scenario for the guards of the usually stately Section B. I'm an exception. I find something magical in it—the energy in the room, the often exceeded or confounded expectations, people shout-whispering "the Blue Period!"—and I tell the section chief to post me inside the show as often as he likes. Doing everyone a favor, he complies, and over a four-month span I spend easily two hundred hours rattling around in Picasso's capacious head.

One Sunday, I am posted in front of *The Actor*, a six-foot-tall Rose Period painting that has recently been in the news. A few months ago, an unfortunate visitor stumbled into the painting—they were blameless—and the result was a six-inch vertical gash in its lower-right corner. The painting is repaired now, and behind glass, but I wince to see people leaning in to peer at the faint scar. Now, if you can imagine a gallery packed with people jockeying for position to see Picasso paintings, you can also imagine the narrow moatlike channel that is supposed to separate the art from its audience. On the far side of the gallery, I spot a gentleman blithely encroaching on the channel, but although I gain his attention with a wave, he doesn't know how to interpret me pantomiming a healthy step backward. So he elects to come speak to me—which, fine—except the shortest route is through the very channel I'm trying to keep him out of. Obliviously, he strides toward me and immediately throws his shoulder into the frame surrounding Picasso's *Woman in White*.

The painting swings once, twice, three times on copper wires anchored just below the ceiling. When at last the terrible pendulum comes to rest, I feel as though I have witnessed an earthquake, like reality itself was briefly unmoored. Somebody cries "Holy shit!" Instinctively, the crowd shrinks away from the man, who has his hands up, I suppose, to see if I'll arrest him. I call the section chief, and ultimately I am assured that the painting is unscathed and was never in any real danger. But I don't know. It's hard to feel that all is well when you've just seen a swinging Picasso.

A couple of weeks later, I have another shock. I open the *New York Times* as I wait to be assigned my post and read there's been an art heist in Paris in which a Picasso, a Matisse, a Braque, a Léger, and a Modigliani have been stolen. It seems that a lone thief broke a window in the night (actually, he painstakingly worked on the window over seven con-

secutive nights, the police will eventually learn), and disappeared into the Sixteenth Arrondissement with a hundred-million-dollars' worth of modern art. It is yet another reminder, as if I needed it, that a museum is not as immune to chaos as it first appears. It is not a locked vault. It is made for people; and as long as that remains true, it must contend with all the foibles and chicanery people bring.

I am posted in the Greek and Roman wing one afternoon when Mr. Whitehall, an old-timer, points to what looks like a run-of-the-mill marble Greek head. "Know who this is?"

I don't.

"Hermes," he says. "Know how he ended up in a storage locker at Grand Central Terminal?"

I don't know that either.

"Well, I'll tell you how. It wasn't long before I started here, I believe 1979. I hear it was a day like any other day, except that the King Tut exhibit was in town—biggest show we ever had, you can look that up. Whether that was a factor, I can't say. All I know is some poor guard turned around in the Greek wing and there was an empty plinth he was pretty sure wasn't empty before. A few days pass. Now it's February the fourteenth, Valentine's Day. The cops receive a tip that if they're looking for Hermes here—the god of thieves, by the way—they'll be interested in having a peek in locker number such and such at Grand Central Terminal. So they turn the sirens on, get out the old crowbar, and sure enough when the door swings open, they're looking into these empty eye sockets."

We both look.

"And that isn't even the strange part! Look here, just above his left eye. . . . In this spot, there had always been a little heart carved into the marble—no one knew why or by whom or if it was an accident or what; it just had always been there, probably for centuries. Well"—needlessly, Whitehall begins to whisper—"when Hermes here came back home, there was a second heart carved above the right eye. A matching heart.

A freshly carved matching heart! I swear to God, Mr. Bringley. You can look it up." (I later look it up. It's true.)

I ask him how the second heart got there.

"I'd guess it went down like this. A guy brought a girl to the Met on a date. She looked at Hermes here, saw the heart, said something like 'How cute!' and our guy socked that info away. Then Valentine's Day was rolling around, and he hadn't gotten her a present. He remembered the statue with the little carved heart, went back to the museum, swiped it, and because he was really that stupid, carved the matching heart and put the thing in a box. So. She took the little bow off, opened up her gift, called him out as the moron he was and probably still is, and an hour later, two hours tops, the cops had their anonymous tip."

On my very next break, I head to the Met's research library to plug words like "Metropolitan Museum," "theft," "stolen," and "guard," into old newspaper databases. There is nothing quite like an art heist to both chill and excite the blood. I've been questioned at least five times about the *Thomas Crown Affair*, a movie set inside a fictional Met in which guards wield electrified cattle prods. ("No comment," I say on that subject.) And though it turns out nothing quite so cinematic has transpired here in real life, there have been a number of incidents that add up to an alternate, messier history of the grand institution.

The first theft I can find is from 1887, when a watchman made the "startling discovery" that a case had been jimmied open and robbed of gold bracelets from ancient Cyprus. Cypriot art was the only really valuable collection the young museum had and was apparently the source of great controversy. The earliest Met security guard I come across is a Mr. Dickson D. Alley, who appears in news articles that allege fraud on the part of the Met's first director, General Luigi Palma di Cesnola. (Born in the kingdom of Sardinia, this colorful character became a Union officer in the American Civil War and later American consul in Cyprus.) According to Mr. Alley, he had been tasked with unboxing and washing ancient Cypriot pottery—not something I am ever asked to do—when

the museum moved to its permanent home in 1880. To his surprise, he discovered that some vessels were apparently forged or altered as their colors were modern, soluble, and running down the drain. He was then handed an ancient terra-cotta figurine and charged with finding its head from a jumble of possible candidates. When the best of the bunch proved to be an eighth of an inch too narrow, it wasn't a problem for General Cesnola, who allegedly ordered that the figurine's neck be shaven down to accommodate it. When later Mr. Alley answered questions about the "restoration" forthrightly, he was fired in retaliation.

The next article I find is from 1910. In that year, a man entered a pawnshop on the Bowery carrying an Egyptian figurine. "I've a bit of brass here that I'd like to raise some money on," the *New York Times* quotes him saying. "I don't know how much it's worth, because it belonged to my aunt," but she "was a judge of these things, and whatever she bought has always turned out to be the real goods." The pawnbroker looked over the 2,500-year-old relic and grunted: "What you call the workmanship may decrease the value of the brass, for all I know." He gave the man fifty cents (enough "to buy five whiskies or ten beers," according to the detective) and the thief sold his pawn ticket for an additional dime. The cops, already on the lookout, spotted the statuette on their normal pawnshop rounds. Today the goddess Neith, whose name means "the terrifying one," is back on view in the Egyptian wing.

The robbery of 1927—five miniatures painted in the seventeenth century—was surely an inside job, as the perpetrator used a skeleton key. In 1944, a fourteenth-century Sienese painting was pried off the wall from its screws, then returned anonymously by post, its wood panel cracked in half. In 1946, a burglar carrying two screwdrivers, a hammer, and a pair of flashlights had a Turkish rug stuffed under his coat when veteran guard Dan Donovan decided "that bulge was suspicious."

In 1953, the Met's guards went on strike, incidentally soon after a ceramic likeness of William Pitt the Elder was ripped from its moorings. Picketing guards stood on the stately marble entry stairs wearing gaudy

historical costumes. The knight in shining armor held a sign reading: "Even My Wages Are from the Middle Ages; Medieval Exhibits Paid for My Medieval Pay."

In 1966, there were two incidents. First, a man in a raincoat snatched a Gainsborough[3] painting but dropped it when the guards gave chase. Later, a Bronx vegetable peddler poked a hole in Monet's *View of Vétheuil* for no discoverable reason.

In 1973, the museum was the *beneficiary* of a theft. The Met's director steered the purchase of a glorious Greek vase by the painter Euphronios that had obviously been smuggled in fragments across multiple borders. "The Hot Pot," as it was nicknamed, became the subject of multiple exposés by the *New York Times*'s mafia reporter, and was finally returned to the Republic of Italy in 2006.

Nineteen-seventy-nine to eighty-one was a very bad stretch. First, the Hermes head was nicked. A year later, teenagers used a coat hanger to remove Ramses VI's ring from a poorly designed display case (they were caught when a jeweler tried to extort the museum for the ring's return). The arrests in that case came just days after the museum announced the theft of two bronze sculptures by Edgar Degas, then quickly recanted. Citing "a bit of a boo boo," Met officials admitted the statues were in a storage room all along. Finally, a cleaning man reported several small objects missing from a vitrine, including a pair of Celtic coins and ancient gold dress fasteners. The apparently sharp-eyed custodian turned out to have been the thief.

And then, in a remarkable turnaround, the security department cleaned up its act. I was born in 1983, and in my entire lifetime there appears not to have been a single theft in the Met's galleries (though a few baseball cards were swiped from a study room). It's a remarkable achievement, due in no small part to the vigilance of my forebears and colleagues.

3. The painting has subsequently been reattributed to Thomas Gainsborough's nephew and pupil Gainsborough Dupont.

The Met welcomes almost seven million visitors a year. That's a greater attendance than the Yankees, Mets, Giants, Jets, Knicks, and Nets combined. It's more than the Statue of Liberty or the Empire State Building. It's less than the Louvre or the National Museum of China, but as far as museums go, that's the entire list. About half of its visitors are from overseas, and of the American half, half are from out of town. The Met has a "pay whatever you will" policy,[4] so money isn't an object, and a lot of people will spend a day in the museum in the spirit of an outing to a public park. All in all, it's fair to say the Metropolitan Museum draws an audience worthy of that name, a diverse crowd who for diverse reasons have found their way to this great metropolis and one of its most fascinating gathering places.

As a non-native New Yorker, I can remember my introduction to the city's unmatched people watching. Working people and fancy people and neighborhood eccentrics laid claim to the same sidewalks, and nobody looked hesitant. Nobody looked afraid. A person might look put-upon, tired, or cranky but seldom self-conscious, shrinking, or guarded. In short, they didn't look watched, and it is this "alone in a crowd" quality that makes New Yorkers ideal subjects for people watching. In college, I would sometimes sit out on the Met's stone steps and spend longer than I had intended surveying the eternal parade along Fifth Avenue. When I tired of it, I would turn and walk through the Met's big entry doors, joining a crowd just as thick and heedless as the one I'd been observing. Standing apart . . . then melting in . . . standing apart . . . melting in . . . A city dweller's respiration.

As a guard, I don't melt into the crowd passing by me on post. I melt into the furniture maybe, but never the crowd, a pageant for whom I'm the steadfast audience. It is one thing to sit on a park bench for an hour

4. Sadly, as of 2018 this is now true only for New York State residents.

or two, it is another to spend days sharing quiet rooms with oblivious strangers. It is an intimacy that must be known to butlers who disappear behind their silver trays, only I am not just incidentally a pair of eyes and ears. It is my main duty.

There is no one way that visitors experience the museum, but there are a few typical ways. Like anything else, people watching is something one can get better at; and once I commit myself to mastering the art of it, so to speak, I learn to pick out exemplary characters among the thousands I see every day. There is the Sightseer—a father in his local high school's windbreaker, camera around his neck, on the hunt for whatever's most famous. He has no special interest in art, but it doesn't mean that he's blind to what he sees. In fact, he loudly says, "I mean, the frames alone!" several times while admiring the workmanship in the old master wing. He listens carefully as his school-age children relate what they're learning in Global History. But he is surprised and disappointed to learn that the Met—which he conceives of as a kind of Art Hall of Fame—doesn't have any Leonardo da Vincis. Nevertheless, he leaves the museum enthused.

There is the Dinosaur Hunter—a mother with small children who cranes her neck to peer around corners, panicked by each new piece of evidence that this museum *only* has art. It is a first visit to New York, a big deal for her and her family; they're staying in Times Square. And she just sort of assumed that a famous museum would have a T. rex or an interactive laser display or *something* to entertain the kids. But she resolves to make the most of it, and a guard pulls her aside to recommend the mummies and the knights in shining armor. She gets a kick out of this guard, who says goofy stuff to her kids, and she walks away ready to report that actually New Yorkers are very nice.

There are three distinct types of Lovers. The first is the Art Lover—a quiet, intent-looking person who's traveled from another city to see an exhibition that got a great write-up in the *New Yorker*. Her face doesn't move much but her mind is furiously churning as she inches through the galleries like a tortoise among hares. Then there is the Lover of the

Met itself, a local who's known it as a secular church for as long as he can remember. In his youth, he paid a few dollars each visit; now he can spring for the basic, no-frills membership. Though his job has nothing to do with big ideas or beautiful things, he lives in this city because here they feel at his fingertips. Finally there are the Lovebirds, who flutter through the galleries, alighting in spaces where silences aren't awkward and strong emotions feel natural.

There are several different kinds of visitors who can't keep their mitts off statues, sarcophagi, antique chairs, and anything with drawers. For the most part, people are good about not touching paintings, but anything else, forget it. If you dusted the Met for prints, you'd have countless suspects. Some can't help themselves: the cold, cold marble calls to them and before they know it, they've caressed. Others lock on to their targets with premeditation, a certain too purposeful quality in their gait allowing me to detect their motive and jump in between. Finally, there are visitors who simply don't know the rules, who haven't thought through the various questions about old and fragile art that all lead to the one answer: "Don't touch." When I stop a middle school kid from climbing into the lap of an ancient Venus one day, he apologizes and looks around thoughtfully. "So all of this broken stuff," he says, surveying a battlefield of headless and noseless and limbless ancient statuary, "did it all break in here?"

There are also singular individuals who catch my eye. An old man bends horizontally down on his walker, exhausted by the effort of looking, and his wife bends her head to whisper in his ear. For several long minutes she minutely describes the medieval reliquaries that, for want of energy, he will have to miss. Finished, she helps to right him, and they inch along their way.

A mother at the American Wing fountain hands her child two coins: "One wish for yourself," she says, "and another, just as big, for someone else." I have never heard this before and immediately know I will say it to my children one day.

Two elderly, white-haired ladies are dressed exactly alike. On closer inspection, they are identical twins. On even closer inspection, there is one difference between them: a string bow tie worn by one but not the other.

Sometimes I will be watching such a person for a minute or more when an uncanny thing happens. All of a sudden, the visitor will turn on their heel, walk in my direction, and ask me a question.

I am standing in the Early Renaissance galleries one afternoon, watching a man look pleasantly astonished. He gazes at Duccio's *Madonna and Child*, the beautiful folds of her veil, their rhythm, their delicacy. He turns to me. "These paintings . . ." he says, looking over the little masterpiece, "Were they . . ." He stops. "Were they . . ." He is not even sure he has a theory. "Were they . . . found in . . . caves?"

The man is well-dressed and middle-aged, devoutly religious as he tells me; and he had no idea such old Christian pictures had survived. He cannot believe how fresh this seven-hundred-year-old picture looks, especially after I explain that it was painted with a mixture of egg yolk and ground up vegetables, bugs, and stones. He finds that dizzying. "So was it found in . . . a cave?"

Well, no, I say. These paintings were handed down person to person, priest to priest, monk to monk, buyer to seller, and every other way, until they wound up safe in the museum's collection.

"And were they painted by . . . priests?" he asks.

I tell him they weren't. For the most part, they were painted by workmanlike artists and their workmanlike assistants on commission for a rich patron or a church. Pigments had to be ground up and brewed, gold pounded into gilt sheets, wood panels cut and prepared, compositions designed and balanced, the contours sketched in, and the paint applied in careful, hatched strokes, layer by layer, day by day, with a medieval sort of patience.

"And why do the people look like that?" he asks next, by which he means kind of strange looking.

Well, I say, good question. (Having to think as I go, what follows is a generous paraphrase.) "Well, for a long time, artists weren't too concerned with making their pictures look like photographs. For one thing, they'd never seen photographs, didn't dream that they could exist. For another, they were usually painting angels and saints and suchlike, and those seemed to be well captured by beautiful designs that were almost like symbols. These beautiful near-symbols were doing the job. This painting, though, by Duccio, this was painted in the early days of the Renaissance. That was a time when people grew very interested in people: what they looked like, what they thought about, what they might accomplish, the makeup of their lives and dreams. This was something new, as the previous tendency had been to see humans as sinful, fallen creatures, putting in their short time on earth before advancing to the hereafter.

"As a consequence, the artists of the Renaissance had to make up new ways of doing things. Of seeing things, really. Ways that paid attention to the visible world—surfaces, wildflowers, our bodies, our faces—but that at the same time expressed their belief in divine harmonies and hierarchies. The amazing thing is they succeeded. The way they learned to balance things, to harmonize the accidental and eternal, it affects how you and I see today. It's influenced generations of artists. We're looking at the first stretch of that hike, a little rough under foot, but very fresh and very beautiful I think."

Throughout my halting explanation, the man listens to me hungrily. He is a rare person, one who doesn't pretend knowledge or fear ridicule, who throws the gates of his mind wide open and invites a battalion of new ideas to crash in. I admire the openness more than I've admired anything else all day. The man thanks me and leaves, and from this point forward, I make a habit of looking out for others like him.

He was a listener. Others are talkers. Still others are out loud thinkers. There is a woman who monologues to me so slowly, with such effort and care and earnestness, I almost don't dare move lest I break the spell.

"These talented artists . . ." she says, looking up at the vast landscape *The Heart of the Andes.* "You see how beautifully they painted. . . . You see how good people are at what they do . . . and it just stays with you for months, for years. . . . You reminisce about it. . . . It returns you to a place of relaxation. . . . It's amazing. . . . They weren't working from photographs. They just looked . . . and they painted. . . ."

I tell her about another American landscape, *The Oxbow*, and she says, "Let me go gaze at that."

People talk to guards the way they wouldn't engage a busier person in a fancier suit. When they love an exhibition, they sidle up, wondering if we've ever seen anything so beautiful in all our lives. When they think something is artsy-fartsy nonsense, they shoot us looks like: Everybody buys this horseshit but you and me. It's something in the uniform, I think—a shabby gentility that reads as sympathetic to fancy and working people alike. That, and we aren't needy. I'm sure visitors would scorn us if we wore vulgar Ask Me Anything! buttons on our lapels. But museum guards are the opposite of those buttons. It's clear we're content with the silence. But we're also perfectly botherable.

Still, people are pretty good at reading my mind: whenever I've been preoccupied with thoughts, they've mostly left me alone. Lately there must be something open and inviting in my expression, because more and more people are approaching after uttering the oft-heard phrase: "Let's ask this guy." I especially like it when baffled people ask me questions. I like baffled people. I think they are right to stagger around the Met discombobulated, and more educated people are wrong when they take what they see in stride. Baffled people are surprised by things that are, in fact, surprising—that a Picasso is right there for them to breathe on, that an Egyptian temple has been picked up and moved to New York. I learn not only to choke back any snobbish impulses I might have, but to dismiss them as stupid and absurd. None of us knows much of anything about this subject—the world and all of its beauty. I might know the dates of Michelangelo's birth and death, but imagine how overwhelmed

by ignorance I would be in his workshop or in a Persian miniaturist's or in a Navajo basket weaver's, and on and on. Even those artists wouldn't firmly grasp their often huge and elusive subject matter. They, too, would be baffled inside the Met.

Around the holidays, the museum is jammed. For tourists especially, the city and everything in it feels Christmasy from Thanksgiving to New Year's Day, and they glide about the galleries like ice-skaters at Rockefeller Center. As it is my third holiday season, I'm attuned to the special texture of these crowds: the sightseeing vacationers, the elderly parents spending Christmas in the city with grown children and grandchildren, the former New Yorkers ("We live in Scottsdale now, but I'm Brooklyn born and raised") come home to spend time with their ma. It is high season for people watching.

I am working inside a photo exhibition—*Stieglitz, Steichen, Strand*, three Americans working in the early twentieth century. The first thing I notice is how familiar so much of this looks. Strand photographed a blanket of snow on Central Park like the one I saw on my walk from the train. Steichen made a portrait of the Flatiron Building, an old friend of mine since we used to walk by it from the hospital to Madison Square where we sometimes picked up lunch. Stieglitz produced cityscapes of high-rises and low that have me saying to myself, "Yes, that is exactly how New York looks." In the best pictures, I can sense the excitement of the eye behind the viewfinder and the eagerness of the hands withdrawing the magical image from its chemical bath.

A couple of galleries away, there is a series of pictures Stieglitz made of his partner and later his wife, the painter Georgia O'Keeffe. They aren't portraits, and they aren't snapshots. Studies, I suppose you'd call them: efforts to see her better—her hands, her feet, her torso, her breasts, her face, her face again, her face again. She was strikingly beautiful, but the

series mostly makes me feel alive to the way people in general look, how concretely and peculiarly we are built, how much we communicate by bearing and gesture, how we appear to others as line, color, light, shade. In the pictures, O'Keeffe looks at once like a hairless primate and an austere goddess, and that's really how it is, isn't it? The mystery of our entire species impresses itself on me.

Turning from the picture, I look around the room and am brought to the verge of laughter by what I see. Here at close quarters are dozens of people from all over the world, live and in the flesh, every one of whom looks past their neighbors to stare at colorless, motionless pictures of people hanging on the wall. Real people, it seems, are just commonplace. We can see them any old time. Why would we give our attention to strangers when, in mere moments, they'll pass forever from our lives? Georgia O'Keeffe here, as a work of art, has virtues the rest of us appear to lack. She is still. She is permanent. There's a frame around her, putting space between her sacred beauty (an older meaning of the word *sacred* is "set apart") and the profane, mundane world. I think that sometimes we need permission to stop and adore, and a work of art grants us that.

Steps away from me, a visitor holds a camera to his eye to take a photograph of a photograph of Georgia's unblinking face. In the moment it feels like a surreal thing to witness, but again I understand why it's happening. Behind that apparatus, the gentleman feels that he has a surer grip on reality, as it can be difficult to fully experience what we know will slip through our fingers. We want possession, something to put in our pocket, so to speak, and carry away. Except what if nothing very beautiful fits in our pockets, and only the tiniest sliver of what we see or experience can be possessed?

With this thought, suddenly the strangers in the room appear to me wildly beautiful. They have good faces. They have eloquent walks. They're emotive; their eyebrows jump about. They are daughters who look like their mothers' pasts, fathers who look like their sons' futures. They are young, old, blooming, decaying, and in every sense they are

real. I strain to use my eye as an investigatory tool—as a pencil, with my mind the sketch pad. I am not very skilled at it, which means that I can get better. I look for meaning in the way people wear their clothes and carry their weight, hold hands with their boyfriends and girlfriends or don't, style their hair, cut their beards, meet or avoid my eye, show pleasure or impatience or boredom or distraction on their face or in their posture or through their gait. And when I find I can discover no definite meaning in most of what I see—nothing I could put into words—I take pleasure in the flash and sparkle of the scene.

When the day is over, I board the subway at 86th Street and look at my fellow passengers with a ready well of sympathy. On a typical day, it is easy to glance at strangers and forget the most fundamental things about them: that they're just as real as you are; that they've triumphed and suffered; that like you they're engaged in something (living) that is hard and rich and brief. I can remember subway rides home after visiting Tom in the hospital. If anyone behaved meanly, if someone sniped at another passenger for bumping into them, it felt like such lowdown blindness it was almost unbelievable—though we're all prone to it sometimes. Tonight, I'm fortunate. I can look with love at the tired, preoccupied faces of strangers.

After a half hour and a transfer at Union Square, my train passes over the Manhattan Bridge and barrels into Brooklyn. Now I begin to feel greater love thinking of the person I'm headed home to.

VII.

CLOISTERS

The day of my brother's funeral was meant to have been my wedding day. We had booked the hall, hired the band; we had even been married, a stop at city hall a few weeks prior to the big white event. Tom and Krista were meant to have been our witnesses that day, but at the last moment the call came that Tom was too weak. And if we tied the knot at the Queens city clerk's office instead? Too weak. This was June third, 2008. He died on the twenty-second.

My first date with Tara Lohr was on Valentine's Day about sixteen months before. The timing was a bit of happenstance that embarrassed us both, so we compensated by eating at a greasy spoon diner called Big Nick's. In the booth, Tara's cell phone rang, and she picked up the call. "Saara!" said Taara, her Brooklyn accent suddenly flowing like harbor water under the Verrazano Bridge. "You back in Bay Ridge? Listen, I saw your mutha. I saw your mutha yestuhday." I guess I really didn't know this girl, who up to this point I had thought talked normally. This was good. This was surprising.

A month before, we had been strangers at a New Year's Eve dance party. Not too long after, I was spending the night at her place uptown. Oh, those early days, when I would ride the A train to the last stop in

Manhattan and feel that the air was actually thinner up there! I would climb the stairs to her fourth floor apartment, knock on the door, and enter surely the most secluded spot in the whole city. Tara would rise at dawn to prepare for her job as a schoolteacher in the Bronx. Half awake, I would watch her, picking out her Ms. Lohr clothes, just so; getting her overstuffed backpack together, just so; coming to give me a kiss as a prince would Sleeping Beauty, and leaving me alone in that small, sacred apartment. *Sacred* in the sense of "set apart."

Around the corner from her building, high up on a forested hill, loomed the Cloisters, an annex of the Met at the northernmost tip of Manhattan. On another of our early dates, we climbed the hill, huffing and puffing and saying the same things everyone must say while advancing toward the unlikely museum: "Can you believe we're still in New York?" Emerging from the woods, we took in the weathered gray stone building modeled on a thirteenth-century abbey. Then we climbed still more, up the Cloisters' winding staircase that in my memory, anyway, was torchlit. We donated $10 between the two of us, which felt generous, and entered the first of the museum's medieval sanctuaries.

It was a twelfth-century French chapel built of heavy stone blocks. Small and little ornamented, it had a somber sort of grace. Tara, a former Catholic school girl, a Brooklyn Italiana, compared it favorably to St. Anselm's on 82nd Street, which made me laugh. Taking my hand, she led me to the altar, pointed out where the tabernacle would have been, spoke about her God-fearing years with lightness, nostalgia, and eye rolls. Evidently she lacked the reflexive hush I exhibit before churchy things. But we were both enchanted. The beautiful melancholy of the echoey room suited us, though we were too happy to be somber.

I had visited the Cloisters before, but somehow the precise definition of a cloister eluded me. I would have guessed it was a tiny cell where a monk shut himself away to pray. In fact, a cloister was the open-air center of a monastery, a place set apart from the wider world but not from the sun, moon, and stars. The first cloister we visited, from twelfth-century

Catalonia, was a garden bursting with flowers. It had fruit trees full of songbirds, pathways intersecting at a central fountain, a colonnaded perimeter constructed of pink marble. Monks would have crossed through it on their way to the refectory or the dormitory. Or they would have rolled up their sleeves, grabbed their spades, and tended this isolated garden, their own little patch of creation.

As Tara and I walked across the smooth pavers, she subtly practiced tap dance steps, a habit of hers. Pointing out some flowers, I told her that my Cub Scout troop in suburban Chicago used to make us sell tulip bulbs door-to-door. She found this amazing. Under a crab apple tree, she described growing up with two siblings in a third-floor two-bedroom apartment, her grandmother (from Abruzzo) on the first floor, her great-grandmother ("Mammuccia") directly downstairs, a fig tree in their tiny, scrubby yard.

She led me into the adjoining chapter house (a meeting place for the monks), and we sat on benches too short for her five-foot-ten-inch frame. Here, we could look out at the garden while feeling hidden in a shadowy place, its ceiling a network of rib-vaults like the tentacles of a giant squid. Relishing the chance to rest, Tara told me she and her friends used to hang out in the chapter house "all the time." Now it was my turn to be amazed.

"You mean in high school? Hadn't you moved to Staten Island?"

She had. But she attended a magnet public school in Manhattan, which meant that every morning she took the city bus to the Staten Island Ferry to the subway to get to school—a two-hour commute. This inured her to even the longest intra–New York journeys, so she and her friends (also outer-borough kids) thought very little of meeting up in midtown and riding the A train all the way up here.

"But why here?" I pressed.

"We were poets," she said, laughing. "Or we thought we were. It felt like the ends of the earth, like a secret place. I had my fifteenth birthday right here. I wore a black spiderweb dress, and I don't think we did anything but lounge on these benches and talk."

We laughed at the recollection like it was a very long time ago, though we were then only twenty-three.

We walked through the next several galleries without stopping. If I had been alone, I would have paused to pour over the Mérode Altarpiece and study the Bury St. Edmunds cross. But Tara isn't an "art person," not really, and there were more pressing beauties to think about. We stopped when we arrived at a second cloister, with an outrageous view. Instead of being encircled by the museum-monastery, we were now at its edge, looking down at the Hudson River flowing against the Palisades. I had the strange sensation I could see us from high up above, standing at the narrowest part of a skinny island, watching the great river run slowly toward New York Harbor. It was like I could see the clear, crisp outlines of the love story we were writing.

"You wouldn't exist if it wasn't for the harbor," I reminded Tara. (Her father, a sailor, met her mother while docked at the Brooklyn Navy Yard.) The clarity of the true statement felt incredible. It felt miraculous that, the next day, we would ride under the length of Manhattan and over the East River to her grandmother's house for Sunday dinner. And that the following weekend we would zip over to Queens and visit with Tom and Krista, our elder statesmen in love.

We took a turn through the herb garden, laughing at soapwort, wormwood, black horehound, all the witchy names. Then we left the Cloisters and climbed back down the hill.

Eight months later, we announced our engagement in Tom's hospital room, a merry cloister that day. We smuggled in beer and toasted with plastic cups. Tom's face was all lit up with surprise.

And only four months after that, Tara and I took our turns sitting vigil by his hospital bed, watching television on mute as he slept.

On one of these nights, it was Krista, Mia, Tara, and I watching over

Tom. It was late. He was seldom cogent anymore. But all of a sudden he lifted his head and demanded some Chicken McNuggets. I don't know that I've ever been happier than when I charged out into the Manhattan night and returned with a great bounty of dipping sauces and breaded meat. Around the bedside, we picnicked, a loving, sad, laughing little group, managing the best way we knew how.

Looking back, it makes me think of Pieter Bruegel's great painting *The Harvesters*. In that picture, a handful of peasants take their afternoon meal against the backdrop of a wide, deep landscape. There is a church in the mid-ground, a harbor behind, gold-green fields rolling back toward a distant horizon. Closer to the picture plane, men mow the grain with scythes and a woman bends low to bundle it. And at the nearest corner of the foreground, these nine peasants—comical and sympathetic—have broken from their labor to sit and sup beneath a pear tree.

Looking at Bruegel's masterpiece I sometimes think: here is a painting of literally the most commonplace thing on earth. Most people have

been farmers. Most of these have been peasants. Most lives have been labor and hardship punctuated by rest and the enjoyment of others. It is a scene that must have been so familiar to Pieter Bruegel it took an effort to notice it. But he did notice it. And he situated this little, sacred, ragtag group at the fore of his vast, outspreading world.

I am sometimes not sure which is the more remarkable: that life lives up to great paintings, or that great paintings live up to life.

VIII.

SENTINELS

On my fourth year on the job, I arrive one morning to find a loose line of rookie guards waiting by the stacks of empty art crates. Running a touch late, I hurry past them into the Dispatch Office, where Bob struggles to find the tile with my name. "Ah, Bringley," he says at last. "You're training somebody today. Go ahead and get your uniform on and report back. . . . Beavers, Section A! Novikov, Section G!" I quickly climb into my suit—I've never trained anybody before—and return to find a growing circle of veteran guards casting sideways glances at the rookies. I join them.

"Really? You've never done this before?" Mr. McCaffrey asks me. "I've been training guards for twenty years, and I only ever tell them one thing . . ." We all wait for the punch line. "Find a better job!"

I tune out the chatter and take a good long look at the novices. It is always strange seeing new heads poking out of the blue suit—strange for about a week, that is, when it will switch to being strange to see them in their street clothes. I wonder which of these rookies I'll be carrying under my wing. Might it be the older woman with boyish white hair and chic Buddy Holly glasses . . . or the big teamster-looking fella with his arms crossed, humming to himself . . . or the just-out-of-college kid who is only

now scampering into place (late on his first day, he won't last . . .). My reverie ends when one of our bosses emerges from the Command Center and lets the door shut and lock behind him. "Right," he says, looking at a clipboard, "let's get to it. Smitty, you'll be training Ms. Cooper here. Ms. Karaj, you're with Mr. Goldman. Mr. Calabrese, meet Mr. Espinoza. Mr. Bringley—Where are you? Right—you'll be training Mr. Akakpossa." A man in his late fifties with salt-and-pepper hair and squarish glasses looks toward me. He steps forward and shakes my hand with polite deference, and my first impression is of a man who belongs to a statelier generation and may well be a cold fish. But a second later, he softens, meets my eyes with curiosity, and says in a lovely West African accent, "I am Joseph, and who is my teacher today?"

I delight in playing the teacher. As we begin our walk, I point out the bulletin board with results from the latest union election, the electric shoe buffer few of us use, a big pile of excess foam board clearly labeled Free Foam. We stand aside as an Egyptian statuette rumbles by on a pushcart, and I lead us up a backstage staircase—bare concrete, harsh fluorescent light, an empty coffee cup in a corner—giving onto a metal door marked Open Slowly. With my encouragement, Joseph pushes it open (slowly), and we stride out into his home section, the American Wing.

We are standing in a glassed-in sculpture court with a two-story Greek temple–like facade on one side. "Did they tell you about that facade during training?" I ask. "It used to be a bank on Wall Street—built in the 1820s, torn down a hundred years later and rebuilt here. How much do you know about Wall Street?" I'm speaking rapidly, excitedly, really feeling myself in this teacher role. I tell him about the wall that gave Wall Street its name in the colonial period, about the African laborers forced to build it and the Dutch colonists who used it to keep the English and the native Lenape out. Joseph is a patient, attentive, bright-eyed student, but at last he interrupts me with a low belly laugh: "I lied to you," he apologizes. "I know about Wall Street. I worked there many years."

With this, the first pieces of a fascinating puzzle are laid. I learn that

Joseph is from Togo, "the New Jersey to Ghana's New York," as he puts it; that he had a banking career there; that a hinted-at dramatic incident brought him to New York and to Wall Street; and that further unstated twists and turns find him standing here with me, looking up at this facade. The gaps in his story he fills in for now with shrugs.

Normally, the Section G chief's desk is upstairs in the American painting galleries, but they are closed for a major renovation. Instead, we enter a catering kitchen that is used for private events, notably the red-carpet Met Gala, which I advise Joseph not to work. ("I did it once. They posted me far from the action and I didn't see a thing.") Our colleagues, awaiting the chief, are eager to stick a hand out and greet Joseph. I can't recall receiving the same treatment on my first day, but in general, no one trusts that a twenty-five-year-old is long for the job. An older rookie is a better bet to realize its merits and stick around. We receive our assignment slip from the section chief, and I see that we're posted in the American period rooms, what guards call the "old wing."

We ascend in a glass elevator to access this original core of the American Wing, built back in the 1920s. (Watching the statues in the courtyard grow smaller, Joseph correctly observes that children must love the ride.) We step off onto a creaky wooden floor—"Soft," I tell him, "easy on the feet"—and round a corner into a room modeled on the Old Ship Church Meeting House from seventeenth-century Massachusetts. Joseph takes in the beautiful bulky timber rafters whose structure is owed to the wisdom of shipwrights. He tells me he is a big-time history buff, an avid reader of both Bill O'Reilly and Howard Zinn. We pace the full length of the room, which, like many historical places, is smaller than the picture you had in your mind. I tell Joseph that the Salem witch trials were conducted in a similar meetinghouse. The farmer in the very last row could have looked into the condemned women's eyes.

After a little while, we duck—literally, in Joseph's case—into the low-ceilinged Hart Room, also from seventeenth-century Massachusetts, which the museum surgically removed from a house slated for demolition.

"Poor people?" Joseph asks me, looking over the dark, claustropho-bic, but charming room.

"Rich people," I say, "or pretty rich," pointing out small leaded glass windows that were a luxury at the time.

"And the ceilings?" Joseph asks, laughing to find that, at five feet eight I can just slide under the massive crossbeams.

"People were short," I say. "They didn't eat like you and me."

It feels like as good a setting as any to go over some finer points of the job, and I find myself stealing lines from Aada. I say sage things like, "You have to remind people not to be idiots." I also share wisdom of my own—for instance, that one should avoid the phrase "down the hall" while giving directions, as it causes visitors with shaky English to look for the staircase. Joseph interrupts with the occasional well-considered question, and I am proud of my ability to answer each one. I use all the lingo—"post," "push," "your relief," "Command Center," "Dispatch," "the third platoon"—and he seems impressed.

We do a circuit around this, a tiny third floor that connects awk-wardly with the newer additions to the American Wing. Being so tucked away, we're unlikely to have customers at this hour, and I get to hear a bit more of Joseph's very American story. He arrived in Nashville, Tennes-see, as a graduate student—"the same type of scholarship Obama's father got," he tells me. He studied business at Vanderbilt University, then re-turned to Togo where he rose quickly, eventually becoming the "number three man" at a large bank. But he got into trouble when he stuck his neck out and blocked a corrupt deal, making him an enemy of powerful men. Then, the incident happened—he still skates over what exactly it was—and in the early nineteen nineties he settled in New York City as a refugee.

At 11 a.m. we are pushed to our next post by my old classmate Ter-rence. At last Terrence has gotten his transfer from the Cloisters and is now a mainstay of the American Wing. Standing and chatting with these two unassailably affable gentlemen, we talk Togo, we talk Guyana, we

talk shop, we talk families, and I experience a rush of joy feeling something click into place. We three will become a little triumvirate, some of one another's best friends at the Met.

Joseph and I descend a flight of stairs to another tiny floor of the old wing, 2A. Here, we stand inside a Virginia tavern where George Washington celebrated his final birthday. There is much to tell Joseph about George. Gilbert Stuart's famous portrait of the president hangs in the gallery, and Joseph will see more than a few visitors hold dollar bills up to it and squint. They will then turn to him and ask to see *Washington Crossing the Delaware* (or occasionally the Potomac or the Hudson), and he will have to disappoint them since, considering its billboard-like size, it couldn't be moved during the renovation and can't be seen right now. I tell him to watch out for an amusing feature of the American Wing: any portrait of a man wearing a white wig—and they are legion—will sooner or later be mistaken for George Washington.

The tavern—which again is smaller than you'd picture such a thing— is lined with fine mahogany furniture, its crimson wood appearing almost aflame. We stroll over to a Chippendale-style chair and I remember something Terrence taught me. The mahogany was harvested in the Caribbean, probably Belize, and certainly by slaves. He told me he himself likely descends from some of the final Africans brought to the Caribbean. How does he know? Because earlier generations weren't typically allowed families; they were used up until death and replaced by more Africans brought across the Middle Passage. Telling me this, he leaned in to double-check the date on the chair we'd been considering, an uninspired imitation of an English model. "1760? Oh no, boy," he said gravely. "That wouldn't be good. . . ."

Having now relayed this information to Joseph, I point out what hardly needs to be said about the American Wing. Its fine objects tell a particular American story. The American guards who watch over them embody others.

Visitors arrive around this time, and Joseph makes himself ram-

rod straight to greet them. They are French, which is perfect, as he can address them in their mother tongue. They step off onto floor 2A and pause, look around, mutter, and clearly confused but not asking questions, retreat the way they came. Ah well. We both laugh. I bring Joseph over to the windows, and we peer down into the American Wing courtyard, he and I now looking *through* the Wall Street facade. I feel an easy connection with the man beside me and my enthusiasm gets the better of me. I begin to articulate beliefs I would have thought were too embarrassing to say out loud. Speaking quickly, I reveal my devotion to what I do, that I think I'd like to be a guard forever, because why would I need to do anything else? It's simple and straightforward and you learn things and your thoughts are entirely your own.

In fact, not only do I like our job, I am offended by the idea I will ever not like it! It would be an indecency, a stupidity, even a betrayal to find fault with such peaceable, honest work. No, I prefer to be grateful, grateful for the soft wood floors and thousand-year-old art, grateful for all the stuff I *don't* have, like a product to sell, lies to tell, a ditch to dig, a register to ring. Joseph clearly gets a kick out of my performance and looks on with hair-tussling eyes—patronizing, but appropriately so. I think that he may be enjoying a private joke with himself, thinking of the twists and turns in his own life that brought him here. Maybe thinking: "This kid really thinks he can guess how his life will unfold. . . ."

"I was assassinated," he will tell me later. "I was coming home from work one day when I was shot by two gunmen hired by men whose dirty deal I was gumming up. I took a bullet in my left arm and eight in my stomach." (He says it matter-of-factly, no special emphasis on the word *eight*.) "By the grace of God, no vital organs were pierced. This was 1994, a Tuesday. On the Friday, my bank paid to have me flown to a hospital in Paris where my guts were put back together and where I spent four months recovering. I secured a tourist visa to America. As soon as I arrived I applied for and was fairly quickly granted asylum. My first job in New York paid four dollars and twenty-five cents an hour. My

first job as a security guard paid five-something. Thanks to a connection from Vanderbilt, I landed the Wall Street job, but it was a middle management–type thing, nothing like before, not with my accent and my skin. I was laid off following a merger and then the Great Recession hit. I bought a check cashing place in a rough neighborhood, but I proved to be neither tough enough nor nasty enough for that business. I lost my shirt. I lost all my life savings. It's okay, though. It's okay." He shrugs at my astonished concern. "Really, it's okay. I have my life, my family, my integrity. If today I met those men who murdered me, I'd shake their hands. Why not? It's okay."

Completing his tale, Joseph looks around at our colleagues gathered at day's end in the Great Hall. "So many stories under the blue jacket," he says.

Guarding art is a solitary pursuit, but there are exceptions, for instance while working in the Great Hall. There are three kinds of posts in Section C, as we call it: "tables," "points," and "the box." "Tables" is bag inspection: when visitors come in off the street, they plop their belongings down on tables, and we paw through their bags with partners checking for contraband. Banned items beyond the obvious include food, luggage, original artworks, musical instruments, and bouquets of flowers with potential stowaway insects. The "box," or "check box," is our name for the coat check—actually two coat checks, a north box and a south box, both of which are enormous and not at all boxlike. Each is outfitted with eight motorized metal carousels typically loaded with hundreds of jackets, peacoats, hoodies, furs, and other outerwear. We also accept backpacks, shopping bags, basketballs, and motorcycle helmets—anything you probably shouldn't be carrying through the galleries.

My preferred assignment is "points," or "checkpoints," which is ticket-taking essentially: when visitors pay admission, they're given a

small tin pin of the day's designated color, which we make sure they're wearing as they enter the galleries one of three different ways.

Working points is one of the more sociable jobs not only in the museum but on the planet. Two guards stand feet from each other on either side of an intentionally narrow entry channel, talking the day away. These aren't unbroken conversations—we are also giving directions and admonishing scofflaws—but they are easy conversations, without any of the awkwardness caused by eye contact and with external events (a rude visitor, a funny question) stoking the conversational flames. Amazingly, these eight-hour-long chats are sometimes conducted without either participant knowing the other's name. The guard corps is so large that it is never gauche to stick out one's hand and say, "I've seen you around a thousand times. I'm Patrick, by the way." But some guards have had hundreds of these randomly assigned tête-à-têtes, and they aren't going to feel like any particular niceties have to be followed.

These days, I am motivated to hold up my end of these conversations. I gradually learn how. I follow baseball even more closely than usual, so every day I can say something along the lines of "Santana is looking good, eh?" I talk politics and music and books and shop, and I allow myself to get a little theatrical when bemoaning a work pet peeve, as these are the things that bind us together. None of this exactly distorts my personality, but it does force me to get out of my own head and communicate on other people's wavelengths.

By far my best conversational trick is asking questions, ideally wide-open ones begging for long-winded answers. I'm happy if I can get a person telling me their life story, and I find most people are surprised to be asked about it, and, once prompted, find they have much to say. I am candid about my ignorance, asking questions like "Moldova, huh? Would you believe that I don't know anything about Moldova?" And they can believe it. As a rule, guards are excellent about suffering gaps in each other's knowledge, being well aware they come from a very big world.

Nazanin is my partner on points one day. She comes from Iran, and

at first I try to demonstrate some knowledge of her country by saying I'd love to visit Tehran one day. "Tehran?" she says, making a face. "I guess you could go there. . . ." So I drop the pretense that I know anything, really, and I let her tell me about her city, Shiraz, capital of the Fars province, homeland of the ancient Persians, "the City of Roses," with the most beautiful gardens and mosques. She grew up with eleven siblings whom her father primarily raised while her mother worked as a schoolteacher.

"Was that unusual?" I ask.

"Of course!" she replies. "My mother used to complain that my father was a nonworking 'white-handed man.' He took care of twelve children, making each of us feel like the only one, and still she thought he was lazy! But bless my mother. She was a very respected teacher and I go home to visit her when I can." (Nazanin is a teacher herself, giving Farsi lessons after work. Not long after this conversation, she is promoted to security chief.)

The glory of so-called unskilled jobs is that people with a fantastic range of skills and backgrounds work them. White-collar jobs cluster people of similar educations and interests so that most of your coworkers will have somewhat similar talents and minds. A security job doesn't have this problem. When the Met is looking to hire new guards, it posts a notice (formerly in the *New York Times*, but today online) that is short and to the point, basically "come and interview." The security department looks for able people who will take the work seriously, and it knows there's a vast and varied pool of grown-ups who could fit the bill. The result is a workforce that is not only diverse demographically—almost half of the guard corps is foreign born—but diverse along every axis. No particular type of person sets out in life to become a museum guard, so countless types take on the role, each marching to their own drummer. At the *New Yorker*, my peers had all recently graduated from elite private schools and maybe had worked another job in publishing. At the Met, I know guards who have commanded a frigate in the Bay of Bengal, driven

a taxi, piloted a commercial airliner, framed houses, farmed, taught kindergarten, walked a beat as a cop, reported a beat for a newspaper, and painted facial features on department store mannequins. They are from five continents and five boroughs. They love the art or they're indifferent to it. They're bright-eyed or they're surly. They're career security professionals or they bumbled into the work. And remarkably, it doesn't feel disorienting to stand on points with just about any of them. The ice is already broken. We're wearing the same clothes.

One morning I'm working in the Robert Lehman Collection with a guard called Troy. Robert Lehman, an investment banker, bequeathed the museum an art collection so fine they built a new wing for it. Troy's gift to the museum—and it's a considerable one—is himself. He is a character. Born in Oklahoma, he lives (rent controlled) in an Upper West Side hotel, listens to jazz LPs, and repairs antique furniture. Many mornings, I see Troy at his locker carefully tearing pages from the *Times* (of London) *Literary Supplement*, which he slips in his pockets to read at odd moments in lieu of owning a smartphone.

"Hey, Troy," I say, "how's the morning going?"

Gravely, he checks his watch. "I see that the hour hand has begun its journey around the dial," he deadpans. "It's all we can ask of the universe." I laugh, so then he laughs, and, checking to see that the coast is clear of bosses and early-bird visitors, we keep each other company.

We convene on the subject of how foolish everyone is, present company excepted—not in a serious or mean way, just in the way that one sometimes will . . . Visitors who approach us and just say "bathroom"— not "Hi, where's the bathroom?" or even "Gimme the bathroom," just the one word, as if we're robots taking voice commands . . . curators who write descriptive labels as if everybody secretly wishes they were reading peer reviewed papers in graduate school . . . upper management who

never ask our opinions on anything because what could museum guards who stand in museums all day know about museums . . . wealthy art collectors who spend millions of dollars acquiring what amounts to the pitiful table scraps of the great public collections. . . . Actually, this last bit is a very cheering thought.

"Hey, Troy," I say, "how did you come to have this job?"

"Well, I worked in insurance for twenty years," he tells me, "and one day my boss assigned us a career aptitude test, supposed to show which job in all the world we're best suited for (don't ask me why). Well, I looked at the thing and I thought to myself, You know, the only thing I've ever wanted to be is an independently wealthy patron of the arts. This," he concludes, tugging on his blue suit's lapels, "comes the closest."

Not long ago, I would have been circumspect around Troy, feeling unprepared to meet the great man on a pair of colleagues' curiously level ground. I was operating as a kind of watchful ghost, whereas he was this obvious grown-up, full-blown. His natural warmth and candor were a threat to my self-imposed lonesomeness.

But things change.

A few months after this chat, I am breaking bread with Troy at his retirement dinner. We eat Moroccan food, just a small group of us, and Troy pulls me aside afterward as we're walking past St. Mark's Church-in-the-Bowery on the way to the train. "You know," he tells me, "it really isn't a bad job. Your feet hurt, but nothing else does."

In the spring of 2012, we are celebrating the release of the third issue of *Sw!pe Magazine*, a journal of art, prose, and poetry produced and edited by guards at the Met. The editors organize a group show at a not-for-profit gallery in SoHo, and we drink heavily and merrily at a release party that doubles as a talent show. Colleagues play jazz together, noise out in a Sonic Youth–like ensemble, belt show tunes, perform stand-up, rap under

the stage names Joey Jesus and Mike-rophone. Some are excellent, others less so; the audience is rapturous; the booze flows. Toward the end of the night, I get to talking with a *Sw!pe* contributor named Emilie Lemakis.[5] Emilie has for many years been a working artist—not the kind you'll find in the Met's contemporary wing; that is, not a lotto-hitting artist. Rather, she is the kind of artist who, come what may, works and lives to think and make. Emilie's three-hundred-square-foot Manhattan apartment is less than half the size of her studio space in Red Hook, Brooklyn, where she (illegally) spends some nights. She arrived in the city in 1977 at age twelve and spent her teenage years "in a boarding school for bad kids." Since 1994, she's worked at the Met, where she impresses all who know her with her levelheadedness. "It's a full-time job having a full-time job and keeping a creative life going," she says. "And it's hard to do all that and be pretentious. Don't get me wrong, I don't have anything against pretentious art. I just don't have the time for it."

My favorite piece by Emilie was her entry at the 2011 Employee Art Show. Every few years, the Met invites its staff to contribute to these closed-to-the-public exhibitions, and guards are well represented. Tommy's entry was an elegiac painting about the Liberian Civil War. Andrei copied works of the Dutch masters onto the backs of old frying pans. Chief Finley made large-scale color photographs of glitzy advertisements he captured on the dirty streets of New York. Emilie's submission was hard to miss: a towering, almost ceiling-scraping birthday cake constructed of wood, wire mesh, foam, twine, bottle caps, wine corks, artificial flowers, and the dry-cleaning bags our uniforms are returned in, which she'd woven into long roping braids. The bottom layer of the cake contained a boxy television set playing "Dumb Belle Curls," a video of Emilie in a homemade leotard pumping iron. And a sparkly cake topper high above clued us into the occasion: "50."

"It was a self-portrait," she tells me at the *Sw!pe* party. "The braids"—

5. Her real name.

she always wears long braids—"the dry-cleaning bags, the video, the late slips . . ." (I hadn't noticed this detail, but there were apparently bright yellow infraction notices stapled here and there.) "It's all me."

As she's telling me this, I watch dozens of my totally-not-art-crowd colleagues paging through the magazine, giving congratulations, laughing, listening to a performance, slapping backs, and I feel myself just entirely a proud security guard. I have been harboring a secret self under my uniform? Well, of course I have. Guards are really nothing but secret selves barely hidden under dark blue suits. One conversation at a time, I am finding that out.

I'm surprised by the meaning I begin to find in even small interactions with guards and visitors. A favor asked, an answer given, thanks proffered, welcomeness assured . . . There is a heartening rhythm to it that helps put me back in sync with the world. Grief is among other things a loss of rhythm. You lose someone, it puts a hole in your life, and for a time you huddle down in that hole. In coming to the Met, I saw an opportunity to conflate my hole with a grand cathedral, to linger in a place that seemed untouched by the rhythms of the everyday. But those rhythms have found me, and their invitations are alluring. It turns out I don't wish to stay quiet and lonesome forever. In discovering the cadence with which I meet people, I feel as though I'm discovering the kind of grown-up I'll be. Most of the big challenges I'll face in life are also little challenges I confront in daily interactions. Trying to be patient. Trying to be kind. Trying to enjoy others' peculiarities and make good use of my own. Trying to be generous or at least humane even when the situation is rote.

There is a day in the summer when I'm working inside the check box. Randy is on my right, Yeta is on my left, and the three of us are leaning forward on our elbows, chatting and staring at the lack of customers. A

customer arrives. Randy straightens up and accepts the young woman's Strand bag with his typical New Yawk aplomb. "Say, whatcha got in here, miss?" he voices in a rich baritone. "Hey, the *New York Times*! Good for you, young lady. That's a good papah!" He stashes the bag overhead and, apropos of nothing, breaks out one of his catch phrases: "Hey, another day, another buck."

A second customer. This time Yeta straightens up, though she also continues carrying on a conversation she's having with me about Albanian airfare. Watching her take the man's bike helmet but otherwise ignore him, I'm enough of a Midwesterner to know that, in most parts of the country, this would be rude. I'm also enough of a New Yorker to know that here the ethos is different, and working people are given wider latitude to operate as human beings. When the gentleman thanks her for his claim ticket, she shoots him a kind wink.

Finally, a third customer. I straighten up knowing exactly the style of coatroom attendant I wish to be. In fact, feeling as if I now know the guard that I am. Then it is break time. Randy waves me away, and I step outside to have lunch out on the wide stone steps. It can be ludicrous out here on Fifth Avenue, when the sun shines and the apartment towers gleam and doo-wop singers pass the hat and taxicabs streak by like dandelion smears. I buy a frank with mustard from the hot dog guy (he only charges guards a dollar) and sit amid a crowd of out-of-towners feeling like the one man who truly belongs. Settling onto the steps, I unbutton my jacket, unclip my clip-on tie, and feel downright picturesque, almost as though I can see myself from a bird's-eye view high above. At the heart of a great city, on the steps of a great museum, there sits a little security guard . . . little, but not invisible anymore. . . . My seat is comfortable and my uniform fits.

I retrieve a little notebook from my polyester pocket and scribble a few sentences about ambitions percolating to the top of my mind. Whereas once I had remained mostly passive, observing the Met and its collections as a kind of invisible eye, I feel now that I can adopt a new

posture. I have spent my hours absorbing art, but what if instead I actively wrestle with it, trying to bring all different aspects of myself to bear on the questions it raises? It seems to me that this is a worthy mission for anybody entering an art museum. After we quiet our thinking mind to experience art, we will want to switch it back on, reassert ourselves, and in that way learn even more.

IX.

KOUROS

When on a Sunday morning I am sent to the Greek and Roman wing, I think first about my feet. Coming off a pair of twelve-hour days, I failed to find a seat on the subway this morning, and now I'm being sent to a section without a scrap of carpet to take pity on a poor guard—just cold, sole-slapping marble as far as the eye can see. I am assigned to the main Greek team. My first order of business is unhooking long braided ropes from heavy iron stanchions, which I roll to their resting place behind ancient Greek vases. I wonder how ancient the stanchions themselves must be as I set them down on rust-colored rings they've worn on the floor. Along similar lines, I can make out a faint blue cloud on a nearby portion of the white wall. This is a so-called guard mark, the product of hundreds of footsore workers leaning against it in cheap polyester suits.

I groove my shoulders into the mark and look around. I am posted in a very bright, very high-ceilinged gallery full of art from the Archaic period, a transitional age about a hundred fifty years after Homer and a hundred fifty years before Socrates. Out of tall east-facing windows, I can see sidewalk vendors setting out their wares against the backdrop of an apartment tower Jackie Kennedy's grandfather built. It is a very New

York scene, and it feels fitting that the celebrity in this gallery is a statue that is called the New York kouros—a conventional name distinguishing it from other famous kouroi, but one I choose to love for my own reasons. The name makes it sound as if this slender Athenian youth left the old country, rented an apartment in Astoria (he's Greek after all), and commutes to the Met on the subway like the rest of us. I feel a kinship with the kouros as a fellow transplant, and as one who also stands in the museum day after day.

Pushing off the guard mark, standing up tall, I draw as close as I can to the nude Greek, who is himself standing with one foot in front of the other in the manner of an Egyptian pharaoh. But this young man is not a pharaoh, not a king, and not a god; and he wasn't carved for any magical purpose, as much of the art before him had been. The kouros was a grave marker, carved simply to say "This was a mortal man" before it was placed atop this particular man's remains.

Oddly, I feel a spark of pride, as I believe many people do while viewing the kouros. Something tells us we ourselves are the subject of this uniquely approachable masterpiece. There is something touchingly plain and even awkward about the statue, one of the first freestanding nudes ever attempted. Stylistically, it has an adolescent look, indicating an artist who hadn't perfected his formulas, who was feeling his way through, discovering how to manifest a fresh thought. The kouros seems alive to the audacity of the undertaking (shaping a vital mortal form out of cold hard stone). Its carver achieved a figure that is godlike in its beauty and at the same time callow, naked, vulnerable. As I stand in front of the statue, I find it easy to grasp that two things are true: that the kouros was carved a very long time ago, and also that it was carved not so long ago, by an artist with hands like mine. On the timescale of the marble the kouros was shaped from, ancient Athens is a heartbeat away.

Looking to the kouros's right, my eyes alight on a wonderful neck amphora, or storage jar, that was shaped on a potter's wheel, painted, and fired in the sixth century BC. On the vessel, a craftsman has taken great

care in depicting the Homeric hero Achilles, recently slain, being carried from the field of battle by his comrade at arms. In the *Iliad*, Achilles is all life and vivacity. He is the "great runner," "well-made," with eyes as "wide and bright as blazing fire," whose cries of "fierce joy" and "wild fury" split the air. Here, however, his body hangs pathetically limp, his psyche, or spirit, having departed with his final breath. (Indeed, *psyche* derives from the Greek word for breath.)

Walking over to the beautiful, practical pot, I try to call to mind everything I can remember about Greek death. I recall that there wasn't a priest present at a Greek funeral: the immortal gods could not understand death and didn't care to; they looked away. The family took charge of the body, which in its lifeless state was seen as gentle, pitiable, and strikingly child-like. The Greek word for funeral translates to "a caring for": they washed their loved one, anointed him with oils, tied a strap around his jaw to keep it from sagging. Meanwhile, in Homer's words: "Spirit from body fluttered to undergloom, a well of dark"—a place defined by everything it is not. The Greek underworld is formless, bloodless, "blurred and breathless," to quote Homer once again. Reading about this indefinite world, I suspect the Greeks thought they couldn't know very much about what happens after death. They only knew about life, and what they knew they poured into statues like the kouros.

On my half-hour-long break, I sit at my locker with a paper and pen, furiously trying to wring words out of the kouros, to set down what its meaning might be. It's a difficult task. I write about the statue's sheer verticality, even comparing it to a bowling pin. It seems to celebrate the pluck of a species that goes around on its hind legs. I write about its "shoulders-back arrogance . . . life aware that it's the very best thing," indeed the only thing that strides over the graveyard of the past. I make notes about the statue's nakedness—tender, defenseless, soft to whatever arrow might pierce it; this was a young man who died. Finally I try to jot down something about you, me, all of us, who are still kin of the young man and look about the same under our clothes.

If you were to stand at the center of the Greek sculpture court and look up, you'd see a plaster barrel-vaulted ceiling overhead. In Homer's day, the sky was thought to be a brazen dome every bit as concrete and solid. It rested on columns footed in the sea, which encircled the disk-shaped earth. Beyond the sea, there was a netherworld that saw only the back side of the disk-shaped sun. And beyond the netherworld there was nothing—not even nothing, really. Being a very hands-on people, the early Greeks didn't make room in their philosophy for the concept of infinity or of the void, neither of which is observable in nature. As Greeks' thinking developed over the centuries, they never entirely lost their peculiarly concrete habits of mind. Everything in their world, even their gods, had shape—a quality that supercharges their visual art.

I am standing in a doorway adjacent to the sculpture court when I overhear teenagers discussing a homework assignment. It seems they've been given the following writing prompt: "Did the ancient Greeks really believe in their gods? Explain why you think they did or they didn't, citing two works of art as evidence." It is an admirable assignment, and I decide I'll eavesdrop long enough to learn the students' verdict. A young lady, picking her lip, argues that they must have, obviously, I mean look around, right? It's weird, but . . . and she shrugs. However, the young man she is with doubts it. He thinks it was probably more like the devil: some people think there's an actual devil, like an *actual* guy who's the devil, but most people think it's a story, don't they? And with that, they look around blankly at silent gods and goddesses, apparently at an impasse.

My fear is that they'll eventually compromise on a cop-out answer like "sort of," so gingerly I step in. "Hey, do you guys want help?" For a startled second, they see my uniform and think that they might be in trouble. But my expression is reassuring and they say sure, they'd love help. I give them a word to use in their essay: the Greek word *epiphany*,

which described a visitation from a god. The Greeks were having epiphanies all the time, I say, both in dreams and in the waking world. "Here, look at this. . . ."

I take them over to the head of the so-called Medici Athena, an ancient Roman copy of a now-lost masterpiece by the classical sculptor Phidias (the body of this version is lost, too). Together we look at a face that is placid and impassive but not fixed or frozen—a supple, blood-in-the-cheeks vision of what the goddess of wisdom looked like, her beauty all sturdiness and strength. "Athena was the goddess of a special kind of wisdom," I tell them. "Have you read the *Odyssey*? You have—perfect. In the *Odyssey*, Athena shows up every time Odysseus needs a jolt of confidence and inspiration. You know the feeling. . . . You're stumbling around feeling blah and out of nowhere your mood lightens and you have the energy and courage and clarity required to do something that felt impossible moments before. Today we would think that the change came from inside us, but the Greeks didn't believe that. For them, all forces originated in the external world, forces that were powerful and unpredictable and grabbed hold of people's emotions just like it controlled their fates. Athena was sometimes called the goddess of nearness because of the way she could penetrate and transform minds"—I gesture to the face—"for the better, wouldn't you say? Look at her awhile. Look at what the Greeks thought wisdom looked like. See if she improves your mood."

Perhaps they are patronizing me, but they nod along like I'm making sense and jot sentences in their notebooks as they circle the head. Then, saying "Thank you, sir," they depart to find another god—a second marble epiphany—to encounter. Watching them from a distance, I am heartened. Too many visitors think of the Met as a museum of Art History, where the objective is to learn *about* art rather than *from* it. Too many suppose there are experts who know all the right answers and it isn't a layman's place to dig into objects and extract what meaning they can. The more time I spend in the Met, the more convinced I

am it isn't a museum of art history, not principally. Its interests reach up to the heavens and down into worm-ridden tombs and touch on virtually every aspect of how it feels and what it means to live in the space between. There aren't experts about *that*. I believe we take art seriously when we try to discern what, at close quarters, it reveals. I hope those kids will take their assignment seriously, and I think they've made a good start.

The Islamic wing is getting ready to reopen after an eight-year soup-to-nuts renovation. Anticipation is high. For months, I've been running into Moroccan workmen in white smocks and red fezzes, smoking outside the 81st Street entrance; the courtyard they're building is said to be a marvel. A couple of weeks before the ribbon cutting, I am passing the wing on the way to lunch when I spot Chief Davis emerging from behind a pair of accordion screens. I crane my neck to peek in, he smiles, and with the antenna of his radio he gestures me inside. "You serious?" I say as he's pushing me through.

"Of course," he says. "You work here."

I sign in with a guard who's working on a rare, coveted "sit down post" and check my watch. Forty-three minutes. I have forty-three minutes to forget about lunch and explore a veritable new museum opening up within my old familiar one. Out of the corner of my eye, I catch a glimmer of the Moroccan court; but, no, I am going to do this right. I take a deep breath, still myself, and begin at the beginning.

I am standing in an introductory gallery displaying Qurans from around the world and across the centuries. There is a ninth-century sheet from North Africa on indigo-dyed parchment. There is a complete edition so small it could dangle from an Ottoman soldier's neck, and a page from a seven-foot-tall Quran that belonged to the Turko-Mongol emperor Timur.

Turning, I begin to make my way through a doughnut-shaped sequence of galleries, the hole of which, it occurs to me, is the Roman court a floor below. Seventh-century Damascus . . . eighth-century Baghdad . . . then onward and eastward into Persia and Central Asia . . . The galleries are laden with the kind of practical but beautiful objects I sometimes overlook, from silk and linen textiles to glass- and earthenware. Arriving in twelfth-century Iran, I come face-to-face with a pierced bronze incense burner in the shape of a lion near an eight-hundred-year-old game board with shah kings, vizier queens, elephant bishops, and chariot rooks. Like other rarely used chess sets I've encountered, this one is missing a single pawn.

Mindful of the time, I blow past so many alluring items, a long and interesting future in the wing is foretold. I have to linger over a true rarity: an unobscured depiction of the prophet Muhammad, in a six-hundred-year-old Central Asian painting. (Some Muslims would consider it blasphemous.) And I spend less time than I would wish looking over dazzling Turkman armor. Because I once again have the Moroccan Court in view, and now I can't help but make a beeline.

Were this a real medieval courtyard, open to the sky at the center of a great house or madrasa, I would have knelt at its bubbling fountain to ritually wash my hands and feet. Here the fountain is much reduced in scale, and I'll eventually have to stop visitors from tossing in coins. But the room is stunning. On the near wall, a dense mosaic of hand-cut tiles of many colors and shapes scrambles my brain. I look to the opposite wall; the same mosaic, from a distance, pulls together into a design that is supremely orderly yet refuses to hold still. As soon as my eyes pick out a design component to rest on, I blink and perceive a larger whole of which it is a part. Narrow white channels called straps race through the tiles, crossing and converging into spectacular many-sided stars before racing off again to zig and zag and birth more stars elsewhere.

But the courtyard's greatest wonder is overhead. Supported by

columns on its two open sides, stucco arches are carved so finely as to look like lace, and also so deeply that the designs on their surface are three-dimensional. One area looks to me like crazy varieties of dry pasta strewn across a table. Other areas resemble entangling vines, honeycombs, ruffled icing on a fancy cake, the S-shaped holes on violins, tiny leaves resting on a subway grate, the rose windows of European cathedrals. I don't have nearly enough time to absorb what I'm looking at. My lunch hour is running out. I leave the Islamic wing eager to return and guard it for a full eight- or twelve-hour day.

A couple of weeks later, I walk into the Dispatch Office, and Bob, taking a minute to find my tile, holds it in the air as he addresses me. "Bringley, we've had to switch your home section with the opening of the new wing." He places my tile in a brand-new column. "Head to Section M—Islamic Art."

Thus begins a three-months-long stretch of working every day in a department that is officially titled Art of the Arab Lands, Turkey, Iran, Central Asia, and Later South Asia. Not since probation have I worked so regularly in one section of the museum, and again I feel utterly immersed. Back when I ruminated on old master paintings, I was mainly interested in art's sacred aspect, its stillness and numinous silence. Since that time, I've been mixing it up more with inquisitive visitors and fraternizing guards, the profane attractions of the Met. In the Islamic wing, I find tools that help me think about how these two strata of the museum—and of the world—might relate to each other.

I have been warned that this might happen and then one day it happens: a devout Muslim visitor asks me if we are facing east. He and I are looking at a prayer niche called a mihrab that orients worshippers in the direction of Mecca. I think about it a moment and tell him yes, we are. He asks if he is permitted to pray. I tell him in stillness, yes, of

course, but we are afraid prostrations are a tripping hazard. He thanks me, folds his hands, and stares intently into the niche. I do likewise and think about how it must be to have a single central point, in this case an actual latitude and longitude, to orient one's faith. For the visitor, this work of art is a gateway, on the other side of which lies holiness as he conceives it.

Rules are rules, but certainly this mihrab is a prostration-worthy

piece of tilework. Eleven feet tall, weighing forty-five-hundred pounds, it once graced a madrasa in fourteenth-century Isfahan and appears not to have aged a day. A busy mosaic of mainly blue, white, and turquoise tiles, it appears electrically ethereal, a heavens buzzing with dancing arabesques and Quranic verses written in an energetic script. I pay special attention to a passage above the innermost part of the niche, in which bending, swaying, interlacing lines conspire to make forms that suggest plant life. The lines themselves call to mind creeping vines and curling tendrils, and clearly this part of the mihrab celebrates nature, its rhythms and fecundity, its lushness and density, its perpetual movement and growth.

Then I lower my eyes into the niche itself, a rounded hollow with a pointed arch. Here, natural forms share space with abstract geometry, another cornerstone of Islamic design. Down in the gift shop, they have a highly mathematical book about Islamic design that I've spent a couple of my breaks paging through and puzzling over, wishing I could get an assist from Tom. As far as I can make out, designers always began with the circle, the simplest and most primordial shape, which they would subdivide to tease out implied shapes inscribed within. By choosing to erase certain lines and extend and repeat others outward over an infinite grid, they created innumerable patterns that were all derived from the original circle, which in its oneness was emblematic of God. The final product would contain no visible trace of the circle but stood as a demonstration of the unity that underlies multiplicity, a tenet of the Muslim faith.

By the time I can register all this, the visitor has completed his prayer and moved away. I think about what it must be like to return five times a day to a ritual designed to fix the mind on oneness. Religion contains the root word *ligio*, as in *ligature*. In its basic form, it is "a tying back," a return of one's focus to certain elementary truths as a community perceives them. I belong to no particular religious tradition, but I often feel the need to be tied back, to brush away triv-

ial concerns and commune with something more basic. I stare into the beautiful mihrab not as a pious worshipper but as a worshipper nevertheless.

One of the pleasures of working in the Islamic wing every day is getting to know the regular supervisor of the section, Chief Abdullah. Mr. Abdullah stands about five foot five and carries himself like a prince. Practically every word he speaks is incisive and funny, though he rarely cracks more than a slight smile. Once, I was chatting with him when a visitor interrupted to ask about the source of Abdullah's evident accent. The chief deadpanned: "Washington Heights."

The fuller answer, I find out, is Washington Heights by way of Iraq, with stopovers in several great world cities (Milan, London, Istanbul . . .). Now, of course, he lives in New York, where he moonlights as an adjunct professor of Islamic art history. I am interested to learn that he doesn't actually like New York very much—"all asphalt, all aggression," he tells me, "no warmth, no air, no sense of history; anything that is old and meaningful is torn down." When I object by pointing out that constant rebuilding and reinvention sort of *is* New York's history, Abdullah doesn't disagree. "Quite right," he says. "That is well put. I just don't like it."

This is all to say that when, one morning, Abdullah posts me inside the Ottoman galleries, I have other things than theology on my mind. I am thinking about cities I've never been to, about history I haven't had a chance to study, about the multifaceted richness of a world that has created a Chief Abdullah. The One is not as interesting today as the Many in its startling variety. I have heard Abdullah rhapsodize about Istanbul, and I'd like to learn ten or twenty or a hundred things about the Ottoman Empire.

I lean my elbows against a railing and stare down at the famous "Simonetti" carpet. Illuminated by delicate spotlights, it is magical, like the smoky surface of some varicolored pond. If I was in a certain mood, I would allow myself to get lost in what would feel like a visual universe unto itself. But today I am in a different mood, and what I see is a small, surviving scrap of a vast lost world. I think about the many feet that trod the carpet, which was woven in Cairo around the year 1500. Its earliest owners were Mamluks, whose history would seem custom-made to scramble modern brains. The Mamluks were a ruling class of elite slave soldiers—mainly Turks, Circassians, Georgians, and Abkhazians—who for centuries commanded an empire from their seat in Cairo. Once loyal to Abbasid sultans and emirs, they seized power in the thirteenth century and perpetuated the institution of bondage, even as many slaves ascended to the highest ranks of imperial government. In 1517, when the carpet was just a teenager, the Mamluks were conquered by the ascendant Ottoman Empire but continued to govern Egypt as vassals to the Ottoman sultan until their final defeat in—the modern sound of the date amazes me—1811.

Looking intently at the carpet, I feel as though its tens of thousands of knots and threads are a metaphor for the sheer density of reality, present and past. I am conscious of the world that once spread out from its four corners, unfathomably rich in detail, a stage set for every kind of grand and mundane human drama. I am also aware of the stupendous poverty of the bare historical sketch I have just laid out. I use a little word like *Egypt* to signify a thousand miles along the Nile and thousands of years of history, every moment of which was inexhaustibly complex. Looking down at the carpet, it feels like a fool's errand to quest for abstract answers to transcendent questions. It feels like the more I explore, the more I will see, the more I'll understand how very little I've seen. The world feels like a surfeit of details that refuse to coalesce.

———

Toward the end of my third month in Section M, I arrive on post early enough to take a seat. This always feels strange and wonderful. The designers of the wing have placed wooden stools in front of the Persian miniature paintings, with the effect that visitors linger over these rich and delicate works. I sit with a painting of a dervish of a sixteenth-century Sufi order, an ascetic figure somewhat like a monk. The portrait was executed on paper in what is today Uzbekistan, and its subject crouches low to the ground in an orange cloak and distinctive thimble-shaped cap, his gaze falling down the crooked line of his nose. Prayer beads in his hand are a reminder of a dervish's daily ritualized effort to obtain direct experience of the divine. God is nearer to us than our jugular vein, the Quran counsels; Sufism endeavors to take this to heart.

I love the feeling of *sitting* in front of a work of art! And I take the time to read the picture's label, which contains a translation of its Arabic inscription:

> *Why am I then obliged to heaven that it has given me a soul? For it has created within me a source of sorrows from which that soul suffers.*

I read these sentences two or three times over, not quite believing how pointed is the accusation being leveled at God. The painting is so restrained and magnificent that I am caught off guard by the plaintive tone of the dervish's words. The portrait puts a human face, and as I now can see a melancholic one, to some of these questions I've been thinking about. What, I wonder, was the source of this man's evident heartache?

On the subway to and from work, I begin reading about Sufism. The best book I've found is about a thirteenth-century theologian named Ibn

'Arabi, and I wade in expecting to understand very little about the way he saw the world. But there is something fascinating about Ibn 'Arabi. Time and again, he insists that we understand more than we know—that first-hand knowledge is what we should be after and that we have the right tools to gather it. "Yes, *you*" seems to be the gist of his message, just as it's the gist of Walt Whitman's poetry.

In Ibn 'Arabi's conception, humans have two distinct ways of seeing. First, we have a faculty of awareness at the heart of our hearts, a piece of our consciousness fine-tuned to perceive reality, an unmediated ability to apprehend the world's beauty and sublimity such that the Real (or God) feels near and unconcealed. It is the type of seeing the mihrab inspires in me.

But we also have our logical brains, and they remind us how little we've seen of the world and what small means we have of deciphering its ultimate reality (or manifold realities). Looking at the universe this way, its truth seems distant and hidden, and the Real feels incomprehensible. It is the type of seeing the "Simonetti" carpet inspires in me.

Ibn 'Arabi can find no way to reconcile these modes of vision, proposing a metaphor of the human face with its two separate eyes. We need both modes, he insists, and can switch our focus from one to the other with the pulses of our hearts. Reading this passage, I lift my head. I am on a Manhattan-bound train that is emerging from the Brooklyn underground and rattling its way across the bridge. My fellow passengers, commuting to work on a Sunday morning, look at the world sliding across our windows with all sorts of different eyes—vacant, dreamy, shrewd, sleepy, shut. About forty minutes later, I get into work and ask Chief Abdullah to post me near the dervish. Again I look at a man who is feeling so heartsick that he questions why he's been given a heart. It would of course be easier to be a spiritual automaton, reciting prayers without having to see or think or feel for oneself. But the dervish hasn't chosen this path.

The dervish, I think, has pushed his perceptive equipment to the

limit, where pain and exhaustion sometimes lie. Somehow I feel confident he will recover his energies and begin the push again. Using one of my eyes, I feel an intimacy with this sixteenth-century follower of an esoteric religious sect. And then my heart beats, and he feels distant and strange. And then my heart beats again and, like the painting before me, he's near.

X.

THE VETERAN

On Manhattan's Upper East Side, a wasteland for good cheap food and cold unfussy drinks, there is somehow an unpretentious pub called Carlowe East. The usual Irish flag hangs outside it, with the usual knot of convivial smokers huddled underneath. Inside, it is the same dark, not-great-smelling watering hole you have probably visited countless times if you have any sort of a thirst. Sunday night is our main drinking night. As the museum is closed Mondays, most of us won't have to work, and the rest of us won't have to work very hard. "But you've heard the rumor?" Ms. Lester asks the group, sipping from a discounted happy hour beer. "Pretty soon we're going to be open seven days a week. What a shame! I suppose they'll make us rope off galleries when the technicians have to move things around. I loved my Monday OT days—watching the riggers hoist the statues makes me so nervous!"

"Did you ever bring a date around on a Monday?" Ronnie breaks in. "They love it. Everybody loves being brought inside a locked-up door. Almost makes up for dating a security guard."

It is 6 p.m., and at this hour it isn't only the usual suspects who have gathered for a drink—young guards, childless guards, guards with a bit

of a problem—it is also family men and women who stopped by to have "just one," a phrase generally understood to mean "two."

This group includes Terrence and Joseph, whom I begged to come out tonight. Arriving a touch late (slow dressers), they belly up to the bar and allow me to buy a round of Miller High Lifes, indicating that after they buy their rounds, we'll be having three. Sports highlights are on the television, and we reminisce about the Brooklyn Nets game we attended together. Up in the cheap seats, Joseph's vertigo was so bad you'd have thought we were doing loop de loops on a roller coaster. Begging our way into a lower section, he appealed to the class consciousness of a sympathetic usher: "The three of us, we are security guards, we are just like you!"

Baseball is up on the screen, and Terrence is reminded of breaking news from the world of another batted ball game: cricket. The West Indian team, which he calls the Windies, has had a "nine wicket morning" or something of that nature. But Joseph steers the conversation back to a point he has raised many times and simply can't let go. "Why are they called the *Brooklyn* Nets and not the New York Nets?" he asks with pained disappointment. "You, Patrick, are from Chicago and Brooklyn. You, Terrence, are from Guyana and Queens. I, Joseph, am from Togo and the Bronx. If the Nets win a championship, they should parade down Broadway (the Canyon of Heroes!) not Flatbush Avenue! We are one New York!"

Finishing our first High Lifes, we swing around on our stools and join a wider circle of conversation. It includes Ronnie and Ms. Lester, both regulars; a couple of chiefs whom it's nice to see out of their suits; and three friends I walked the ten minutes to the bar with: Lucy from Hawaii, Blake from Westchester, Simon from Connecticut.

Blake regales us with a work story. "Get this," he says. "I'm in a French gallery up in Section B, the one with *The Abduction of the Sabine Women*, when I see a kid poke a painting with the eraser end of a pencil. Jesus Christ, I think. I make the kid stand there as I look the painting over, and

I think—I *think*—there might be a little pockmark in the area of the poke. So I call it in. The tech arrives. And, this is the crazy part, the tech runs his fingers all over the area, hard, like he's rubbing in sunscreen. Then he turns to me and says, 'Nah, whatever that is, it's under a few layers of varnish. It's old.' "

Lucy jumps in with the next story, about a visitor asking the locations of galleries 813, 432, 731, 622. . . . Her voice trails off comically and we all groan. The museum has recently issued a redesigned map, one with a bonanza of gallery numbers that few veteran guards care to learn. "Just tell me what you're looking for" is a common refrain. "Mummies, water lilies, Mary Cassatt? Say the name and I got you." Over our drinks, we talk about a slow creep of changes at the museum that feel corporate and impersonal to some of us, rolled out after long-time director Philippe de Montebello hung up his hat. "Say what you will about Philly Cheesesteak," Simon puts in, riffing on the name "Philippe," "but he never made us learn how to count." It's a funny quip, but we're all too busy laughing about "Philly Cheesesteak" as a nickname for the aristocratic de Montebello.

"Pretty good," Terrence says. "Like when you call a fat guy 'Tiny.' "

Often, shoptalk turns into a teacher's lounge–style exercise in venting a touch dramatically about those little monsters—in our case, the museum-going public. To this end, I have quite a good story to tell. "So I'm on team three in Wrightsman," I tell the group, which they know means the French period rooms. "It's closing time and there's a guy in my gallery—a rich guy, but like a hip rich guy: shoulder-length hair, an expensive suit that seems too small for him, and a little son who's just as dressed up as he is. 'Excuse me, five fifteen. The galleries are now closed,' I tell him. And without looking back at me he raises a hand in the air like a baseball player signaling time.

" 'Five minutes,' he says, just like that: a period, not a question mark.

" 'Well,' I say, 'I'm afraid that's not how this works, but I'll give you one minute,' and I clear my other two galleries, where everybody's per-

fectly happy to let me do my job. When I circle back around to Mr. Five Minutes, he gets a cute little smirk on his face. He's amused. He's finding it incredibly funny that *I* am trying to order around *him*, whoever the hell he is. 'Sir,' I say, 'come on now ...' appealing to his humanity. But he doesn't budge. And naturally, other guards start poking their head in to see what's up, and pretty soon he has sixteen of us, the whole section, tapping our feet in his direction and staring at our watches. Finally, Mr. Franklin bursts in bellowing 'CLOSED! CLOSED! CLOSED! CLOSED! CLOSED! CLOSED! CLOSED!' You know that style Mr. Franklin has, where he can get away with being really aggressive because he also sounds bored. There's no standing up to that. So at last my man is beaten, but as he turns to go, he has to have the last word. He turns to his son and says, 'Small people, small power.... It's life.'"

I don't get the laugh that I expect. The line lands heavy, occasioning grave head shakes and a "Fuck me ..." as the group contemplates this level of moral rot. We've all had moments when we've been treated like gum on the bottom of somebody's shoe. You can't work as a security guard without the occasional asshole reminding you, in so many words, that you're *just* a security guard. At our best, we don't recognize this as an insult. At our worst, we do sometimes feel as small and powerless as the bullies intend. But on these days, at least we can make them villains in the stories we tell at the bar.

Around seven o'clock the crowd begins to thin. Terrence, Joseph, and their ilk head home to their families, and it's up to the rest of us to keep the night alive. Lucy waves me over to an out-of-the-way table by the jukebox, and I join my friends in this little pocket of intimacy in the loud dank bar. For a long time I resisted, but I've found my group of like-minded young people who make me feel not alone. We are in our late twenties and early thirties, an age when you stop showing off to your friends and begin to lean on them for support. It's a tricky age. The apprentice stage of adulthood is ending, honest-to-God adulthood looms, and you have to figure out what to do with your life, again, and maybe

this time for real. Of the four of us, I'm the only oddball who became a museum guard on purpose. Simon wanted to be a teacher. Blake majored in geology. Lucy holds an MFA in poetry. And there is not a lot of certainty at our table concerning what exactly we're up to in life, even as it's becoming increasingly clear that this is it, this is life.

As the evening wears on and the drinks take hold, we grow less silly, more earnest, less guarded, more vulnerable; and, who knows how it looks from the outside but from the inside we are conversing beautifully. Over the course of this and future Sundays, we will talk about deaths of parents, about health struggles and mental health struggles. We will toast Lucy's poem being published in a lit mag. We will pregame before Blake's open-mic night gigs. Simon and Lucy will fall in love at a table like this one, and they'll remain loving even as they return to being friends. And then one day Simon will break the news that he's met a girl and is moving in with her in Utah, where eventually he will find a job as a mailman and live in the mountains with a couple of dogs. Real shit. Real shit is being talked about in the privacy of an overloud bar.

At the end of my third month in the Islamic wing, we have the section up on its feet, and I'm given the chance to transfer to a new home section. All the Section M regulars are faced with the same choice, and we spend some time kicking around our options. Section R, perhaps? (By security department logic, R encompasses modern, African, Oceanic, and ancient American art and seasonally is responsible for the rooftop sculpture garden.) Oh, but it's miles away from the locker room, someone points out. . . . True, but a lot of it's carpeted, another counters. . . . Yes, but you get all the dudes insisting their little nephew could paint a Kandinsky. . . . Sure, but so what, that's funny. . . .

Okay, well how about Section F (Asian Art)? Everyone agrees it is uncommonly quiet. As veteran guards, we understand the power of

lighting and know that F's use of darkness and spotlights causes people to whisper as though afraid to wake the statues. Where we disagree is on the desirability of so much silence. Some would prefer to be mixing it up with schoolkids every hour of the day (in which case, they should head to Egypt). There is also a sharp divide over the chief who regularly presides over the section, his agreeableness, his fairness.

It used to be I consciously avoided developing these kinds of preferences. Opining about this team or that section or this chief or that break schedule would have broken the spell I was under; I simply showed up wherever Bob sent me and drifted into a silent day. But the spell did break eventually. The time came when I didn't wish to act like the doe-eyed rookie anymore and began to delight in feeling a little wiser and more discriminating. I like to engage in the occasional shoptalk. Occasionally I bitch and moan. And slowly but surely I've developed some habits of mind that would have surprised my less veteran self, and perhaps disappointed him.

When ultimately I decide on Section G as my home section (encompassing the American Wing, Musical Instruments, and Arms and Armor), it isn't for the noblest reasons. Bathrooms are plentiful. It's right above the locker room. Chief Singh, the section's usual supervisor these days, lets us pick our own teams. Besides all that, I am not right now in the mood to go exploring unfamiliar territory and questions. I would like fellowship (Joseph and Terrence are both in the section) and, as an American, I wouldn't mind a little taste of the informality I expect to find in the American Wing.

The wing's most famous picture is the rather formal *Washington Crossing the Delaware*, except that no one takes it altogether seriously. It delights; it doesn't overawe. People walk straight up to it and say things like "Man! You couldn't fit that thing under a highway underpass!" as though it were a roadside attraction you're meant only to get a load of. When I'm stationed in front of it, which is often, I like looking way down the approaching hall to see people catch their first sight of George. To see

them ignore the wonderful John Singleton Copley portraits and walk-run in my direction, getting their cameras and phones out. I like watching Dad crack everyone up by holding in his beer gut and striking the Washington pose. I like assuring people that, yes, the painting is real, and, no, the little placard does *not* say it's a reproduction. (It says the *frame* is a reproduction, but the curators should know better than to put that word anywhere near a famous painting.) I like debating with people whether rowboats could really carry horses into battle, and I like hearing from know-it-alls that the version of the American flag the artist painted in fact didn't exist at the time of the crossing. I like helping people pronounce the name of that artist, Emanuel Leutze, the ultimate one-hit wonder of American art. And I don't particularly mind that I'm developing less than reverent attitudes and idiosyncratic areas of interest. The American Wing feels like the right place for them.

Just below the main painting galleries, there is a mezzanine that is one of the strangest, most eclectic places in the whole museum. The "visible storage" area houses tens of thousands of objects that haven't found a place in the galleries proper. Without much signage, visitors navigate long narrow channels flanked by tall glass cases presenting a jumble of Americana from the past four hundred years. If you like tables, here are dining tables, tea tables, worktables, card tables, drop-leaf tables, tilt-top tables, console tables, trestle tables, and chamber tables. If you favor clocks, it offers tall clocks, shelf clocks, wall clocks, acorn clocks, lighthouse clocks, banjo clocks, and lyre clocks. The mezzanine is the one area of the Met where visitors declare objects to be "just like the one Aunt Barb has." It's a place to take a break from hallowed masterpieces and enjoy the company of looking glasses, sugar nippers, and firemen's leather helmets and shields.

The mezzanine does have "fine art," but it's treated with an appealing lack of pomp. Statues are shoved awkwardly close, like boys and girls at a middle school dance. Hundreds of paintings abut one another both side to side and top to bottom, creating crazy mosaics in the long

glass cases they occupy. Walking between these cases, I am conscious of being looked at by dozens of pairs of painted eyes, eyes belonging to Job Perit and Mrs. Thomas Brewster Coolidge and Mr. Henry La Tourette de Groot and even some early Americans who didn't have striking names. Typically, the sitters for these portraits have tried to look as sophisticated as they could and have been painted in a style franker and plainer than they probably would have liked. Early American painters envied high European culture but—and this is their charm—couldn't emulate its refinements.

It is natural in a place as attic-like as this to grow curious about the process of collecting. One day, I come across some of the first paintings the museum acquired. I am clued in by their accession numbers, serial code-like numbers found at the bottom of objects' labels. Usually they are something long like 2008.11.413, but I find one reading 74.3, telling me it entered the collection in 1874, six years before the Met even had a permanent home. The paintings are lovely, understated landscapes by John Frederick Kensett, one of the museum's founders. He grew up at a time when landscape artist wasn't a profession on these shores, so he'd trained as an engraver and found work engraving plates from which banknotes were pressed. Over the course of his lifetime, New York grew by bounds, he found company in the artists of the Hudson River School, and he joined an effort to create the first grand American art museum.

Only it wasn't so grand at first. A museum like the Louvre was a royal collection. The Met's collection would have to be assembled by private citizens—by the merchants, financiers, reformers, and artists who comprised its first board of trustees. For years the Met struggled to have much of worth to exhibit and depended on sudden windfalls— gifts and bequests—that were owed more to accident than planning. The Kensett landscapes, I find out, were a gift from his brother after the artist drowned trying to save a woman in Long Island Sound. Together they are called "The Last Summer's Work."

I get into the habit of reading to the bottom of labels and discover

that I'm finding the same two words all over the place: Rogers Fund. The Met acquires art through gifts, bequests, and purchases, and no one, apparently, is more responsible for the Met's purchasing power than Jacob S. Rogers. A locomotive manufacturer, Rogers was born in 1824, in Thomas Jefferson's lifetime, and died a month before Louis Armstrong was born—such is the brevity of United States history. In the American Wing alone, his name is attached to more than fifteen hundred objects according to a search I perform on the mezzanine's computer portal. An eighteenth-century jack for repairing covered wagons? Rogers Fund. A silver tray made by Tiffany & Co. in 1879? Rogers Fund. Yet he was almost entirely unknown to the Met in his lifetime, having no special interest in art; and no one knew what was coming when, without a funeral (per his wishes), his will was read. For reasons known only to him, the ill-tempered codger froze out his only family (a few nephews and nieces received a pittance) and left his $5 million fortune to the Met—then, an astonishing sum. At a stroke, the Met's endowment became serious business. Rogers's money throws off interest to this day. And it's all thanks to spitefulness or whim, and of course to steel chariots puffing smoke across the continent.

The collecting impulse grips individuals as well as museums. J. P. Morgan, the Met's fourth president, burned through most of his cash amassing rare manuscripts and artworks, some seven thousand of which are now in the Met. "And to think," John D. Rockefeller quipped at his will reading, "he wasn't even a rich man!" More rarely, the museum is gifted a collection by someone who actually wasn't filthy rich. My favorite example of this phenomenon is here on the mezzanine.

One weekday afternoon, I am posted by the Jefferson R. Burdick Collection. Chief Singh is keeping me company. The soft-spoken supervisor is in his mid-seventies and seems unlikely to ever retire. After forty years at the Met, he is totally comfortable with silence. For several minutes now, we've been standing with our arms crossed, not saying anything at all.

"Do you like baseball, Mr. Singh?" I venture at last. We are surrounded by scores of ballplayers' likenesses on colorful cardboard rect-

angles, arranged in grid patterns and framed. There are baseball cards of Willie Mays, Henry Aaron, Honus Wagner, all the way back to King Kelly—"$10,000 Kelly," they called him, for the outrageous sum paid by the Boston Beaneaters in 1886.

At my question, Mr. Singh's face brightens with pure delight. "No!" he says resolutely. "But I like cricket."

"Look here. . . ." The Guyanese native walks me over to the nineteenth-century baseball cards—color lithographs printed in several stages, expertly, beautifully, then shoved into cigarette and loose tobacco packets. He points at an image of center fielder "Jack M'Geachy," who is cupping his hands together as though catching raindrops. "No glove!" Mr. Singh says. "In cricket that's how we still do it. Are you with me? Do you follow? We pluck the ball from the air with just these." He shows me lively wrinkled hands. Terrence has taught me a few things about cricket, but I would be foolish to slow Mr. Singh down. I play up my ignorance and pretty soon he's miming batting stances and bowling techniques.

"You know who else didn't like baseball, Mr. Singh?" I ask, when it's my inning. "Jefferson Burdick! The Met has the best baseball card collection outside of Cooperstown, thirty thousand cards, and it's thanks to an electrician from Syracuse who never went to games. Burdick wasn't interested in baseball; he was interested in *cards.* Postcards, advertising inserts, menus, valentines . . . Everything ephemeral, he collected, never paying more than a dollar for some of these cards worth thousands today (or in the case of our Honus Wagner, millions). He had more than a quarter of a million items when, in 1947, he came knocking on the door of the Met. He spent the last years of his life in the Drawings and Prints department trying to catalogue it all."

"This Burdick sounds like a real character," Mr. Singh says, still animated by memories of cricketers. "He would have made a first-rate guard. . . ."

Lately, Mr. Singh has been posting me in the Musical Instruments galleries, a collection that catches many visitors by surprise and actually saddens a few of them. I am working by a guitar that classical virtuoso Andrés Segovia called the "greatest guitar of our epoch," when a visitor turns to me aghast. "Have you read this?" he says, and he looks at the instrument like it is King Kong in chains. "Why lock it up in a case? I mean, what the hell?" He tells me he's a retired high school band teacher who "gigs around a little bit" playing jazz trombone. Recalling the prodigious talents of my own high school band teacher, I ask him how many of these instruments (I gesture around the wing) he thinks he could play. "Badly? Probably all of them," he says. "If you gave me enough time to mess around . . ."

As he's walking away I imagine myself in a less cautious museum, one that would hire some fantastically musical person (the world abounds in them) to open the vitrines at will and mess around with the instruments. In full view of the public, day after day she could teach herself the Persian kamanche, the Japanese koto, the Sioux courting flute, the Italian harpsichord. You cannot imagine how popular this would be. Visitors adore seeing art objects handled in the rare instances they're allowed, and it would be so heartening watching an eager, patient person bring these instruments to life. I can already hear curators, conservators, and insurance adjustors object, with a long list of reasons it could never, ever happen. But I don't know, man. Would you rather have a 100 percent chance nothing happens to your Stradivarius, or would you rather have music coming from your Stradivarius? You can't have both.

All the same, there is plenty to love about the wing. As luck would have it, it fills in some of the gaps in the collection of its American Wing neighbor. One of my favorite instruments is an Iroquois snapping turtle rattle made near Niagara Falls. It is wonderful to look at, with a bony skull at the knob and a shell the size of a catcher's mitt. But what counted about the rattle was not so much its own properties but rather its union with the dancer who kept time with it—or slowed or sped up or warped

time with it—as part of a sacred ceremony. It appears to me both play-ful and deadly serious. It is a hollow filled with cherry pits, no different really than a child's rattle, but then again a guitar is just a wooden box with vibrating strings. At the same time, it might as well bear the famous Latin legend *memento mori*, remember death, seeing as I can picture its maker cutting away and scooping out the turtle's soft flesh. Oddly, these aspects of the instruments feel related. Your death will come soon; rattle with abandon.

With America so much on my mind these days, I'm drawn to the story of a quintessentially American instrument, the banjo. Remarkably, the Met owns a homemade example known to have been crafted by a Black musi-cian in Georgia as early as 1850, though the luthier's name has been lost to time. Surpassingly simple, it is entirely lovely: a taut circle of goatskin around a steam-bent wooden rim, a fretless whittled walnut neck, and a head with wooden tuning pegs. I'm guessing it was holy hell to keep in tune, but someone took immaculate care of the instrument—perhaps its maker, who played it himself and needed the outlet it gave him as badly as he needed anything in his trying life. It looks that well loved.

I have half a mind to stop visitors in their tracks and invite them to take a picture with it as they would with *Washington Crossing the Dela-ware*. It seems like the perfect emblem of American music making, which is probably the richest and most accomplished American art form. The earliest banjos were made in the West Indies out of gourds, and I don't have to walk very far to see the instruments that inspired them: African lutes, harps, lyres, and zithers; European lutes and guitars.

Thanks to a busker on the 86th Street subway platform, I can hear a Senegalese kora in my mind as I survey that instrument's extraordinary form. Featuring twenty-one strings, its body of calabash and goatskin looks as big as a fat man's belly and soft as a pillow. I look at the diminu-tive banjo again, a descendant of the African tradition and a progenitor of an American tradition that in a small way I'm a part of. While growing up, I had the job of holding the flashlight as my uncle David played blues

and bluegrass and workers' songs and cowboys' songs around the camp-fire. My uncle David is sick now, and as his apprentice of sorts, I will be the one at future family gatherings playing guitar by firelight.

Arms and Armor, the last piece of Section G, has in common with musical instruments that its objects were meant to be *used*, not just looked at, though perhaps in this case their impotence is for the best. When I'm posted among the knights in shining armor, as the kids say, I find myself occasionally horrified by what these hollow men, mounted on dummy horses, represent. Certainly, the workmanship on some of the etched, embossed, blued, and silvered steel suits is astounding. And I'm happy answering questions about the rules of jousts and exactly how much this or that weighs. But I can't help reading personalities into suits of armor I know increasingly well, and many are nightmarish. The typical tournament helm gives the appearance of an ogreish creature with an enormous, jutting lower jaw and squinty slit-like eyes. Imagining its wearer in motion, I see a stupid, lead-footed killing machine, his erstwhile kouros-esque body made as tanklike as possible. The most brutish face belongs to the helm of a Sir Giles, who engaged in foot combat (the organized clubbing of opponents) at the famous Field of the Cloth of Gold of 1520. Bereft of ornamentation, it is entirely without identifiable humanoid features, a grid of tiny punctures the only thing allowing Sir Giles to (I assume barely) see and breathe. The most terrifying aspect of it, though, is its cold hard honesty. It is nothing but a huge hollow heavy metal orb to protect your skull as you bash someone else's head in.

And then at some point all these steel suits went away. When in 1944 my grandfather landed on the beaches of Normandy, he was wearing cotton. Not because men had grown less violent, but because arms had so far outstripped armor, centuries of defensive innovations became use-

less. In a way it's even more horrifying. To understand how the change came about, I take a stroll to the far back of the wing to look at the guns. In the latter part of the seventeenth century, firearms became powerful enough that there was no longer any sense in dressing up like the Tin Man; bullets could make you a colander. But all the way into the nineteenth century, the procedure to fire a gun was not much different than it had been in the weapon's primitive stages. Prior to every shot, you had to measure your gunpowder, pour it down the barrel, drop a ball down after it, tamp that down with a ramrod, add primer to the flashpan, adjust the flint before firing, then do it all over again. It was a method unsuited to more modern forms of violence; and to track that innovation, I find myself again in America.

Among the few American items in the Arms and Armor collections are sixteen Colt revolvers in a single case, and it would be hard to contain more of the country's violent history in so small a space. I look at the earliest gun, a dainty little weapon from 1838, and at its literally revolutionary feature: a spinning cylinder allowing multiple bullets to be fired in rapid succession. The barrel of this patented pistol is aimed at the Colt Model 1851 Navy Revolver, engraved with a battle scene between the Republic of Texas and Mexico. The Yankee Samuel Colt chose the image to flatter the sensibilities of his most important early client: the Texas Rangers. His revolver, it turned out, was exactly the weapon needed to wage war against the Comanche and expel them from their lands. Not only in Texas but across the continent, the weapons in this case became the quintessential tool of American empire building, displacing native tribes whose warriors could fire arrows at a rate of one every two or three seconds, far faster than firearms—until the revolver. And Samuel Colt's influence didn't end on the battlefield. To manufacture his pistols—more than 400 thousand of which were sold by the end of the Civil War—Colt pursued the novel goal of producing perfectly interchangeable machine-made parts, a leap forward in the development of assembly-line-style manufacturing that came to be known as the American system. In 1855,

he opened a 230-thousand-square-foot facility with machines for pounding, milling, boring, filing, and shaping metal into identically manufactured items. It was one of the most conspicuous signs that the world would never again be what it was.

I have a close look at a .45 caliber revolver ordered up in 1874 but still manufactured today: the iconic single-action army model sold to civilians, perversely, as the "Peacemaker." ("God created men; Sam Colt made them equal," was a saying out west.) Staring down the barrel, I can't decide if it's art, but if it is, it is modern art.

Having been on the job almost five years now, I have my settled habits. I have my established friends. I know the galleries I like to work and those I don't much like to work. And when I overhear familiar conversations— "Why do you think Impressionist paintings always look so blurry?"—I know when and how to offer my two cents (though more often these days I'll let things lie). In other words, I'm a veteran, and I'm comfortable. I'm grooved into a rhythm that suits me and that doesn't require much effort to sustain. On most days, the singular job I'm performing feels just . . . normal, like any old job. And on some days this state of things fills me with longing and regret.

There's a morning when, for the umpteenth time, I take a post in the American paintings galleries. The pictures on the walls happen to look lifeless and dull—not an indictment of the paintings, just an acknowledgment that there's time enough in a veteran's week for art to look all sorts of ways, even hardly worth looking at. The church-mouse quiet atmosphere that once pervaded my mornings is more elusive than it once was. The thoughts in my head are a bit nosier now, replacing the erstwhile silent poetry with intermittently interesting prose. At the moment, I am trying to remember which team I've just been assigned to—team one? or was that yesterday?—and also running through a short

list of mental errands I plan to run (think of a Father's Day gift for my dad, that sort of thing). I take up a post beside John Singer Sargent's *Madame X*, a famously glamorous portrait, though I'm not at the moment mindful of the schlubby figure I cut by contrast and the comedy of our pairing. It's just normal. As time passes and the public comes parading in, various unconnected thoughts run through my mind. I wonder how many Jehovah's Witnesses groups are on the schedule today. (Some days, the organization will lead upward of two hundred of the faithful through the Met on biblically minded walking tours.) I think about the time that a man and a women approached me for directions to *Madame X*, I turned to look at them, and it was rock star Michael Stipe with actor Kim Cattrall. I think a few uncharitable thoughts about Mr. Avery, a teammate today, who is infamous for returning late from his breaks. And about what I'll do for lunch now that the panini place on Madison closed. And about a funny crack I overheard in the locker room the other day : "I told her 'We aren't security guards, ma'am . . . we're security artists.' "

When I'm pushed a little bit late, as expected, I lose my sense of humor and stew. In a job where not much goes wrong, the smallest insult can stick in one's craw. I walk the twenty-odd feet to my next post: the windswept coast of Maine, with Winslow Homer's mighty scenes of waves crashing against the breakers. The pictures are so forceful, they succeed in coloring my mood a little, but only a little—I don't smell or care to smell the salt air. Then before I know it I've mechanically moved on to my A post in the rotation, where I find myself in the company of the American Impressionist Mary Cassatt.

Cassatt was clearly a wonderful painter, but I've always found her hard to place, and for that reason she hasn't figured into my recent rambles through American art. Born in Pittsburgh, she was educated abroad and painted all her most important pictures in France, exhibiting with the likes of Monet and Degas. Not quite French but not quite American, not an insider (owing not least to her gender) but respectably bourgeois,

not as "blurry" as your typical Impressionist but more spontaneous than the old masters, she has a neither fish nor fowl quality. If I haven't thought about her in a while it's because I haven't found anything very definite to think.

Today however, there is something, or rather someone, to rouse me. At the far end of the gallery, a woman stands at an easel, paintbrush in one hand, palette in the other, drop cloth spread out below her feet, brow knitted in concentration as she dabs at a canvas that, per security department regulations, is at least 25 percent smaller than the original painting she's attempting to copy. If she is an art student, as copyists tend to be, she is not a young one, and she has a serious, concentrated look that dissuades me from making conversation with her. It is evidently far from her first session with the picture; she appears to be just about finished—though whether that means one hour or five hours more, I couldn't guess. Like most people who look at paintings, I have a shaky feel for how they are made, and all the reading I've done has been slightly helpful at best. So, like everybody, I'm always fascinated watching copyists at work, and I join a few visitors who are standing at a respectful distance and watching the movements of her slow, silent brush.

Sizing up her work, I decide it is lovely—a pleasant depiction of a mother in a marigold dress caring for a nude little boy. Clearly, she's taken her time with it, and it's come together more or less convincingly; it looks like fine art. After a few moments, I raise my eyes to take in Cassatt's version and, well, put it this way: there's no danger of anyone pulling the switcheroo that the 25 percent rule is designed to guard against. Cassatt's picture isn't lovely, it is bathed-in-sunlight beautiful—bold and easy and colorful and right, more robust somehow than "fine art." It isn't fair to the poor copyist, who works carefully and doggedly, while Cassatt soared on the wings of her hard-won mastery. This was her style; this was her subject; and she made a thousand choices with quick, inspired intelligence that can't be replicated, only woodenly mimicked. To sum up, I

can neither believe nor stand how good her picture is, and for the first time in a long time, I simply adore.

These moments don't come around as often as they once did, and I am saddened to recognize that. The great painting stirs up dormant feelings of awe, love, and pain, distinct from my curiosity about the bric-a-brac on the mezzanine. Strangely, I think I am grieving for the end of my acute grief. The loss that made a hole at the center of my life is less on my mind than sundry concerns that have filled the hole in. And I suppose that is right and natural, but it's hard to accept.

XI.

UNFINISHED

Five years to the day after Tara and I were married, five years almost to the day after my big brother died, I am again sitting at a bedside, this time on the maternity floor. Just as before, the atmosphere in the hospital room is simple and still. Nurses duck in to check on Tara but without any particular air of worry or expectancy. We of course are expectant, but it turns out it isn't like the movies, and there are long, quiet hours just to sit and wonder, as before, at a momentous, mysterious, and ordinary thing that is happening in a little room. Our doctor shows up right on time and he is none other than Dr. Singh, the son of Mr. Singh, the regular chief of Section G. (I heard his father boast of him so many times, we looked him up, and we are happy we did.) And then the promised onrush arrives, and the bearing down, and the culminating moments this time are the opposite of their counterparts from five years ago. Instead of a silence, a wail. Instead of grace, commotion. Instead of a final memory to hold fast to, a great mess of work to be done.

Sometimes, when I am up in the night with my son, Oliver Thomas, my thoughts return ruefully to Virgin and Child pictures. How composed the Child always looks! How serene the holy parent! By contrast, the animal squirming in my arms is lusty, rude, ridiculous. I watch him slurp

greedily at a bottle of milk, chin soaked, limbs jerking, bowels active, shit-ting and at the exact same moment passing out in a milk-drunken bliss. I try to clean him off as gingerly as I can, but of course the cold insults him and he explodes with disproportionate fury. Unfair! Several long minutes later, I hold my again-sleeping son while holding a strained, baroque pose I am afraid to vary for several long minutes more. Crazed with exhaustion, I stand there, feeling a heartbeat through the fusing plates of his cranium.

Before Oliver arrived, I would have guessed that a newborn baby would feel like a delicate thing to hold in my arms, that I'd be afraid of breaking him. What I find instead is that this little sack of life, this heap of billions of cells, feels thick and powerful and robust. It makes me think of the way that Tom used to rhapsodize about the marvelous mess of cell biology and by extension of life in general. Nature tends to prize hardi-hood over simplicity, which makes for beautiful creations but not neces-sarily artful or straightforward ones. From what I can tell, the same will hold true of my own life, which is now done being simple. But with this addition, it is perhaps on its way to growing more beautiful and robust.

For three months of mostly unpaid leave, my workplace becomes a third-floor walkup apartment smaller than a single post in the Metro-politan Museum of Art. I've traded serene, pristine galleries for junky rooms full of half-finished projects that bear my fingerprints. Somehow I have more to do in these seven-hundred square feet than I ever did in the Met's two and a half million. And to be honest, I have a brutal time adjusting. I had been living a life largely free of trivialities, where the essential thing was just looking around in an unburdensome world. Imagine my shock when I discover the most essential part of parenting is handling heaps of trivialities. Mounds of laundry. Constant doctor visits. The never-ending packing and unpacking of diaper bags. The result is that most of the time I feel the way that a farmer must feel: too exhausted by his chores to adore their results.

Occasionally, though . . .

One afternoon, I decide to chance it. I grab only a half-packed diaper

bag, put the little man monkey-like on my hip, and stride out bravely into the great wide world. Brooklyn's Sunset Park is our destination, sitting on a slope between Fifth Avenue's taquerias and a thriving Chinatown at the top of the hill. Climbing that hill, we pass picnickers, kite flyers, and soccer players, and then we summit, where maybe six dozen speakers of Mandarin and Min dialects are performing light aerobics and a musician is making beautiful music on a single ehru string. Ollie's head is on a swivel—"Owl-ie," we sometimes call him, because he can just about turn it all the way around.

I take him to the playground so he can gawk at the neighborhood kids. They race around with reckless agility, and he's as delighted as it's possible for a human to be. I love him. I drop him down a slide, nearly scaring the soul right out of him, but all my gambles are paying off today and he lets out just one fleeting cry. I lay him down in a patch of very patchy grass in this lovely, scruffy, well-used park. It is crowded. The sounds of surrounding traffic can be heard. But for all that, nature's primary glories are in evidence: the sun shines, the wind blows, the park's old elm tree is as noble as any living thing on earth. And also my son. I look into big wide wet eyes that smile to meet mine, and I marvel at the moment's vibrancy. Not only is this beautiful, I think, this is good, its goodness subsuming the struggles.

On my first day back at work, Joseph heads up the welcoming committee. "The family man!" he bellows. "Our family man has returned!" We are standing outside the Dispatch Office, just like when I first met him. But this time *he* shepherds *me* around, making sure that everyone has heard my news. Several guards welcome me into the club, as it were, shaking my hand and slapping my back as though we're handing out cigars. Then a cavalcade of questions vie with words of advice. *How's he eating? How's he sleeping? I'm sorry to hear that, but if you let him sleep*

in the room with you you're asking for trouble. Oh, he has a cold? The poor thing . . . I'll tell you what you do. You get a jar of quality honey, and you grind up some fresh ginger, not too much, just enough to . . .

Aada is among the well-wishers. My former mentor is one of these princely people who ask constantly after one's family and listen to the report with genuine interest. Squeezing my arm and taking me for a walk, she badly wants to know how my parents felt laying eyes on their first grandchild. "And look here," she says, as we pull up to a newly acquired painting, "have you ever see anything so hideous?"

At 10 a.m., we open the doors to the public, and I remember what these familiar faces look like. Few are literally familiar, but I recognize their expressions of awe, bewilderment, and annoyance if they can't locate a bathroom. But the museum does have regulars, and over the course of the day, I see my fair share. There's Kenji, a young man with developmental differences who asks the guards which trains we're riding home and alerts us to any service advisories, which is very useful. There's the old man who every day wears a green blazer like Arnold Palmer and gives long-winded advice to any college kid he can waylay. There's the fellow who looks at pictures with an ivory-handled magnifying glass and dresses a bit like a silent movie star, a long coat hanging on his shoulders. (I regret not knowing his name, but we call each other "Sir.") And there is Dwight, who is sure to walk the entirety of the museum with his distinctive slow stride, saying hello to every guard he sees exactly once per day (if he sees you a second time, you get nothing). I've seldom been able to coax more than two words out of Dwight, who is usually busy writing (or drawing?) on small scraps of paper. But today he says: "Haven't seen you in a while . . ." and walks on without waiting for a reply.

As I settle into the day, I am reminded of the hilarious abundance of time I have, time to cross my arms and look around and just stand inside my shoes. Every grown-up person I know at least claims to be frantically busy, but in this place I am not allowed to be. Long quiet

hours are punctuated with questions ("Hey, pal, is this original?") and require occasional interventions (a little girl tugs on a frame), but there is still plenty of stillness to savor. For the first time in months, I can notice what an hour is like when it feels exactly an hour long. I've had some downtime at home with Oliver, but there's a difference between that downtime and this empty time. The former is used up, spent, frittered away, dropped down the swift chute of television, perhaps, which not only kills time but disposes of the body. The latter is old-fashioned, like sitting on a porch on a summer's day watching tumbleweeds blow past. As the hours crawl by, it becomes clear that I'm out of guarding shape; standing is a skill that can rust. I am reminded that "standing" really means standing, leaning, pacing, stretching, and shaking out the legs like spent ink cartridges. By the late afternoon, I'm depleted and sore, but it's a welcome, straightforward kind of fatigue compared to the manic exhaustion of parenting.

So this is my life, I think to myself. I'll move back and forth between two worlds that resemble each other as much as a mosh pit does a monastery. I am posted near Pieter Bruegel's *The Harvesters*, and I approach this old friend, wondering if there is any way to reconcile my two lives. How does a temple of stillness and art relate to the world of churning toil outside of its doors?

As if through a window, I look for the thousandth time at Bruegel's scene. Today my eye is attracted by the smaller details, the children throwing sticks at a helpless rooster, the monks bathing in a swimming hole, a cattle driver hauling a load of hay. It's a lively scene, but of course the figures are arrested on the canvas's brilliant surface. We can't see the complexities of their lives in motion across days, months, years. Perhaps a work of art will necessarily struggle to depict the artless sides of life: the tedium, the anxiety, the loss of perspective as you're consumed by one damn thing after another. Today at least, the finished paintings in my galleries feel as if they exist across a chasm from the world that is still in process.

Two years after Oliver, Louise arrives, a blond-haired thing like me, whom we call Weezy, Weez Girl, Little Miss, Weezer, and the Weez. She is easygoing compared to her brother, who has become a toddler Captain Ahab: fierce, obsessive, and indomitable. Louise is sunny, funny, and oblivious. It turns out that a child's temperament is a dice roll, and much of what we had taken to be human nature was in fact Oliver nature.

The following becomes the new routine. I get home from work (on a short day) around seven o'clock and am immediately down on my hands and knees to play trains with Oliver. Somehow, dinner is figured out and put on the table, often by Tara, who picked up the kids at day care and has Weezy nibbling at her breast. Then it's back on the floor with the tedious, tedious, tedious trains. Bedtime is a series of standoffs. We fight to get Ollie washed, fight to get him in bed, fight to get his eyes shut, at last winning a victory we never trust is final. Meanwhile, Louise has hardly left her mother's arms, increasingly the precondition for her easy good cheer. When finally the kids are both asleep, we turn around, and the house is in such disarray that a social worker would probably take the children away. We straighten up until it falls somewhat below that threshold, and then we too fall asleep, leaving room on one side in case Oliver crawls into our bed, and on the other side in case little Weez starts wailing. My days off at this point are Monday, Tuesday, Wednesday, which means that Tara will barely see me Friday (a twelve-hour shift), Saturday (ditto), and Sunday. She has to handle the weekends alone.

For seven-plus years now, I've worked a job where, by design, there is nothing I cannot handle. Not one piece of art has been damaged on my watch. Not one masterpiece has gone missing. I bat a thousand. In my new life, I see, I will struggle like hell in a process called growth.

I am learning about the motion part of emotion, how a child can ping-pong unpredictability through sunny and stormy states, and how adults aren't too different. When, for instance, I am posted in the ancient Roman

wing, I look at the portrait busts of stone-faced patricians and find myself wondering about how secretly ridiculous they probably were under their austere masks. I can easily picture the rugged Emperor Caracalla getting "all worked up over nothing," as my mom would say, like a petulant child. I can also imagine his eyebrows unknitting as for no good reason he feels light and confident and happy to be alive. Looking back on my first months at the Met, it seems remarkable to me that I could once spend days on end in the same quiet, watchful mood. I suppose it speaks to the unique power of grief. Now my days consist of so much push and pull, it's hard to imagine living in such a focused way. I don't have a simple purpose anymore, as I did when I came to the museum. Instead I have a life to lead.

In the spring of 2016, Louise is just beginning to walk, and the Met is taking the first steps of a brand-new venture. The Whitney Museum's move downtown has left its former building vacant, and the Met has signed a lease to use it as a satellite site. In other words, when we check into Dispatch in the morning, Bob now has the option of sending us right out of the building: over to Madison Avenue and down to 75th Street, where the Met Breuer is announcing itself to puzzled passersby (Marcel Breuer was the architect of the landmark midcentury building). It's a quaint workplace by our standards—the whole of it can be handled by a couple dozen guards—with a clean-lined, modernist aesthetic unlike the comfortable fustiness we are used to. The public, too, is not used to a Met that looks or feels like this, so there's a curious, tentative atmosphere in the galleries, everybody both in and out of uniform trying to figure this thing out.

Reading the newspaper one morning, I see that the *New York Times* has panned the Breuer's inaugural exhibition, *Unfinished*, a high-concept show exploring art that was abandoned before completion or else has some conceptual claim to being still in process. I take it as a positive sign. In the Met proper, the curators don't allow themselves a lot of failures, a

sure sign they're erring on the safe side too often, and I'm excited to work a show that may well be a valiant mess. When I am sent to the Breuer I enter a world where history and geography are not the organizing principles. The show features both Jan van Eyck of Bruges and Kerry James Marshall of Chicago in its eclectic ensemble cast. There is a half-painted Salvator Mundi by Albrecht Dürer, Christ's inked-in face awaiting a coat of flesh. There is a portrait of a Black Vietnam War draftee by Alice Neel, declared complete when he disappeared after only his first sitting. Of special interest to the guards, there is a 175-pound pile of colorfully wrapped candies visitors are permitted to not only touch but take, intended as a portrait of the artist Felix Gonzalez-Torres's partner, who wasted away from AIDS. Unlike its subject, the monument's weight is continually replenished.

What the newspaper critic's beef was, I can't remember. What I notice immediately is that the public is really into the show; it reaches and tickles a part of their brains that museums usually leave dormant. One afternoon, I observe a visitor wearing a T-shirt that reads Illinois Makes Time for Fun. He doesn't look like a high culture maven but he's found his way here somehow and is looking over Jan van Eyck's *Saint Barbara*. Evidently, he's having his mind blown, and it isn't matters art historical or theological that are blowing it. It's the fact that this painting, like a broken-open clock, reveals its inner workings. He marvels, as everyone does, at the artist's almost microscopically detailed underdrawing and the beginnings of an atmosphere lightly brushed above the horizon line. He is engaged, he is involved, by perhaps the most immediately relatable quality of any exceptional object: that it's a job well done (or in this case, a job well started). "Beautiful," he says aloud and matter-of-factly, in a tone that wouldn't sound out of place describing top-notch bathroom tiling or kitchen cabinetry. It's the work that's beautiful, as in that ultimate compliment paid to a contractor: "They do beautiful work." He lopes away to find something else to admire and I'm cheered. In fact, I'm proud. We all know what it is to produce something with care and skill and patience, so that in the end it is better than it really has any right to be. We all know how difficult it is to get really good at *any-*

thing, what hard work is required and how much effort lurks behind the appearance of effortlessness. I suppose I'm proud because it's something that, for all our faults, we humans so often do: produce better stuff than is altogether reasonable.

It's an enormous exhibition, such that my first two or three times through I overlook the object that becomes, for me, the most memorable one in the show. In a gallery off the main loop, it is a block of applewood, one corner rotted away, its surface dotted with wormholes. A small sec-

tion is meticulously and deeply carved, prepared for a day when printers' ink would be smeared upon it and pressed indelibly against a page to create a commercially viable product: a woodblock print. Except that for reasons unknown, the carver was interrupted and therefore never got a chance to methodically destroy the drawing that was guiding him. As a result, we are able to see it today: a drawing made directly on the wood by the hand of Pieter Bruegel.

I am startled to make this discovery. Seeing the master's pen strokes on rotting applewood sends chills through me in a way that a finished print never would. The picture he drew is as engaging and humane as I would expect from him. Called *The Dirty Bride*, it depicts townspeople acting out a folk play of the same name. A man with a false nose pretends to make music with a knife and a coal shovel, while a young man playing Mopsus, the groom, leads his non-virginal bride, Nisa, by the hand. The moral of this tale—"Mopsus marries Nisa, what may not we lovers hope for"—was another way of saying "anything can happen." Performed in the ebullient Shrovetide festival before the somber days of Lent, it was about making the most of a hairy situation and finding joy where one can.

But the revelation for me is seeing the master's fingerprints, figuratively speaking, on an object so labored and malformed and imperfect and incipient. It occurs to me that it isn't enough to learn from finished works of art in all their apparent perfection. I should keep in mind the toil these works entail. One good reason to look at someone else's creation is because you're studying how you might build something yourself. And for the first time in my life really, I feel as if I am building something. In a terribly inelegant, ad hoc process, I am building two little humans; and I am making the little world I would wish them to live in, a project that can't be perfected or finished.

The Met Breuer for its part doesn't even get to finish out its lease. After only four years it closes its doors amid high costs and uneven attendance. Even an institution as mighty as the Met must experiment and stumble to create anything new.

XII.

DAYS' WORK

Two exhibitions fire my imagination over the next two years. One is enormous, the other modest. One features perhaps the most famous name in all of art, the other a group of unknowns who may not have even considered themselves artists. One brings us to the center of sixteenth-century Christendom. The other to a rural Black community in twentieth-century Alabama, the center of nothing in particular except, importantly, its inhabitants' lives. Yet for all their differences, the two exhibitions—of Michelangelo's drawings and the works of the Gee's Bend quiltmakers—are alike in how they challenge my understanding of art, the making of art, and really the making of anything worthwhile in a world that so often resists our efforts.

If somehow you were able to get close to the Sistine Chapel ceiling, if you stood on a high scaffold as Michelangelo did and raised your chin, you could see exactly how much work the master got done in a day. Each morning, the artist and his assistants prepared an area that would need to be fully painted at day's end, when the fresh application of plaster dried. The result would be a *giornata*—Italian for "day's work"—and the ceiling is really a mosaic of these small, irregularly shaped accomplishments with barely perceptible borders. Adam, reclining, is four *giornate*. God,

outstretching, another four. Making a count, we can see that Michelangelo spent some five hundred and seventy days at that altitude with his trowels, brushes, pots of paint, and bags of sand and lime.

The Met's exhibition is the closest I will come to seeing the master at work, albeit on a more intimate scale. It gathers 133 drawings he produced over the span of a seventy-year career—studies, for the most part, which he intended for no one to see. The title of the show is "Michelangelo: Divine Draftsman and Designer," but its effect is to make its protagonist eminently mortal. It reveals a Michelangelo who didn't see himself as MICHELANGELO, a colossus of art history, because he was too absorbed in the struggle to complete each day's work.

I am standing in the show early one morning, while down on Fifth Avenue, a crowd already waits impatiently to be let in. It's dark in the galleries— drawings spotlighted amid pools of black—and to fall into the orbit of one is to enter a whisperingly intimate world. Approaching a drawing I look through the eyes of a teenaged Michelangelo as he looks through the eyes of an older old master, the painter Masaccio, whose fresco of Saint Peter he sketched in red chalk, pen, and brown ink. When Michelangelo first began making such drawings, his father beat him savagely for it. The Buonarrotis, though broke, were noble, and it pained Lodovico to see his son working with his hands. Lodovico was right about one thing, I think, as I look at the drawing with its careful, painstaking crosshatching. This was manual labor: repetitious, tedious, physical. Skilled labor to be sure, but of a humbling type that admitted no shortcut taking, no way to proceed except stroke by patient stroke.

I am looking at a young artist's hand at work and also, I realize, his mind at work. After Michelangelo had finished copying (and subtly correcting) Masaccio's saint, he redrew Peter's outstretched hand, this time turning it ninety degrees to see how it would look from above. It seems

a remarkable conceptual leap, though less so when I remember he was training for a career as a sculptor (and indeed would later resent being made to work in other mediums). Speaking of three dimensions, the drawing is framed such that I can walk around its display pedestal to view the verso, its back side, where I find he's drawn yet another hand, this one flayed of its flesh and muscle, the chilling hand of a skeleton. Perhaps he dissected Saint Peter with his eyes. Or perhaps he reused the sheet (one seldom wasted paper) while he carved up an actual corpse in the hospital in Florence's Santo Spirito. Whatever the case, I take a long look at my own hand and marvel at the scale of the project the young artist set out for himself. How accurately and how deeply he wished to see!

Walking alone through these early galleries, where drawings by Michelangelo's teachers are also on view, I'm reminded of something basic about the art making process. The world doesn't make itself easy to draw. The safe route is to mimic others' tried-and-true formulas that limit the complexity. The dangerous route is to push the limits of your eyesight and try to invent ways for your pen to keep up. Michelangelo fell in love with maybe the most demanding subject matter of all: the human body, with its six hundred muscles and two hundred-odd bones. In these galleries, he is depending on his eyes, hand, and mind to learn how to set it in motion.

When at ten o'clock the museum opens, I am pushed from Florence to Rome. I leapfrog his early professional triumphs and land inside the Sistine Chapel—or rather a gallery made up to evoke it, with its great ceiling reproduced overhead. A few minutes later I am swarmed by arriving pilgrims, who step past drawings hung around the perimeter and point their cameras straight up. I chuckle, as, a few yards away, a doodled version of Michelangelo holds his paintbrush straight up. In the self-portrait, he stands with his head thrown back ninety degrees and his arm pointed toward twelve o'clock, his posture for at least 570 days. Beside the doodle, he's written a sonnet complaining about the state of his spine, his buttocks, his paint-splattered face, and his brain in the "casket" of his head.

It ends with a miserable line that might surprise my picture-happy neighbors in the gallery: "I am not in a good place. And I am no painter."

I chuckle again, remembering those words. I relish hearing about a master's insecurities; I suspect they make most of us feel less alone. Since the exhibition opened, I've been devouring Michelangelo's cranky, despairing letters. "I waste my time without result. . . . God help me!" is a line that keeps popping into my head. Indeed, his first few dozen *giornate* were wretched failures, spoiled by improper plaster applications, an amateur mistake. He begged the pope for permission to give up. There seems to have been no part of him that reveled in the awesome grandeur of the commission.

And yet.

With many excuse me's, I work my way around the perimeter to view the most celebrated drawing in the Met's permanent collection, also a highlight of the show. Because of its sensitivity to light, I've seen it displayed on just one other occasion in my time as a guard. When he wasn't up on the scaffolds, Michelangelo went back to the drawing board, literally. This drawing in red chalk is one of thousands he must have produced. I look at a figure called the Libyan Sibyl, but what I really see is a model posing in Michelangelo's studio—a nude male model, perhaps a student or assistant. (The sibyl is meant to be a prophetess, but Michelangelo's typical interest was the male body.) He ordered the young man to strike a challenging corkscrew pose, and I wonder if he was sympathetic about cramps, given his own ergonomic struggles. I try out the pose myself before becoming self-conscious and playing it off as a stretch. Then I lean in closer.

Given what I know about Michelangelo's discontent, how can a drawing this beautiful exist? It is on the one hand inspired, and on the other infinitely diligent; he's taken the time to shade every muscle on the model's back and arms. Michelangelo was responsible for some four hundred and thirty figures across the ceiling. Yet here, he found himself so interested in the sibyl's foot, he drew a big toe pressing against the ground three different ways, and managed to make even that beautiful.

Courtesy of the Metropolitan Museum of Art

Nothing on the sheet is rote. Every stroke evinces energy, ambition, devotion to the difficult task. Clearly, Michelangelo was one who could sit down with an empty sheet, forget his troubles, give everything he had to the work in front of him, and leave his bitter complaining for afterward. I doubt there's a better formula for getting difficult things done.

When after four years the entire ceiling was finished and "the whole world could be heard running up to see it" according to a contemporary, Michelangelo had only this to say: "I have finished the chapel I have been painting: the Pope is very well satisfied," he wrote his father. Then he added: "Other things have not turned out for me as I'd hoped. For this I blame the times, which are very unfavorable to our art."

Today, we call those "unfavorable" times the High Renaissance.

On a different day, I am assigned to the back team, which covers the long unfurling of the master's late career. He lived so unexpectedly long a life—nearly eighty-nine years—he spent decades assuming he was at death's door. Even so, he never managed to wind his work down. He spent forty years, on and off, preparing the tomb of Pope Julius II, begging for pay and suffering change orders all the while. The first half of the show has a "demonstration drawing" for the tomb it would have pained Michelangelo to revisit: he completed fewer than one third of the sculptures planned. Nor did his personal life settle down. At the age of fifty-seven, he fell in love with a twenty-three-year-old nobleman, giving him gifts of drawings that are part of the show. A few years earlier, he lost a brother in the plague of 1528, and assumed responsibility for his three young children (the youngest of whom also died). If that wasn't enough, there was at this time a hostile army approaching Florence.

"As far as I can make it out," I say to an inquiring visitor, "we're looking at a drawing Michelangelo made to beef up Florence's defenses. The spiky structures that kind of look like crabs, those are bastions and

ramparts for returning cannon fire. Not only did he make the drawings, he was conscripted into running a large crew of workmen, some of the same men who'd quarried marble alongside him, now building for their lives."

The visitor is a "war nerd," he tells me, and I do my best to remember the details of this particular aggression. (I've been reading up.) "I believe it was the pope in league with the Holy Roman emperor to bring the Medici family back into power. Michelangelo's defenses held up okay but it didn't matter in the end. The enemy surrounded Florence and starved it into surrender."

The war nerd and I spend another twenty seconds studying a drawing that must have been the result of weeks of fieldwork (there are written notes about the surrounding landscape), and then he moves on. It takes most visitors an hour or so to feel finished with an exhibition that took Michelangelo seventy years to finish. This isn't a criticism, though knowing his temperament I can imagine the master being annoyed. These war drawings ate up hundreds of his workdays, and they're just a neat sideshow for us.

After a push, I am posted in galleries where Michelangelo is an old man, even by today's standards. Judging by poems he wrote, he wasn't exactly happy about aging: "What file's incessant bite / left this old hide so shrunken, frayed away, / my poor sick soul?" In his seventies, he was appointed the supreme architect of Saint Peter's Basilica in Rome. He wasn't happy about that either, having been given the honor "to his intense dismay and completely against his will," according to Giorgio Vasari, his friend. It would be impossible to imagine a knottier, more ungainly project to take on. Not only would he have to navigate Vatican politics, he was hemmed in by the work of two previous architects. Saint Peter's would occupy the remaining seventeen years of his life.

I look at a sheet about ten inches tall by ten inches wide whereon he dreamed up the shape of the cathedral's great dome. Soaring above Rome, it would seem to be a superhuman assignment and is one of the reasons the name Michelangelo sounds superhuman to our ears. On this modest sheet

Courtesy of the Ashmolean Museum, Oxford

however, he has free-handed a number of rainbow shapes, trying to find a curve to his liking. However exalted, he was not above this childlike exercise.

I leave the dome and search out drawings linked to his other last project, a sculpture of the Pietà, left unfinished at his death. On one sheet there are five studies made with a shaky, octogenarian hand. Small, intense, earnest, they don't bear a trace of consciousness they're being made by the most famous artist in the world. (Even in his eighties, Michelangelo could upbraid himself for a misstep causing construction delays on Saint Peter's: "If one could die of shame and grief," he wrote, "I would be dead.") Two of the drawings resemble the marble sculpture he eventually produced, with the dead Christ vertical, his mother supporting his great weight.

Michelangelo originally carved a stout and muscular body of Christ, but then he just continued to carve, steadily emaciating the figure until it looked frail and shrinking and oddly like modern expressionistic sculpture. His *Pietà* of the 1490s was a virtuosic display. This was something more pained and private.

I look again at the drawings, which express love, piety, and exhaustion. I think about an old man bent over a white sheet, struggling to make his hand perform what his mind and heart require. What made Michelangelo Michelangelo came in the next step. After completing his study, he got up and worked to make the thing real. He was hammering a chisel against obdurate marble just days before his death.

The next exhibition sneaks up on me. Whereas Michelangelo's arrival at the Met was heralded by banners along Fifth Avenue, I haven't so much as heard the words "Gee's Bend" until I am posted in a small exhibition in the Modern and Contemporary Art Wing. Ten quilts hang on the walls of two spacious galleries. Ten quilts by eight quiltmakers, four of whom share a common surname: Pettway. "What is this?" I whisper under my breath, feeling my pulse quicken as I walk from one disorienting piece to the next. Boldly contrasting colors, asymmetrical patterns, rough and worn materials joined by visible stitches . . . This is all that I can make of the quilts on my first day working the show, but my heart rate tells me they are beautiful.

Over the next few weeks, I learn everything I can about these quiltmakers. I read interviews with dozens of women who quilted in Gee's Bend, Alabama, and spoke about their work and lives. "Hard" crops up so often in the interviews it is like a refrain. "We come up hard. . . ." "Time was hard. . . ." "We had a hard way to go. . . ." "Lord, we did work hard. . . ." "Not easy. Hard." Lucy T. Pettway (1921–2004) is one of the artists in the show. As a child, she attended school from late November until late March, at which time she was needed to "knock cotton stalks, cut bushes, clear up

new ground, get ready to break the land and plant." Like virtually all the women, her people were tenant farmers, but Lucy also brought other work to the fields. Each day she carried a handful of quilt pieces to stitch together during her meal break. She hoped to finish "a block or so" (many quilts consist of nine blocks). It was Lucy T.'s version of a *giornata*.

Her quilt from 1955 is the only pictorial one in the show, and it depicts Gee's Bend. On one side a blue stripe represents the Alabama River, which runs between red strips of fabric, its muddy banks. On the other side, cotton fields are rendered with patterned calico. The rest of the quilt consists of blocks of concentric squares, though this "housetop" style allowed all sorts of variations in patterns and color. Here, we are looking at literal housetops, a bird's-eye view of one large and four small homes. If we could zoom out even farther, we'd see the river make a dramatic horseshoe-shaped turn, isolating "the Bend" on three sides from the wider world. If we could draw in closer and have a look at the homes Pettway depicted, we'd have a clearer sense of the area's history. The biggest is the "big house" of the old Pettway plantation, and the four smaller are slave quarters.

The first Pettway to arrive in the region was Mark H. Pettway, who in 1845 purchased a cotton plantation from the heirs of Joseph Gee. With it, he received forty-seven human beings as property, and he moved an additional one hundred from his former home in North Carolina (they traveled on foot). The quiltmaking Pettways descend from slaves who were given the Pettway surname, though in the Bend's patois it's taken on a new music: locals pronounce it "Pett-a-way."

Exploring the exhibit, I see the phrase "self-taught" on exhibition labels. This is art world jargon that's replaced the term "folk art"—an odd choice, as it has little to do with the plain meaning of those words. To my knowledge, none of these quiltmakers taught themselves. Lucy T. Pettway learned from her mother and great-aunt, who in turn learned from older women in a tradition that predates Emancipation and likely owes something to textile practice in West Africa. She also learned from her peers,

with whom she competed and from whom she stole. Like Michelangelo's Florence, Gee's Bend had an unusual rate of artists per capita.

And quilting was an unusually public art. "When the spring came," Creola Pettway explains, women had to "sun out the quilts. Put them on the line . . ." Lucy T. would sun out "sometimes fifteen and sometimes twenty. Sometimes more than that. And people be passing by and sometimes they go in the ditch watching quilts!" In her younger years, she quilt-watched on foot, strolling through the neighborhood with pencil and paper and copying the works of masters—"draw a pattern from it, make me my quilt."

The earliest quilt in the show is one she might have conceivably sketched. Mary Elizabeth Kennedy (1911–1991) would have hung it out to sun in the mid–nineteen thirties. I try to imagine it billowing in a breeze. It is made of many shades of white, pale blue, and blue-green. I didn't know white could have shades, but she's achieved it by using salvaged fabrics, perhaps strips of old clothes that are sun bleached and field worn. These are the colors of real life, not of fine art supplies. Structurally, the quilt adheres to a housetop pattern, with nine blocks of concentric squares. But the underlying structure is wholly obscured by patterns that break out of their blocks and race around the quilt with great energy: there is a kind of pixelated lightning bolt buzzing amid the blue.

It looks wild, bold, daring hanging in the Met's Contemporary Art Wing. I can only imagine how it looked covering one of her children in a drafty log cabin. The 1930s were lean years in Gee's Bend. When cotton prices crashed during the Depression, few Benders could afford to pay their white absentee landlords. Debt collectors executed a coordinated raid, seizing farming equipment, livestock, household goods, sending people into the woods to scavenge for food and fuel. In the midst of all *that*, Kennedy quilted *this*. I don't know that she used the term, but it looks to me like the very definition of art: something more beautiful than it has any right to be.

My favorite artist in the show is Loretta Pettway, the only quiltmaker represented by multiple works (three). Born in 1942, she is still living. She grew up at a time when so-called Roosevelt houses dotted the Bend, fruits

of a New Deal effort to aid a plundered community. Given access to credit and a chance to buy homes, Benders didn't migrate to cities at the rate of other Black Southerners, a boon to its quilting tradition. Nevertheless, poverty persisted, and Loretta Pettway came up unusually hard. "I never had a child life," she told an interviewer. She was similarly blunt on the subject of her husband, an abusive drinker and gambler: "He had a lot of habits. I didn't have no habits. Couldn't afford them." The biggest shock of the interview is learning that she "didn't like to sew." Like Michelangelo before her, she made no bones about her quarrels with her craft and groaned under the weight of her obligations. She had a "raggly old house," and her children slept on corn shuck mattresses that were intolerable without quilts. Quiltmaker Helen McCloud gives us an idea of the production required: "I had to run six beds," she remembered, "children sleeping two in a bed back then, sometimes need four and five quilts on a bed, according to the weather." Many women quilted in groups, chatting and singing church songs as they worked. But Loretta labored in solitude. She struggled with depression and insomnia and by her own account "didn't have friends."

"I ain't had no other choice, because I asked people for quilts and they wouldn't give me none, so I said I'm gonna make these the best I know how and quilt 'em. Think they'll keep me and my kids warm, and they did."

It's a Sunday morning. I am standing in front of the most beautiful quilt I've ever seen and I'm thinking about its maker. In this museum, I'm usually thinking about artists who are long dead, so it's a pleasant change. I can guess where Loretta Pettway is right now: certainly in Gee's Bend (she never travels, not even to be feted at exhibitions like this) and possibly at Pleasant Grove Baptist Church. The quilt I love dates from 1965, the same year Martin Luther King spoke at Pleasant Grove in the midst of a hard-fought, high-stakes voting rights drive. Gee's Bend's ferry service, an important link to nearby communities, was cut off in retaliation for these efforts, and it hasn't been restored to this day. I could decide to look at the artwork as if it were an abstract painting; it is as spare and striking as any modernist picture. But I won't do that; it's a

quilt, and I adore it for a patchwork of reasons: its history, practicality, beauty, texture. I get as close as I can to the work. It billows slightly, casting a shadow on the wall. I picture Loretta assembling her fabrics, in her words: "old shirts and dress tails and britches legs," whatever "wasn't wore out—like the back of the pants legs." Perhaps she arranged all the pieces of this quilt before she began. More likely she worked in a style called "in the lap," with only her immediate task visible as day by day she stitched her way through the entire needed work of art.

Backing up a few strides, I take in a quilt composed of vertical stripes, or "bars," about the width of my hand and almost imperceptibly wavy. The right and left edges are dark blue denim; most bars are lavender; and then there are two bars made up of white fabric spaced near together, but not touching, the quilt's central feature, though somewhat off-center. The work is called *Lazy Gal Bars*. I run my eyes horizontally across them and imagine I'm pressing piano keys. Looked at this way, it is a quick series of transitions separated by lines of stitches. Then I let my eyes float slowly, lazily down the long bars and—I can't find the words that would make it sound reasonable—but I am astonished by them. The lighter pair of stripes are like light-beam-shaped angels, joyfully unbent. I am moved by the quilt's geometry and also by its imperfections: the slightly wandering lines; the swift, unfussy stitching; the improvised materials. It has an abundance of art's most heartening qualities, including diligence and inspiration.

I think to myself: there is a lesson here, and it's a funny one to be learning in a place as grandly cosmopolitan as the Metropolitan Museum of Art. Meaning is always created locally. The greatest art is produced by people hemmed in by circumstances, making patchwork efforts to create something beautiful, useful, true. Michelangelo's Florence, even Michelangelo's Rome, was in this way rather like Loretta Pettway's Gee's Bend. I'll try not to think anymore in terms of the "High Renaissance." I'll think of a person spreading out a bit of fresh plaster, and painting it, and a little bit more, and painting it . . .

XIII.

AS MUCH AS I CAN CARRY

Life is long, I'm discovering. If you die young, it isn't long. But if you don't die young, you're in the curious position of thinking you've grown all the way up, and yet there are decades more—five, six, maybe seven of them—through which you will need to progress. When Tom died, I found my way to the Met, and it was easy to conceive of adulthood as a final state, a winding down of growth and change rather than its own journey. Now I am in the position of having grown older than my older brother, and it's strange and unnatural, like having grown taller than a childhood climbing tree. But I also now have perspective enough to see that my life will stretch beyond its present horizons. That it will lurch and grind and ramble forward, and I had better steer its progress. In short, I have come to understand that my life will consist of chapters, which raises the possibility of bringing my current chapter to a close.

The Gee's Bend exhibit wraps up in the fall of 2018. Around the same time, I begin walking Oliver to kindergarten before my morning commute, while Tara takes Louise to day care, where most of my paycheck also goes. I finally have Sundays off, but I'm unlikely to ever have a proper weekend—only the oldest of the old-timers do. Nor do I have

enough seniority to schedule vacation weeks in the summer, a drag with the rest of the family on a public school calendar. (And Christmas week? Forget it.) When I get home exhausted at about 10:45 on Saturday nights, I generally find a wife and two children asleep together in my bed. It's sweet, but I'm tired of it.

Still, I continue to find pleasure standing on post. It remains a nearly perfect job, though perhaps perfection is no longer what I need. I used to feel the main business of my life was performed in these galleries, and I relished the meditative stillness. These days, my thoughts fly outside the museum's walls, causing my mind and limbs to twitch with restlessness. I no longer need so pristine a setting. I don't have to stand on the sidelines, a quiet watchman. I find myself watching parents and children in the galleries and plotting about all that I could do to introduce my kids to the big city and wide world. The prospect is as daunting as it is exciting. Frankly, I am still overwhelmed keeping our apartment in order, and I would like to learn to become tougher and braver as I engage with more aspects of the world outside.

I spend the fall and winter debating whether to give up the dark blue suit. Bob has been sending me to the old master wing of late, so I ponder the question in front of Bruegel, Titian, and other old friends. Certainly, I can't return to the office world; I am much too spoiled. I need something that will keep me on my feet. I score a phone interview with a tour guide company, which I schedule for my three p.m. break one day. When the call is over, I dial Tara. "Guess who's going to be leading walking tours around Lower Manhattan?"

It's just a part-time gig. It isn't what I imagine myself doing with the rest of my life. But life is long, and this will be a way to literally explore, leading a pack instead of looking on from a corner. As my springtime start date approaches, I realize how excited I am to research and write and perform my tours. To say things. To make something of my own.

On my final day in uniform, I am sent to the Section B chief's desk on the balcony overlooking the Great Hall. Approaching, I take in the scene. There are three saucer-shaped domes overhead, each big enough for their own cathedral. Down below, a pair of my colleagues roll iron stanchions across a vast empty floor. At my back, the General Gaius Marius parades his captive King Jugurtha through Tiepolo's expansive canvas. And as I make my turn around the corner, the guards of the old master wing are lining up for their posts.

"Kurti, first break on team three!" Chief Sutton orders. "McMillan, relief on two! Petrov, you're second platoon? Then you're late . . . call Bob in Dispatch. Weishaar, first break in the show!"

It's the last time I'll hear this language in use, but I have a feeling I'll be fluent in it until the day I die. When it is my turn, the chief tells me in essence to get lost. "Bringley, come on, it's your last day! I'm not going to stick you on a post. Wander the galleries, say your goodbyes, and if you want to be useful, give your friends bathroom breaks. Good luck, Mr. Bringley. Next!"

I had managed to sneak into the line unnoticed, but when I turn around the jig is up. Well-wishers shake my hand, slap my back, ply me with questions about what I'll be doing next. I tell them about my job leading walking tours. No, I admit, it isn't union, but, yes, I do expect the tips to be better than we make down in the coat check.

Mr. Ali presumes to speak for the entire group when he says, "You've made it out, young man. And you still have some of your hair."

I won't permit anyone to say a true goodbye to me, though. "Technically, I don't need to be an employee to come here," I remind them, and they admit people do occasionally visit the Met without being paid for it. Happily, it's the nature of my soon to be former workplace to permit all comers and let them roam freely. And when I visit, I know where to find my friends: standing right out in the open.

Pretty soon, everybody has a post that they need to get to—everybody, that is, except me. It's an unfamiliar feeling, and I just lean

on the balustrade a moment, peering down into the Great Hall. I listen to what it sounds like when only a few voices echo through that limestone cavern. I see Lucy and Emilie preparing to work tables, chatting and wriggling their fingers into latex gloves. Down there it's a day like any other day, and I think about what has and hasn't changed from my first day to my last. Aada is retired now. So is Troy. Randy, king of the coat check, passed away, as did Johnny Buttons. Several wings of the museum have been renovated. Hundreds of new objects have been acquired. But in the main, artworks from fifty centuries have gotten just ten years older. When the Met looks different, it's often the beholder who's changed.

When the guards open the doors at ten o'clock, I decide to wander. For a guard, it's a novelty having nowhere definite to be. I take the stairs down and dodge through representatives of the early-arriving public. I see the galloping Sightseer, camera at the ready; the awestruck Art Lover, uncertain where to begin; the bewildered First Timer, excited to see the dinosaurs or the Constitution or she doesn't know what exactly but hopefully a friendly guard can help her out. I turn past the ticketing desk into the Greek statuary and duck into a side gallery of ancient painted pots. I like it as a place to begin my last tour: earth, baked in fire, painted by some anonymous fellow who worked outdoors, kept goats, knew Socrates. Humble vessels that held a household's oil and wine but had room enough for scenes of life, death, and the very gods.

Passing the great Sardis column, I stroll once more through the Roman Court, still failing to keep straight the many emperors carved in marble and stamped on coins. It is the portrait busts that arrest my attention—craggy heads of honest old Romans, not so different, really, from my colleagues' heads bobbing among them. ("Hey, Ronnie," I say. "Hey, Ms. Pike.")

Making a right turn, I leave behind the classical world and push out onto the sea swells of Oceania. . . . Slit gongs, totem poles, a ten-man canoe, a coil of sixty thousand red feathers used as money in one of these faraway island worlds. I could return to a gallery like this one a thousand

times more without exhausting its contents. But it also makes me think about how little of the world beyond these walls I've seen.

Turning right again, I pass through European Sculpture and Decorative Arts, where Perseus is hoisting the head of Medusa. Speaking of severed heads, I next wend my way through the ancien régime period rooms, each parlor smelling more of the guillotine. After these examples of gilding and finery I pass into an era of plague and religion, entering the cathedral-like Medieval Court. It is as majestic as it ever was, but at the same time it feels homey and familiar: I see a Section A colleague yawning on his post. Approaching the B post of team one, I am buttonholed by Ms. Collins, who clearly hasn't heard my news, and wants to introduce me to a guard she recently trained. I say hello and welcome to the young woman and little else. I'll be seeing them both again.

As I'm forging ahead into Arms and Armor, my cell phone buzzes. It is a text from Joseph that reads simply "Van Gogh." Copy that. I turn on my heel and backtrack toward the Modern Art elevator, out of habit preserving my legs and feet by avoiding stairs. I ride up to the second floor, hang a left at Picasso and a right at Cézanne, and stop when I see Joseph leaning against a doorpost in the classic style, lost in thought. Framing Joseph are about half of the museum's Van Goghs. There are sunflowers. There are oleanders. There are irises in a simple white jug. There is a peasant peeling potatoes, the café owner Madame Ginoux, a farmer on his knees encouraging his daughter's first steps. And finally there is the red-bearded, long-suffering artist himself, clear-eyed and wearing a big straw hat, roped into taking selfies with the tourists.

"Hey, you over there, you want a personal?" I say, startling Joseph as I stride across the room. He laughs. A "personal" is what we call a ten-minute bathroom break.

"None for me, thanks!"

Instead, we stand next to the oleanders, chatting aimlessly about the NBA playoffs, about a Stendhal novel Joseph urged me to read, about his new grandchild, about Louise's upcoming third birthday party, about how time flies. I am acutely aware that when I leave this museum, I'll enter a world where it's unusual to have a good friend twice your age who was born on the other side of the world. Among Met guards, it isn't even notable. I won't miss Joseph, whom I'll make the effort to see, but I'll miss that. And I'll miss the daily, low-stakes, affectionate, time-passing talk among colleagues with nothing but time on their hands. "Nothing to do and all day to do it," we sometimes joke.

After fifteen minutes, Joseph turns to me and says, "You know what? I think I will take that personal," and with my encouragement he leaves me alone on his post. I will miss this, too. I can return to see the Van Goghs, of course, but when I do, I won't be on the lookout for the public's itchy touchin' fingers, and no one will ask me if a painting is real, and no stranger will approach to stumblingly explain to me (a sympathetic ear) what's on their mind. When I visit, I'll be a visitor, always free to pull up stakes and move on to the next gallery, unlikely to loiter for eight or twelve hours.

The most moving thing I've ever read about art is an account of Vincent van Gogh's visit to the Rijksmuseum in 1884. Apparently, he was one of these museumgoers who chronically slow down their companions, in this case his friend, artist Anton Kerssemakers. "He spent the longest time in front of 'The Jewish Bride'" by Rembrandt, Kerssemakers writes.

> I could not tear him away from the spot; he went and sat down there at his ease, while I myself went on to look at some other things. "You will find me here when you come back," he told me.
>
> When I came back after a pretty long while and asked him whether we should not get a move on, he gave me a surprised look and said, "Would you believe it—and I honestly mean what I say—I should be happy to give ten years of my life if I could go on sitting here in front of this picture for a fortnight, with only a crust of dry

bread for food?" At last he got up. "Well, never mind," he said, "we can't stay here forever, can we?"

No, I don't suppose we can. Such moments provide solace; they are heartening; they are pure. When I look at Vincent's irises, I feel him longing to live in their vibrant simplicity forever, escaping his poverty and his demons. But the time does come to turn and face what lies ahead of us. Vincent's story was sad because he was ill-equipped to cope with the business of living. I am grateful beyond words for my better luck. I think my life story will be happy.

I especially think so now that Joseph has returned and begins talking excitedly about the future, both mine and his. "I'll put in four more years here," he says definitively, "then I will retire to my favorite place, my mother's village in Ghana. What will I do? I will wake up and watch the fishermen and if they make a good catch I'll buy their fish and if they don't make a catch, I won't. You know the Winslow Homer painting in Section G of the Black guy lying on the raft? Sharks are circling around him, there's a storm off in the distance, but he's seen the worst already and he's just relaxing like this"—Joseph strikes a pose—"that's me. I've been playing with house money a long time. Que será, será. But *you*, my young friend, *you*, my family man, you are going to go out and make billions. And if you don't, who cares? Look at your fine children! You are already doing well! When Ollie is—let's say twelve, and Weezy is ten you will come visit us in Ghana."

I spend much of the rest of the day chatting with whomever else I bump into. I'm friendly with most of the almost three hundred guards on the floor, and it's clear that I could run out the clock in this manner. But I would also like a last taste of the anonymity that comes from wearing the blue suit. So I head into the old master wing and strike a deal with Mr. Foster to take over half of his post. He stands in one gallery, I stand

in another, and I have a chance to look at a painting I've decided is my favorite in the Met.

One of the last efforts I've undertaken as a museum guard was one of the first things I learned how to do in an art museum. Twenty-odd years ago, my mother took Tom, Mia, and me to the Art Institute of Chicago and didn't allow us to leave a gallery until we'd chosen the picture we liked best. After a decade in this museum, I can't leave without knowing what artworks inside of it I love best. For months, I've scribbled candidates in a notebook, making lists and ruthlessly paring them down, shrinking the Met's enormity into a personal collection. The kouros, the *nkisi*, the "Simonetti" carpet, *The Harvesters* . . . I don't want to choose too many or too few, just the right number of artworks I can carry out with me, so to speak, and use as touchstones as I move ahead. In the old master wing, I decide the picture I need the most is a Crucifixion by Fra Angelico, a fifteenth-century Italian friar.

My fondness for it owes something to my biases. I like when art's old. I like the look of tempera paint on heavy wood panels and cracking gold leaf with its red clay base peeking through. I like old Christian art and its luminous sadness. I like that the picture makes me think of Tom, however painful that may be. Christ's body looks like it's been nailed to the mast of some storm-tossed ship. It's the center around which the rest of the world seems to rock and wheel. A graceful, broken body, it reminds us again of the obvious: that we're mortal, that we suffer, that bravery in suffering is beautiful, that loss inspires love and lamentation. This part of the painting performs the work of sacred art, putting us in direct touch with something we know intimately yet remains beyond our comprehension.

But the body of Christ isn't all the friar depicted. He's imagined a rabble of onlookers at the base of the cross, fancily dressed, astride horses, their faces betraying a wonderful range of responses and emotions. Some are solemn, some curious, some bored, some preoccupied. There is often this streak of realism in old master paintings. As W. H. Auden observes in his poem "Musée des Beaux Arts," even the "dreadful martyrdom" takes place "while someone else is eating or opening a

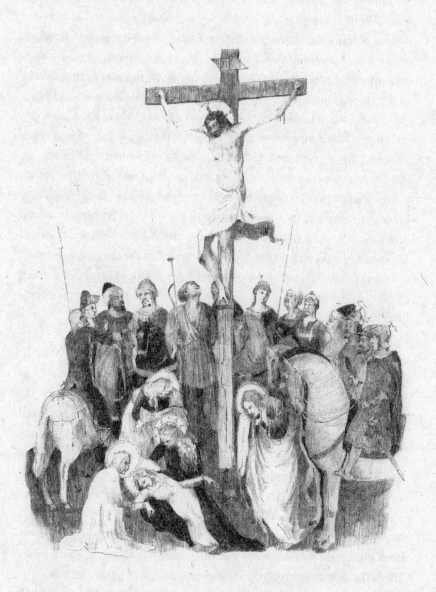

window or just walking dully along." (Auden also writes of the old masters: "About suffering they were never wrong . . .") I take this crowded middle of the picture to represent the muddle of everyday life: detailed, incoherent, sometimes dull, sometimes gorgeous. No matter how arresting a moment is or how sublime the basic mysteries are, a complicated world keeps spinning. We have our lives to lead and they keep us busy.

Finally, there is the painting's bottom register, where the tone shifts once more. Here, compassionate figures attend to the grief-stricken mother collapsed onto the ground. Unlike the passive onlookers, their minds are pointed in a common direction, and it's squarely toward where they can do good. This last part of the picture is an example to follow. In my life ahead, I will be needed and have needs; the hope is I will do everything I can and have others do the same for me. I won't have my big brother. I feel that loss. Looking at the picture, I know he would be part of the alert, praiseworthy, no-nonsense crew bending over Mary. But I can look at my inner portrait of him even now—that bright, frank Titian-painted face—and take comfort. That's a picture I can certainly carry out of the Met with me.

When Mr. Foster receives his push, I follow him out to the top of the Grand Staircase, giving him pride of place on this busy post while I stand well off to the side. Visitors still find me and ask questions, including a young woman who wants to see—I can't believe my luck—the *Mona Lisa*. I get to have this conversation one last time.

"We don't have it," I tell her, sincerely sorry. "It's in Paris."

"What? You don't have, like, a copy of it?"

"I'm afraid we don't. There are no reproductions in the museum. Everything you're going to see is real."

"Well, where are your da Vinci paintings?"

"There's only one in America, and I'm sorry to say it's in Washington, DC. But we have plenty of other painters of the Renaissance era."

She looks at me as though she's arrived at the Baseball Hall of Fame only to be told, "No, we don't have Babe Ruth, but perhaps I can interest you in other right fielders of the 1920s. . . ." I do what I can to lift her spirits, promising she won't be disappointed, and suspecting this is just a hiccup—she'll put her wide-eyed perplexity to good use.

I watch her disappear into the crowd passing into the old master wing. There may be only one half-smiling *Mona Lisa* out there, but there are certainly faces worth looking at wherever you go. Leaning back to people watch, I find myself silently rehearsing the advice I would give Met visitors after ten years as a guard. It's a message I am carrying out with me that I hope to share, not least with my children.

You are now entering a world in miniature, its terrain stretching from the mudflats of Mesopotamia to the cafés of Left Bank Paris and a thousand other places where humankind has really outdone itself. First, just get lost in the vastness of it all. Leave your meaner thoughts on the doorstep and try to feel, pleasantly, like a tiny insignificant speck afloat in a storehouse of beautiful things.

Come in the morning if you can, when the museum is quietest, and at first say nothing to anyone, not even a guard. Look at artworks with wide, patient, receptive eyes, and give yourself time to discover their details as well as their overall presence, their wholeness. You may not have words to describe your sensations, but try to notice them anyway. Hopefully, in the silence and the stillness, you'll experience something uncommon or unexpected.

Learn everything you can about an object's maker, culture, and intended meaning—typically, a humbling process. But at some point, you'll want to switch gears and throw in your own two cents. The Met is a place where, with your own eyes, you can see what fellow fallible humans have made of the world that you live in. You're qualified to weigh in on the biggest questions artworks raise. So under the cover of no one hearing your thoughts, think brave thoughts, searching thoughts, painful thoughts, and maybe foolish thoughts, not to arrive at right answers but to better understand the human mind and heart as you put both to use.

Find out what you love in the Met, what you learn from, and what you can use as fuel, and venture back into the world carrying something with you, something that doesn't fit quite easily into your mind, that weighs on you as you go forward and changes you a little bit.

At closing time, I'm still on my perch at the top of the stairs. It's all commotion down in the Great Hall, a sea of people putting on coats, looking at maps, transitioning out of a speechlessly beautiful world and returning to the forward march of their lives.

Art often derives from those moments when we would wish the world to stand still. We perceive something so beautiful, or true, or majestic, or sad, that we can't simply take it in stride. Artists create records of transitory moments, appearing to stop their clocks. They help us believe that some things aren't transitory at all but rather remain beautiful, true, majestic, sad, or joyful over many lifetimes—and here is the proof, painted in oils, carved in marble, stitched into quilts.

It's plainly mysterious that the world is as colorful and full as it is, that it exists rather than doesn't exist, that people are wired to take such care making such beautiful things. Art is about both the plainness and the mystery, reminding us of the obvious, exploring the overlooked. For all the hours I've spent in art's presence, I am grateful. And I will be returning.

But when I took up my post ten years ago there were things I didn't understand. Sometimes, life can be about simplicity and stillness, in the vein of a watchful guard amid shimmering works of art. But it is also about the head-down work of living and struggling and growing and creating.

At 5:30 I unclip my threadbare tie and bound down the Grand Staircase.

ACKNOWLEDGMENTS

Do you know the scene in *It's a Wonderful Life* where George is given his life back and he bursts into the drafty old house crying "Mary! Mary!" (in his ecstasy forgetting for a moment he has kids, too)? I feel exactly this way about my wife, Tara. Tara, thank you for your love, your wisdom, your hard work, *everything*.

My parents, Jim and Maureen, have encouraged me in all I've done at every stage of my life. Thank you, Mom and Dad. My siblings, Tom and Mia, are my oldest friends and most important coconspirators. Thank you, Mia; and Tom: this whole book is for you.

I am indebted to my agent, Farley Chase, and my editor, Eamon Dolan. Farley took a chance on me when I had no idea, I mean no idea what I was doing. As a coach and as an agent, he went far beyond the call. Eamon loves the Met as much as I do and read every word I sent him with enthusiasm and discernment—"Great!" he always said, before uncapping the red pen and pushing me hard. Farley, Eamon, thank you. Thanks as well to Tzipora Baitch and everyone else at Simon & Schuster who played a role in the book's production.

I owe a huge debt of gratitude to the guards at the Metropolitan Museum of Art. Brothers and sisters of DC 37 Local 1503, thank you

for sharing your stories and wisdom and for the essential work you do. Those of you who are friends I will thank in person, often. The rest of the Met's staff also receives my thanks—custodians, curators, tradespeople, shop clerks, a thousand others who make the institution go. Rembrandt couldn't do it without you.

My illustrator, Maya McMahon, consistently turned in work that is sensitive and alive. Maya, thank you. Thanks also to Emilie Lemakis, who let Maya draw her birthday cake. You should visit emilielemakis.com and buy her art.

I am lucky enough to have friends who helped in various ways, including by agreeing to read pieces of this thing. Mary Hiebert, Alex Ross, Vincent Ketemepi, Winston Moriah, Louisa Lam, Owen Caliento, Cody Westphal, Tanya Erlach, Aaron Dooley, Sam Goetz, Jon Yi, Nick Crawford, Keith Meatto, Michael Haertlein, Dave Shryock, Jack Hannagan, Jason Wyche, Elly Perkins, Corey McCaffrey, Joe Gallagher, Joe Bringley, Cathy Bringley, thank you. I have also had wonderful teachers over the years, including Tom O'Keefe, James Pyne, Jerry Sanders, Rebecca Gaz Healy, and Stacy Pies. Thank you so much.

They don't need my plaudits, but I cannot *not* acknowledge the thousands of artists, ancient and modern, whose paintings, sculptures, drawings, photographs, pottery, quilts, mosaics, prints, and decorative works fill up the Met. It couldn't have been easy. Bravo!

Finally, thanks to my children. Oliver, Louise, you're a joy and I love you. I am so looking forward to being a dad who's done with his book.

ARTWORKS REFERENCED IN THE TEXT

Artworks are in the Metropolitan Museum of Art unless otherwise noted. To find more information (including location within the galleries) and view high-resolution images of most works, visit metmuseum.org. Typically, the best way to search for an object is by using its unique accession number, for example "29.100.6," included below where applicable.

Alternatively, visit patrickbringley.com/art to find the same list with links for all artworks, including those outside the Met's collection.

I: THE GRAND STAIRCASE

View of Toledo
ca. 1599–1600
El Greco (Domenikos Theotokopoulos)
Spanish, born Greece
29.100.6

Madonna and Child Enthroned with Saints
ca. 1504

Raphael (Raffaello Sanzio)
Italian
16.30ab

Madonna and Child
ca. 1290–1300
Duccio di Buoninsegna
Italian
2004.442

The Little Fourteen-Year-Old Dancer
1922 (cast)
Edgar Degas
French
29.100.370

Marble Statue of a Wounded Warrior
ca. AD 138–181
Roman, copy of a Greek bronze statue of ca. 460–450 BC
25.116

Mastaba Tomb of Perneb
ca. 2381–2323 BC
Egyptian, Old Kingdom
13.183.3

The Triumph of Marius
1729
Giovanni Battista Tiepolo
Italian
65.183.1

Bis Pole
ca. 1960
Fanipdas
Asmat people, Indonesia
1978.412.1250

The Harvesters
1565
Pieter Bruegel the Elder
Netherlandish
19.164

II: WINDOWS

Madonna and Child
ca. 1230
Berlinghiero
Italian
60.173

Tiburcio Pérez y Cuervo, the Architect
1820
Goya (Francisco de Goya y Lucientes)
Spanish
30.95.242

María Teresa, Infanta of Spain
ca. 1651–1654
Velázquez (Diego Rodríguez de Silva y Velázquez)
Spanish
49.7.43

Study of a Young Woman
 ca. 1665–1667
 Johannes Vermeer
 Dutch
 1979.396.1

A Maid Asleep
 ca. 1656–1657
 Johannes Vermeer
 Dutch
 14.40.611

Venus and Adonis
 1550s
 Titian (Tiziano Vecellio)
 Italian
 49.7.16

Portrait of a Man
 ca. 1515
 Titian (Tiziano Vecellio)
 Italian
 14.40.640

The Crucifixion
 ca. 1325–1330
 Bernardo Daddi
 Italian
 1999.532

III: A PIETÀ

"Madonna of the Goldfinch"
ca. 1506
Raphael (Raffaello Sanzio)
Italian
Uffizi, Florence

Diana
1892–1893
Augustus Saint-Gaudens
American, born Ireland
Philadelphia Museum of Art
There is a smaller version in the Met: 28.101

Nativity and Adoration of Christ
ca. 1290–1300
Italian
Philadelphia Museum of Art

Christ in the Tomb and the Virgin
ca. 1377
Niccolò di Pietro Gerini
Italian
Philadelphia Museum of Art

IV: OF MILLIONS OF YEARS

Water Deity (Chalchiuhtlicue)
15th–early 16th century
Aztec
00.5.72

Dish of Apples
ca. 1876–1877
Paul Cézanne
French
1997.60.1

Bronze Statue of a Nude Male
ca. 200 BC – AD 200
Greek or Roman
Private collection, on loan to the Met

**Marble Column from the Temple of
Artemis at Sardis**
ca. 300 BC
Greek
26.59.1

Mastaba Tomb of Perneb
ca. 2381–2323 BC
Egyptian, Old Kingdom
13.183.3

Recumbent Lion
ca. 2575–2450 BC
Egyptian, Old Kingdom
2000.485

Biface, or Hand Ax
ca. 300,000–90,000 BC
Egyptian, Lower Paleolithic Period
06.322.4

Hollow-Base Projectile Point
 ca. 6900–3900 BC
 Egyptian, Neolithic Period
 26.10.68

Model of a Traveling Boat being Rowed from the Tomb of Meketre
 ca. 1981–1975 BC
 Egyptian, Middle Kingdom
 20.3.1

Model of a Bakery and Brewery from the Tomb of Meketre
 ca. 1981–1975 BC
 Egyptian, Middle Kingdom
 20.3.12

Model of a Porch and Garden from the Tomb of Meketre
 ca. 1981–1975 BC
 Egyptian, Middle Kingdom
 20.3.13

Model of a Granary with Scribes from the Tomb of Meketre
 ca. 1981–1975 BC
 Egyptian, Middle Kingdom
 20.3.11

Seated Statue of Hatshepsut
 ca. 1479–1458 BC
 Egyptian, New Kingdom
 29.3.2

Large Kneeling Statue of Hatshepsut
ca. 1479–1458 BC
Egyptian, New Kingdom
29.3.1

Mummy of Ukhhotep, son of Hedjpu
ca. 1981–1802 BC
Egyptian, Middle Kingdom
12.182.132c

Canopic Jar of Nephthys
ca. 1981–1802 BC
Egyptian, Middle Kingdom
11.150.17b

The Temple of Dendur
ca. 10 BC
Egyptian, Roman Period
68.154

V: FURTHER SHORES

The Astor Chinese Garden Court
1981 (built), 17th century style
Chinese
Gallery 217

Old Trees, Level Distance
ca. 1080
Guo Xi
Chinese
1981.276

Bridge over a Pond of Water Lilies
1899
Claude Monet
French
29.100.113

Haystacks (Effect of Snow and Sun)
ca. 1891
Claude Monet
French
29.100.109

Vétheuil in Summer
1880
Claude Monet
French
51.30.3

Queen Mother Pendant Mask
16th century
Edo people, Nigeria
1978.412.323

Community Power Figure *(Nkisi)*
19th–20th century
Songye people, Democratic Republic of the Congo
1978.409

VI: FLESH AND BLOOD

Self-Portrait, "Yo"
1900

Pablo Picasso
Spanish
1982.179.18

347 Suite
1968
Pablo Picasso
Spanish
Various accession numbers, e.g., 1985.1165.38

The Actor
1904–1905
Pablo Picasso
Spanish
52.175

Woman in White
1923
Pablo Picasso
Spanish
53.140.4

Marble Head from a Herm
ca. late 5th century BC
Greek
59.11.24

Electrotype Copy of a Stolen Cypriot Bracelet
Copy produced by Tiffany & Co. of a bracelet made in 6th–5th
century BC
Cypriot
74.51.3552

Statuette of Neith
664–380 BC
Egyptian, Late Period
26.7.846

Saint Thomas
ca. 1317–1319
Workshop of Simone Martini
Italian
43.98.9

Anne Elizabeth Cholmley,
Later Lady Mulgrave
ca. 1788
Gainsborough Dupont
British
49.7.56

View of Vétheuil
1880
Claude Monet
French
56.135.1

Sarpedon Krater
ca. 520–510 BC
Euphronios
Greek
Museo Nazionale Cereti, Cerveteri, Italy

Signet Ring of Ramesses VI
ca. 1143–1136 BC

Egyptian, New Kingdom
26.7.768

Gold Coin of the Veneti or Namneti
Mid-2nd century BC
Celtic
17.191.120

Gold Coin of the Parisii
Last quarter 2nd century BC
Celtic
17.191.121

**Ornaments, perhaps dress fasteners
or sleeve fasteners**
ca. 800 BC
Irish
47.100.9 and 47.100.10

Dancer in the Role of Harlequin
1920 (cast)
Edgar Degas
French
29.100.411

Arabesque Devant
1920 (cast)
Edgar Degas
French
29.100.385

Marble Statue of a Crouching Aphrodite
1st or 2nd century AD

Roman, copy of a Greek statue of the 3rd century BC
09.221.1

Madonna and Child
ca. 1290–1300
Duccio di Buoninsegna
Italian
2004.442

Heart of the Andes
1859
Frederic Edwin Church
American
09.95

View from Mount Holyoke, Northampton,
Massachusetts, after a Thunderstorm—The Oxbow
1836
Thomas Cole
American
08.228

Winter, Central Park, New York
1913–1914
Paul Strand
American
2005.100.117

The Flatiron
1904
Edward J. Steichen
American
33.43.39

Old and New New York
1910
Alfred Stieglitz
American
58.577.2

Georgia O'Keeffe—Hands
1919
Alfred Stieglitz
American
1997.61.18

Georgia O'Keeffe—Feet
1918
Alfred Stieglitz
American
1997.61.55

Georgia O'Keeffe—Torso
1918
Alfred Stieglitz
American
28.130.2

Georgia O'Keeffe—Breasts
1919
Alfred Stieglitz
American
1997.61.23

Georgia O'Keeffe
1922

Alfred Stieglitz
American
1997.61.66

Georgia O'Keeffe
1918
Alfred Stieglitz
American
1997.61.25

Georgia O'Keeffe
1918
Alfred Stieglitz
American
28.127.1

VII: CLOISTERS

Chapel from Notre-Dame-du-Bourg at Langon
ca. 1126
French
34.115.1-.269

"Cuxa" Cloister
ca. 1130–1140
Catalan
25.120.398-.954

Annunciation Triptych (Mérode Altarpiece)
ca. 1427–1432
Workshop of Robert Campin

Netherlandish
56.70a-c

The Cloisters Cross (Bury Saint Edmunds Cross)
ca. 1150–1160
British
63.12

"Bonnefont" Cloister
Late 13th–14th century
French
25.120.531-.1052

The Harvesters
1565
Pieter Bruegel the Elder
Netherlandish
19.164

VIII: SENTINELS

Facade of the Second Branch Bank of the United States
1822–1824
Martin Euclid Thompson
American
Gallery 700

Meeting House Gallery, Inspired by the Old Ship Church in Hingham, Massachusetts
1924, based on original from 1681
American
Gallery 713

Room from the Hart House
1680
American
36.127
Gallery 709

**Ballroom from Gadsby's Tavern
(the Alexandria Ballroom)**
1792
American
Gallery 719

George Washington
ca. 1795
Gilbert Stuart
American
07.160

Washington Crossing the Delaware
1851
Emanuel Leutze
American, born Germany
97.34

Mahogany Side Chair
ca. 1760–1790
American
32.57.4

Birthday Thing Number 50
2015
Emilie Lemakis

American
The artist's collection

IX: KOUROS

Marble Statue of a Kouros (youth)
ca. 590–580 BC
Greek
32.11.1

Terra-cotta Neck-Amphora, with Ajax Carrying the Body of Achilles
ca. 530 BC
Attributed to the Painter of London B 235
Greek
26.60.20

Marble Head of Athena (the Athena Medici)
ca. AD 138–92
Original attributed to Phidias
Roman, copy of a Greek statue of ca. 430 BC
2007.293

Folio from the "Blue Quran"
ca. AD 850 – 950
Tunisian
2004.88

Portable Quran manuscript
17th century
Iranian or Turkish
89.2.2156

Folio from the "Quran of 'Umar Aqta'"
ca. 1400
'Umar Aqta'
Central Asian, made in present-day Uzbekistan
18.17.1, .2, and 21.26.12

Incense Burner of Amir Saif al-Dunya wa'l-Din ibn Muhammad al-Mawardi
1181–1182
Ja 'far ibn Muhammad ibn 'Ali
Iranian
51.56

Chess Set
12th century
Iranian
1971.193a–ff

The Mi'raj, or The Night Flight of Muhammad on his Steed Buraq
ca. 1525–1535
Sultan Muhammad Nur
Iranian
1974.294.2

Helmet with Aventail
Late 15th–16th century
Turkish, in the style of Turkman armor
50.87

Moroccan Court
2011 (built), style of the 14th century

Moroccan
Gallery 456

Mihrab (Prayer Niche)
1354–1355
Iranian
39.20

The "Simonetti" carpet
ca. 1500
Egyptian
1970.105

Portrait of a Dervish
16th century
Central Asian, likely made in present-day Uzbekistan
57.51.27

X: THE VETERAN

The Abduction of the Sabine Women
ca. 1633–1634
Nicholas Poussin
French
46.160

Washington Crossing the Delaware
1851
Emanuel Leutze
American, born Germany
97.34

Mrs. Sylvanus Bourne
1766
John Singleton Copley
American
24.79

Shaker Dining Table
1800–1825
American
66.10.1

Walnut Tea Table
1740–1790
American
25.115.32

Mahogany Worktable
1815–1820
American
65.156

Rosewood and Mahogany Card Table
ca. 1825
Attributed to the workshop of Duncan Phyfe
American
68.94.2

Maple Drop-leaf Table
1700–1730
American
10.125.673

Maple and Mahogany Tilt-top Tea Table
ca. 1800
American
10.125.159

Satinwood, Mahogany, and White Pine Console Table
ca. 1815
American
1970.126.1

Yellow Pine and Oak Trestle Table
1640–1690
American
10.125.701

Oak, Pine, and Maple Chamber Table
1650–1700
American
49.155.2

Walnut, Tulip Poplar, and White Pine Tall Clock
1750–1760
John Wood Sr. and John Wood Jr.
American
41.160.369

Mahogany and White Pine Shelf Clock
1805–1809
Aaron Willard and Aaron Willard Jr.
American
37.37.1

Mahogany and White Pine Wall Clock
1800–1810
Simon Willard
American
37.37.2

Mahogany Acorn Clock
1847–1850
Forestville Manufacturing Company
American
1970.289.6

Mahogany Lighthouse Clock
1800–1848
Simon Willard
American
30.120.19a, b

**Mahogany, White Pine, and Tulip Poplar
Banjo Clock**
ca. 1825
Aaron Willard Jr.
American
30.120.15

Mahogany, White Pine, and Tulip Poplar Lyre Clock
1822–1828
John Sawin
American
10.125.391

Walnut and White Pine Looking Glass
1740–1790

American
25.115.41

Steel Sugar Nippers
18th century
American
10.125.593

Leather Fireman's Helmet
1800–1850
American
10.125.609

Leather Fireman's Shield
1839–1850
American
10.125.608

Job Perit
1790
Reuben Moulthrop
American
65.254.1

Mrs. Thomas Brewster Coolidge
ca. 1827
Chester (Charles) Harding
American
20.75

Henry La Tourette de Groot
1825–1830

Samuel Lovett Waldo and William Jewett
American
36.114

Sunset on the Sea
1872
John Frederick Kensett
American
74.3

Conestoga Wagon Jack
1784
American
53.205

Silver Tray
1879
Tiffany & Co.
American
66.52.1

Willie Mays, Card Number 244, from Topps Dugout Quiz Series (R414-7)
1953
Topps Chewing Gum Company
American
Burdick 328, R414–7.244

Hank Aaron, from the Bazooka "Blank Back" Series (R414–15)
1959
Topps Chewing Gum Company

American
63.350.329.414–15.14

Honus Wagner, from the White Border Series (T206)
1909–1911
American Tobacco Company
American
63.350.246.206.378

Mike "King" Kelly, from World's Champions, Series 1 (N28)
1887
Allen & Ginter's Cigarettes
American
63.350.201.28.3

Jack M'Geachy, from the Gold Coin Series (N284)
1887
Gold Coin Chewing Tobacco
American
63.350.222.284.62

Guitar
1937
Hermann Hauser
German
1986.353.1

Kamanche
ca. 1869
Iranian
89.4.325

Koto
20th century
Japanese
1986.470.3

Courting Flute (*siyotanka*)
ca. 1850–1900
Sioux
89.4.3371

Harpsichord
ca. 1670
Michele Todini (designer), Basilio Onofri (gilt work), and Jacob Reiff
(carving)
Italian
89.4.2929a-e

"The Gould" violin
1693
Antonio Stradivari
Italian
55.86a-c

***Kanyáhte' ká'nowa'* (Snapping turtle shell rattle)**
19th century
Iroquois
06.1258

Banjo
ca. 1850–1900
American
89.4.3296

Kora
 ca. 1960
 Mamadou Kouyaté and Djimo Kouyaté
 Senegambian
 1975.59

Foot-Combat Helm of Sir Giles Capel
 ca. 1510
 Possibly British
 04.3.274

Colt Patterson Percussion Revolver, No. 3, Belt Model, Serial 156
 ca. 1838
 Colt's Manufacturing Company
 American
 59.143.1a-h

Colt Model 1851 Navy Percussion Revolver, Serial No. 2
 1850
 Colt's Manufacturing Company
 American
 68.157.2

"Peacemaker" Colt Single-Action Army Revolver, Serial No. 4519
 1874
 Colt's Manufacturing Company
 American
 59.143.4

Madame X (Madame Pierre Gautreau)
1883–1884
John Singer Sargent
American, born Italy
16.53

Northeaster
1895, reworked by 1901
Winslow Homer
American
10.64.5

Mother and Child (Baby Getting Up from His Nap)
ca. 1899
Mary Cassatt
American
09.27

XI: UNFINISHED

The Harvesters
1565
Pieter Bruegel the Elder
Netherlandish
19.164

Saint Barbara
1437
Jan van Eyck
Netherlandish
Koninklijk Museum voor Schone Kunsten, Antwerp

Untitled
 2009
 Kerry James Marshall
 American
 Yale University Art Gallery, New Haven

Black Draftee (James Hunter)
 1965
 Alice Neel
 American
 COMMA Foundation, Damme, Belgium

"Untitled" (Portrait of Ross in L.A.)
 1991
 Felix Gonzalez-Torres
 American, born Cuba
 Art Institute of Chicago

*The Dirty Bride or The Wedding of Mopsus
and Nisa*
 ca. 1566
 Pieter Bruegel the Elder
 Netherlandish
 32.63

XII: DAYS' WORK

*Study after Saint Peter, with Arm Studies (recto); Skeleton of a
Hand with Forearm, Male Torso, and Right Forearm (verso)*
 ca. 1493–1494
 Michelangelo Buonarroti

Italian
Staatliche Graphische Sammlung, Munich

**Sonnet "To Giovanni da Pistoia" and Caricature on His
Painting of the Sistine Ceiling**
ca. 1509–1510
Michelangelo Buonarroti
Italian
Casa Buonarroti, Florence

Studies for the Libyan Sibyl (recto)
ca. 1510–1511
Michelangelo Buonarroti
Italian
24.197.2

Sketches for Compositions of the Pietà and the Entombment
ca. 1555–1560
Michelangelo Buonarroti
Italian
Ashmolean Museum, Oxford

Studies for the Dome of Saint Peter's (recto)
ca. 1551–1564
Michelangelo Buonarroti
Italian
Palais des Beaux-Arts, Lille

**Studies for the Fortifications of Florence: The Torre del Serpe at
the Prato di Ognissanti (recto)**
ca. 1530
Michelangelo Buonarroti

Italian
Casa Buonarroti, Florence

Pietà Rondanini
1552–1564
Michelangelo Buonarroti
Italian
Castello Sforzesco, Milan

Housetop and Bricklayer with Bars Quilt
ca. 1955
Lucy T. Pettway
American
2014.548.52

Log Cabin Quilt
ca. 1935
Mary Elizabeth Kennedy
American
2014.548.44

Lazy Gal Bars Quilt
ca. 1965
Loretta Pettway
American
2014.548.50

XIII: AS MUCH AS I CAN CARRY

The Triumph of Marius
1729
Giovanni Battista Tiepolo

Italian

65.183.1

Terra-cotta Neck-Amphora. Obverse: Apollo between Hermes and Goddess; reverse: Memnon between His Ethiopian Squires

ca. 530 BC

Greek

98.8.13

Marble Column from the Temple of Artemis at Sardis

ca. 300 BC

Greek

26.59.1

Marble Bust of a Man

AD mid–1st century

Roman

12.233

Slit Gong (*Atingting kon*)

Mid- to late 1960s

Tin Mweleun

Ambrym people, Vanuatu

1975.93

Canoe

1961

Chief Chinasapitch

Asmat people, Indonesia

1978.412.1134

Bis Pole

ca. 1960

Jewer
Asmat people, Indonesia
1978.412.1248

Money Coil (*Tevau*)
Late 19th–early 20th century
Solomon Islands
2010.326

Perseus with the Head of Medusa
1804–1806
Antonio Canova
Italian
67.110.1

Boiserie from the Hôtel de Varengeville
ca. 1736–1752, with later additions
French
63.228.1

Sunflowers
1887
Vincent van Gogh
Dutch
49.41

Oleanders
1888
Vincent van Gogh
Dutch
62.24

Irises
1890
Vincent van Gogh
Dutch
58.187

The Potato Peeler (reverse *of Self-Portrait with a Straw Hat*)
1885
Vincent van Gogh
Dutch
67.187.70b

L'Arlésienne: Madame Joseph-Michel Ginoux
1888–1889
Vincent van Gogh
Dutch
51.112.3

First Steps, after Millet
1890
Vincent van Gogh
Dutch
64.165.2

Self-Portrait with a Straw Hat (obverse of *The Potato Peeler*)
1887
Vincent van Gogh
Dutch
67.187.70a

Isaac and Rebecca, known as "The Jewish Bride"
ca. 1665–1669
Rembrandt van Rijn
Dutch
Rijksmuseum, Amsterdam

The Gulf Stream
1899, reworked by 1906
Winslow Homer
American
06.1234

The Crucifixion
ca. 1420–1423
Fra Angelico (Guido di Pietro)
Italian
43.98.5

BIBLIOGRAPHY

Most of the book's factual information about artworks was found on metmuseum.org. On each object's page, there is typically a catalogue entry, technical notes, and a references section pointing to relevant publications. In most cases, official Met publications are freely available to read online at metmuseum.org/art /metpublications.

The following books and articles are grouped by subject matter and then listed alphabetically.

AFRICAN ART

Ezra, Kate. *Royal Art of Benin: The Perls Collection in the Metropolitan Museum of Art.* New York: Metropolitan Museum of Art, 1992. Published in conjunction with an exhibition held at the Metropolitan Museum of Art, January 16–September 13, 1992.

LaGamma, Alisa, ed. *Kongo: Power and Majesty.* New York: Metropolitan Museum of Art, 2015. Published in conjunction with an exhibition held at the Metropolitan Museum of Art, September 18, 2015–January 3, 2016.

Neyt, François. *Songye: The Formidable Statuary of Central Africa.* Translated by Mike Goulding, Sylvia Goulding, and Jan Salomon. New York: Prestel, 2009.

AMERICAN ART

Belson, Ken. "A Hobby to Many, Card Collecting Was Life's Work for One Man." *New York Times*, May 22, 2012.

Flexner, James Thomas. *First Flowers of Our Wilderness.* Volume 1 of *American Painting.* Boston: Houghton Mifflin, 1947.

Garrett, Wendell D. "The First Score for American Paintings and Sculpture, 1870–1890." *Metropolitan Museum Journal* 3 (1970): 307–35. https://doi.org/10.2307/1512609.

O'Neill, John P., Joan Holt, and Dale Tuckers, eds. *A Walk Through the American Wing.* New York: Metropolitan Museum of Art; New Haven: Yale University Press, 2001.

ARMS AND ARMOR

Rasenberger, Jim. *Revolver: Sam Colt and the Six-Shooter That Changed America.* New York: Scribner, 2020.

ASIAN ART

Bush, Susan, and Hsio-yen Shih, eds. *Early Chinese Texts on Painting.* Cambridge, MA: Harvard-Yenching Institute, Harvard University Press, 1985.

Fong, Wen C. *Beyond Representation: Chinese Painting and Calligraphy*

8th–14th Century. New York: Metropolitan Museum of Art; New Haven: Yale University Press, 1992.

Foong, Ping. "Guo Xi's Intimate Landscapes and the Case of *Old Trees, Level Distance.*" *Metropolitan Museum Journal* 35 (2000): 87–115. https://doi.org/10.2307/1513027.

Hammer, Elizabeth. *Nature Within Walls: The Chinese Garden Court at the Metropolitan Museum of Art. A Resource for Educators.* New York: Metropolitan Museum of Art, 2003.

THE CLOISTERS

Barnet, Peter, and Nancy Wu. *The Cloisters: Medieval Art and Architecture.* New York: Metropolitan Museum of Art, 2005.

EGYPTIAN ART

Arnold, Dieter. *Temples of the Last Pharaohs.* New York: Oxford University Press, 1999.

Assmann, Jan. *The Mind of Egypt: History and Meaning in the Time of the Pharaohs.* Translated by Andrew Jenkins. New York: Metropolitan Books, 2002.

Roehrig, Catharine H. *Life Along the Nile: Three Egyptians of Ancient Thebes. Metropolitan Museum of Art Bulletin* 60 (Summer 2002).

Roehrig, Catharine H., with Renée Dreyfus and Cathleen A. Keller, eds. *Hatshepsut: From Queen to Pharaoh.* New York: Metropolitan Museum of Art; New Haven: Yale University Press, 2005. Published in conjunction with an exhibition held at the Fine Arts Museums of San Francisco / de Young, October 15, 2005–February 5, 2006; at

the Metropolitan Museum of Art, March 28–July 9, 2006; and at the Kimbell Art Museum, Fort Worth, August 27–December 31, 2006.

EUROPEAN ART

Ainsworth, Maryan W., and Keith Christiansen, eds. *From Van Eyck to Bruegel: Early Netherlandish Painting in the Metropolitan Museum of Art.* New York: Metropolitan Museum of Art, 1998. Published as a catalogue of key works in the collection of the Metropolitan Museum of Art, and serves to accompany the exhibition of those works held on September 22, 1998–January 3, 1999.

Bayer, Andrea. "North of the Apennines: Sixteenth-Century Italian Painting in Venice and the Veneto." *Metropolitan Museum of Art Bulletin* 63 (Summer 2005).

Christiansen, Keith. *Duccio and the Origins of Western Painting.* New York: Metropolitan Museum of Art; New Haven: Yale University Press, 2008.

Freedberg, Sydney Joseph. *Painting of the High Renaissance in Rome and Florence.* New York: Harper & Row, 1972.

Gogh, Vincent van. *Van Gogh: A Self-Portrait. Letters Revealing His Life as a Painter.* Selected by W. H. Auden. Greenwich, CT: New York Graphic Society, 1961.

Kanter, Laurence, and Pia Palladino. *Fra Angelico.* New York: Metropolitan Museum of Art; New Haven: Yale University Press, 2005. Published in conjunction with an exhibition held at the Metropolitan Museum of Art, October 26, 2005–January 29, 2006.

Kerssemakers, Anton. Letter to the editor, *De Groene*, April 14, 1912. In *Van Gogh's Letters: Unabridged and Annotated.* Edited by Robert

Harrison. Translated by Johanna van Gogh-Bonger. Rockville, MD: Institute for Dynamic Educational Advancement. http://www .webexhibits.org/vangogh/letter/15/etc-435c.htm.

Orenstein, Nadine M., ed. *Pieter Bruegel the Elder: Drawings and Prints.* New York: Metropolitan Museum of Art; New Haven: Yale University Press, 2001. Published in conjunction with an exhibition held at the Museum Boijmans Van Beuningen, Rotterdam, May 24– August 5, 2001, and at the Metropolitan Museum of Art, September 25–December 2, 2001.

Strehlke, Carl Brandon. *Italian Paintings 1250–1450 in the John G. Johnson Collection and the Philadelphia Museum of Art.* Philadelphia: Philadelphia Museum of Art; University Park, PA: Penn State University Press, 2004.

GEE'S BEND EXHIBITION

Beardsley, John, William Arnett, Paul Arnett, and Jane Livingston. *The Quilts of Gee's Bend.* Atlanta: Tinwood Books, 2002.

Finley, Cheryl, Randall R. Griffey, Amelia Peck, and Darryl Pinckney. *My Soul Has Grown Deep: Black Art from the American South.* New York: Metropolitan Museum of Art, 2018. Published in conjunction with *History Refused to Die: Highlights from the Souls Grown Deep Foundation Gift*, held at the Metropolitan Museum of Art, May 22–September 23, 2018.

Holley, Donald. "The Negro in the New Deal Resettlement Program." *Agricultural History* 45 (July 1971): 179–93.

GREEK ART

Bremmer, Jan. *The Early Greek Concept of the Soul*. Princeton, NJ: Princeton University Press, 1983.

Estrin, Seth. "Cold Comfort: Empathy and Memory in an Archaic Funerary Monument from Akraiphia." *Classical Antiquity* 35 (October 2016): 189–214. https://doi.org/10.1525/ca.2016.35.2.189.

Griffin, Jasper. *Homer on Life and Death*. Oxford: Clarendon Press, 1980.

Homer. *The Iliad*. Translated by Robert Fagles. New York: Viking Penguin, 1990.

Homer. *The Odyssey*. Translated by Robert Fagles. New York: Viking Penguin, 1996.

Kirk, G. S., and J. E. Raven. *The Presocratic Philosophers: A Critical History with a Selection of Texts*. Cambridge: Cambridge University Press, 1957.

Otto, Walter F. *The Homeric Gods: The Spiritual Significance of Greek Religion*. Translated by Moses Hadas. New York: Pantheon, 1954.

Sourvinou-Inwood, Christiane. *"Reading" Greek Death: To the End of the Classical Period*. Oxford: Clarendon Press, 1995.

Vermeule, Emily. *Aspects of Death in Early Greek Art and Poetry*. Berkeley: University of California Press, 1979.

ISLAMIC ART

Chittick, William C. *Ibn 'Arabi: Heir to the Prophets*. Oxford: Oneworld, 2005.

Chittick, William C. *Science of the Cosmos, Science of the Soul: The Pertinence of Islamic Cosmology in the Modern World.* Oxford: Oneworld, 2007.

Ekhtiar, Maryam D., Priscilla P. Soucek, Sheila R. Canby, and Navina Najat Haidar, eds., *Masterpieces from the Department of Islamic Art in The Metropolitan Museum of Art.* New York: Metropolitan Museum of Art, 2011. Published in conjunction with the reopening of the Galleries for the Art of the Arab Lands, Turkey, Iran, Central Asia, and Later South Asia on November 1, 2011.

Kennedy, Randy. "History's Hands." *New York Times,* March 17, 2011.

Muslu, Cihan Yüksel. *The Ottomans and the Mamluks: Imperial Diplomacy and Warfare in the Islamic World.* New York: I. B. Tauris, 2014.

Nicolle, David. *The Mamluks: 1250–1517.* London: Osprey, 1993.

Sutton, Daud. *Islamic Design: A Genius for Geometry.* New York: Bloomsbury, 2007.

METROPOLITAN MUSEUM HISTORY

"Art Stolen in 1944 Mailed to Museum; 14th Century Painting on Wood Returned to Metropolitan with No Explanation. Panel Broken in Transit. Package Carelessly Wrapped—Expert Believes Damage Can Be Repaired." *New York Times,* January 19, 1949, 29.

Barelli, John, with Zachary Schisgal. *Stealing the Show: A History of Art and Crime in Six Thefts.* Guilford, CT: Lyons Press, 2019.

Bayer, Andrea, and Laura D. Corey, eds. *Making the Met: 1870–2020.* New York: Metropolitan Museum of Art, 2020. Published in conjunction with an exhibition held at the Metropolitan Museum of Art, March 30–August 2, 2020.

"The Cesnola Discussion; More About the Patched-up Cypriote Statues." *New York Times*, April 10, 1882, 2.

Daniels, Lee A. "3 Held in Theft of Gold Ring from Met." *New York Times*, February 16, 1980, 24.

"Five 17th Century Miniatures Are Stolen from Locked Case in Metropolitan Museum." *New York Times*, July 26, 1927, 1.

Gage, Nicholas. "How the Metropolitan Acquired 'The Finest Greek Vase There Is.'" *New York Times*, February 19, 1973, 1.

Gupte, Pranay. "$150,000 Art Theft is Reported by Met." *New York Times*, February 11, 1979, 1.

Hoving, Thomas. *Making the Mummies Dance: Inside the Metropolitan Museum of Art.* New York: Simon & Schuster, 1993.

"Lost to the Art Museum; A Pair of Gold Bracelets Missing from the Collection." *New York Times*, September 18, 1887, 16.

"Lost Goddess Neith Found in Pawnshop; Rare Idol of Ancient Egypt Stolen from Metropolitan Museum Pledged for 50 Cents." *New York Times*, April 24, 1910, 7.

McFadden, Robert D. "Met Museum Becomes Lost and Found Dept. for 2 Degas Sculptures." *New York Times*, February 10, 1980, 38.

"Metropolitan Art Thief Balked, but a Gang in France Succeeds." *New York Times*, April 23, 1966, 1.

"Metropolitan Museum Employee Is Held in Theft of Ancient Jewels." *New York Times*, January 25, 1981, 29.

"Museum Exhibits Come to Life Outdoors as Artful Guards Picket for Wage Rise." *New York Times*, July 3, 1953, 8.

"Museum Is Robbed of a Statuette of Pitt Between Rounds of Guards." *New York Times*, February 5, 1953, 25.

"On (Surprisingly Quiet) Parisian Night, a Picasso and a Matisse Go Out the Window." *New York Times*, May 20, 2010.

Phillips, McCandlish. "Hole Poked in $250,000 Monet at Metropolitan, Suspect Seized." *New York Times*, June 17, 1966, 47.

"Thief Takes a 14th Century Painting from Wall at Metropolitan Museum." *New York Times*, March 23, 1944, 14.

"$3,000 Prayer Rug Is Stolen in Museum but Guard Finds It Hidden Under Man's Coat." *New York Times*, December 16, 1946, 28.

Tomkins, Calvin. *Merchants and Masterpieces: The Story of the Metropolitan Museum of Art.* New York: Dutton, 1970.

MICHELANGELO EXHIBITION

Bambach, Carmen C., ed. *Michelangelo: Divine Draftsman & Designer*. New York: Metropolitan Museum of Art, 2018. Published in conjunction with an exhibition held at the Metropolitan Museum of Art, November 13, 2017–February 2, 2018.

Buonarroti, Michelangelo. *Michelangelo's Notebooks: The Poetry, Letters, and Art of the Great Master.* Edited by Carolyn Vaughan. New York: Black Dog & Leventhal, 2016.

Gayford, Martin. *Michelangelo: His Epic Life.* London: Fig Tree, 2013.

King, Ross. *Michelangelo and the Pope's Ceiling.* New York: Walker, 2003.

MODERN AND CONTEMPORARY ART

Sw!pe Magazine, Spring 2010.

Sw!pe Magazine, Spring 2011.

Sw!pe Magazine, Spring 2012.

Tinterow, Gary, and Susan Alyston Stein, eds. *Picasso in the Metropolitan Museum of Art*. New York: Metropolitan Museum of Art; New Haven: Yale University Press, 2010. Published in conjunction with an exhibition held at the Metropolitan Museum of Art, April 27–August 1, 2010.

MUSICAL INSTRUMENTS

Morris, Frances. *Catalogue of the Crosby Brown Collection of Musical Instruments* Vol. II, *Oceania and America*. New York: Metropolitan Museum of Art, 1914.

Winans, Robert B., ed. *Banjo Roots and Branches*. Champaign: University of Illinois Press, 2018.

PHOTOGRAPHY

Daniel, Malcolm. *Stieglitz, Steichen, Strand: Masterworks from the Metropolitan Museum of Art*. New York: Metropolitan Museum of Art, 2010. Published in conjunction with an exhibition held at the Metropolitan Museum of Art, November 10, 2010–April 10, 2011.

UNFINISHED EXHIBITION

Baum, Kelly, Andrea Bayer, and Sheena Wagstaff. *Unfinished: Thoughts Left Visible*. New York: Metropolitan Museum of Art, 2016. Published in conjunction with an exhibition held at the Met Breuer, March 18–September 4, 2016.